The Art of Type and Typography

The Art of Type and Typography is an introduction to the art and rules of typography. Incorporating the industry standard—InDesign—for typesetting from the outset, this book serves as a guide for beginning students to learn to set type properly through tutorials, activities, and examples of student work. Encompassing the history of typography from ancient times to widespread modern use, *The Art of Type and Typography* provides context and fosters creativity while developing key concepts, including:

- The history of type;
- Terminology;
- Classification;
- Measurement;
- Spacing;
- Alignment;
- Legibility;
- Hierarchy;
- Layout and Grids;
- Page Elements;
- InDesign tools and style sheets.

Writing clearly and to the point, Mary Jo Krysinski brings over 30 years of design experience to this essential guide. With a glossary, sample class activities, additional online resources and a beautiful clean design, this book is the perfect introduction for a beginning typography student, and a handy reference for those needing a refresher.

Mary Jo Krysinski has taught typography and graphic design courses at the School of the Art Institute of Chicago and at St. Xavier University for over seventeen years, and has been a practicing graphic designer for over 30 years.

The Art of Type and Typography

Explorations in use and practice

Mary Jo Krysinski

Routledge
Taylor & Francis Group

NEW YORK AND LONDON

First published 2018
by Routledge
711 Third Avenue, New York, NY 10017

and by Routledge
2 Park Square, Milton Park, Abingdon, Oxon OX14 4RN

Routledge is an imprint of the Taylor & Francis Group, an informa business

Library of Congress Cataloguing in Publication Data
A catalogue record for this book has been requested.

ISBN: 978-1-138-23685-1 (hbk)
ISBN: 978-1-138-23688-2 (pbk)
ISBN: 978-1-315-30155-6 (ebk)

Adobe product screen shots reprinted with permission from Adobe Systems
Incorporated.
Adobe®InDesign® is a registered trademark of Adobe Systems Incorporated
in the United States and/or other countries.

Design: Mary Jo Krysinski
Typeset in Adobe Myriad Pro and Adobe Caslon by Mary Jo Krysinski

Table of Contents

Preface

When I began teaching the Beginning Typography class at The School of the Art Institute of Chicago in 2000, I looked for a typography book that I could use as a supplement for the class. I quickly learned that there were no books on the market that would suit my needs. None of the books contained everything I was looking for, and most were too general in their coverage of typography and its basic rules. That is the reason I wrote this text.

It began as a short, photocopied book that I gave to my students to complement my lectures and for reference. Over the next few years, I kept adding material as I found gaps in the information, and in recent years added basic InDesign® instructions to enhance our students' InDesign course. Most Visual Communication departments use InDesign in their curriculum.

This book includes a brief history of lettering and type as a base for understanding how letters and type evolved. The rest of the book deals with the mechanics and basic rules of typography with the intention of teaching how to set legible and aesthetically pleasing type. At the end of some of the chapters, I have included samples of exercises and assignments to show how I teach the concepts, and samples of student solutions.

There are many people I need to thank for making this book possible. First, my teachers Frank DeBose and Katharine Wolff in the early Visual Communication graduate program at SAIC, from whom I learned to love type and typography. My colleagues in the Visual Communication Design department at SAIC who have contributed their work to this book: John Bowers, Frank DeBose (Professor Emeritus), Dan McManus, Daniel Morgenthaler, Eliza Rosen, Mark Stammers, and especially Stephen Farrell, who also gave input and support. My students past and present, especially those who have allowed me to use their work in this book.

I want to thank John Powell and the staff at The Newberry Library for help with the majority of images from the type history chapter, and Paul Gehl and Jill Gage, former and current Custodian of the John M. Wing Foundation on the History of Printing at The Newberry Library, for introducing me to the many type treasures contained there.

I am indebted to Judith Newlin, my editor at Routledge, and Elise Poston for all of their support and help throughout this process. Special thanks to Chris Woldt for editing the book as it was being completed.

And last, but no less important, my husband, Bob, and my sons, Rob and Justin, for putting up with me during this process and all of their support in everything I do.

01.
A Brief History of the Alphabet and Type

Our alphabet is a series of marks that represent sounds in our language. Letters are the physical form of our written language, and type is the mechanical form. To understand typography, one needs to understand how our written language developed.

The earliest form of visual language dates back to the Stone Age. In southern Europe between 30,000 B.C. and 9,000 B.C., marks and symbols were painted on cave walls. Many theories exist as to what they represent—number of animals killed, clan narratives, etc. The drawings represented objects independent of their pronunciation. They are called *pictograms*. Once they were used repeatedly and became recognizable, they became a visual language.

Eventually the pictograms began to be combined to form graphic representations of conceptual ideas. These are called *ideograms*. This marks the beginning of a more complete writing system.

The need for better written communication led to the formation of *phonograms*. Here the signs represented the *sound* of the object's

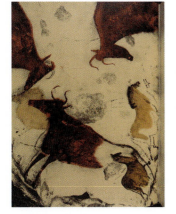

Cave Painting from Lascaux, France.

Photo courtesy of The Newberry Library, Chicago, Greenlee 4528 W76 1948.

30,000–9000 B.C.

PICTOGRAMS—marks and signs painted on cave walls and stones.

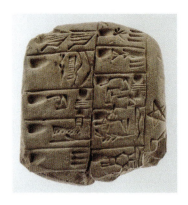 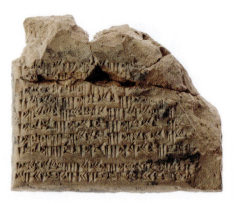

Left: Akkadian tablet from Uruk with pictorial writing.

Right: Sumerian tablet with cuneiform writing.

Both images courtesy of the Oriental Institute of the University of Chicago.

name. Speech elements (consonants and vowels) were now represented by the signs. Different cultures developed alphabetic scripts with these signs that were based on their own languages.

THE FIRST WRITING SYSTEM

The history of our Western alphabet begins with the Sumerians in Mesopotamia, the area that is now Iraq. The Sumerians were an agricultural people who engaged in trade, which required them to have a system for recording business transactions. They started with phonetic pictorial signs drawn into clay tablets. The need for faster recording led to the development of cuneiform writing. A triangular-shaped stylus was pressed into wet clay tablets to form the signs, creating more abstract interpretations of the pictorial signs.

Early cuneiform writing used ideograms, which later changed to phonograms—symbols that represent sounds, either whole words or syllables.

Around the same time, the Egyptians developed *hieroglyphics* (using pictograms to represent words and sounds). Hieroglyphics evolved into a *rebus*-like system of writing where pictograms of short words are combined to sound out longer words or phrases. Example: sun + light = sunlight.

The Semitic alphabet appeared between 1700 B.C. and 1500 B.C., and was based on 24 unconsonant signs from Egyptian hieroglyphics. This

Egyptian hieroglyphics in use.

3200 B.C.	3000 B.C.	2800 B.C.
Pictorial phonographic symbols on clay tablets are scribed by the Sumerians.		The Sumerians develop cuneiform writing.

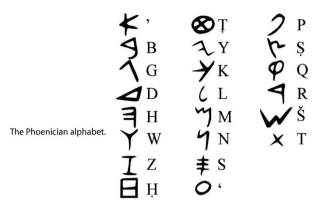

The Phoenician alphabet.

became the basis for a number of alphabets created by different cultures in the Middle East and around the Mediterranean. One of these was the Phoenician culture.

THE PHOENICIAN ALPHABET

Phoenicia was a trading nation on the east end of the Mediterranean Sea, where a phonetic alphabet of 22 characters was created. It was based on the principle that one sign represents one spoken sound. Because of their vast trade empire, Phoenicians traveled all over the Mediterranean, influencing many other peoples including the Greeks, Minoans, Etruscans, and Sumerians.

The Greeks began using the 22 Phoenician symbols, adapting it to their own language, adding characters for sounds in the Greek language that had no counterparts in the Phoenician.

In the beginning, Greek writing read from right to left on the first line, then from left to right on the second line, and back again from right to left on the next line, continuing in a snake-like fashion down the page, also flipping the letters on each row. This is called *boustrophedon,* meaning "as the ox plows the field." Later, their writing changed to a strictly left-to-right orientation.

Greek colonists took the alphabet to Italy, where it was adopted by the Etruscans, who had settled north of Rome. The Etruscans adapted the Greek characters to reflect their own phonetics, which required 26 symbols.

Phoenicians create their 22-character alphabet.

The Etruscans use the Greek alphabet for their language.

| 1500 B.C. | 800 B.C. | 700 B.C. |

Greeks adopt the Phoenician alphabet for their language.

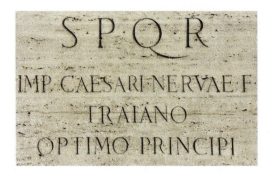

Roman square capitals carved
on the base of Trajan's Column
in Rome.
© Cristiano Fronteddu | Dreamstime.com

THE ROMAN EMPIRE

The Greek alphabet was the source of the Roman alphabet by way of the Etruscans. The earliest form contained 21 letters. As Greek words became part of the Latin language, additional sounds required more letters. By the 2nd century A.D., when Roman inscriptions were at their height, the Roman alphabet had 23 letters with J, U, and W still missing. The missing letters were added at various times between the 11th and 17th centuries.

The Roman alphabet consisted of all capital letters at first, and was used mainly for inscriptions on monuments. They were called *square capitals*, or *Capitalis Quadrata*, also called *majuscules* and known as formal writing. One of the best and most famous examples of these letters is at the base of Trajan's Column in Rome. The letters on Trajan's Column have been called the most perfect of their kind.

The Roman square capitals were drawn and cut into stone, and an important part of these letterforms is the endings—small horizontal lines that finish the ends of the strokes—considered to be the basis for *serifs*. There has been much speculation over their existence and purpose. The most accepted explanation is that these lines were formed as a result of the scribe drawing the letters with a brush on the stone before the mason cut them. The brush formed bracket-like shapes at the ends of the strokes.

Roman capital inscriptions at
their peak.

600 B.C. **114 A.D.**

Earliest form of Roman
alphabet in use.

Rustic Capitals
Photo courtesy of The Newberry Library, Chicago, Case MS 102 2.

RUSTIC CAPITALS

For written documents on parchment, scribes used a dip pen or brush to write the square capitals, and also wrote a more compact version called *Rustic capitals,* which were condensed and had pronounced thicks and thins with heavy horizontal strokes at the ends of the letters.

UNCIALS AND HALF-UNCIALS

By using a reed pen, with the nib held horizontal to the baseline to write the square capitals, the forms became more rounded. These were called *uncials* for the Roman inch because the letters were very large, but not as large as an inch. Church scribes started writing these formal capitals using one pen stroke, eliminating the serifs. Some of these letters began to look like our modern lowercase.

In the 5th century, *half-uncials* or *minuscules* started to appear. They were still written with a reed or quill pen, and were a combination of uncials and cursive script. Almost all of the letters resembled modern lowercase letters.

Insular Uncials used in *The Durham Gospels.*
Photo courtesy of The Newberry Library, Chicago, Case BS 1970 D8 1980.

Uncial and half-uncial forms in use.

100–300	300–800		400–600
Rustic capitals written with a pen or brush.			The emergence of various monastic scripts.

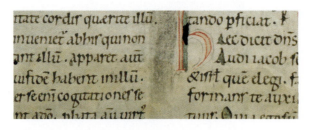

Carolingian Minuscule from a missal leaf.

Photo courtesy of The Newberry Library, Chicago, Greenlee MS 464r.

MONASTIC HANDS

All of the scripts mentioned thus far were used by monastic scribes to write religious texts. The various monasteries around the Roman Empire developed their own variations of the uncials and half-uncials. In Ireland, Insular uncials and half-uncials with thicker, wedge-shaped serifs and curved vertical strokes were used. Other variations appeared in Spain, France, and Italy at this time.

CAROLINGIAN MINUSCULE

At the time of Charlemagne's rule over the Roman empire, there were many regional scripts in use. In 786 A.D., Charlemagne appointed an English monk, Alcuin of York, to create a standardized lettering style. He chose a hand similar to the Celtic uncials, and this new style became known as *Carolingian minuscule*. It became the standardized script throughout Charlemagne's empire.

The influence of Charlemagne's changes began to fade over the next century. A slow re-emergence of regional styles began.

THE GOTHIC STYLE

Until the 11th century, Carolingian minuscule remained the standard script. Gradually, it became more compressed and angular, with word and letter

Carolingian minuscule is the standard script used throughout Charlemagne's empire.

789–1000	1000–1200

Local Gothic scripts used throughout Europe.
Rag paper invented (1085).

Bastarda from a French Bible page.
Photo courtesy of The Newberry Library, Chicago, Case MS 16 folio 256r.

spacing also being reduced. As pen nibs became wider, the letters became more condensed and angular, giving them a blacker, denser appearance. This style of script was also called *Textura* or *Fractura*.

There were certain characteristics common to the Gothic style. The *D* was written like the uncial *d*, and *s* at the beginning and middle of a word resembled an *f* without a crossbar. This type of *s* continued to be used in printing even into the 19th century in some British books.

Bastarda

The 13th century saw the emergence of universities. Scholars and students began using their own form of Gothic script, which was faster to write and more angular. It was called *bastarda*, meaning lowborn.

It was during this period that scribes began to be associated with universities and towns rather than just monasteries. More varieties of the Gothic hand began to appear at this time. In Italy a wider, more rounded version of Gothic called *rotunda* was being used.

Universities emerge across Europe along with the *bastarda* and *rotunda* scripts.

1200	1300

Carolingian minuscule reappears along with the cursive version *Littera Cancellaresca*.

Humanistic Cursive Script
Photo courtesy of The Newberry Library, Chicago, Wing MS ZW 1 .516 01.

HUMANISTIC WRITING

Humanistic hands based on the Carolingian minuscule began to reappear during the Italian Renaissance. They were written with a quill, very evenly spaced, with little difference between the thick and thin strokes. There was also a cursive version used by scholars, and one used in papal and church offices called *littera cancellaresca*.

THE BIRTH OF PRINTING AND REUSABLE TYPE

One of the most important inventions during the Middle Ages was the creation of movable, reusable, type, and the printing press. Johannes Gutenberg (c. 1398–1468), a German metalsmith, is credited with this innovation.

It was a time-consuming process to cast each letter, but the letters could be used numerous times to make multiple prints. Gutenberg's goal was to duplicate the hand-lettered manuscripts written by the scribes, and in order to achieve this he copied the handwriting used in the manuscripts as his model for type. Since Gothic was the script being used in Germany, Gutenberg's typefaces were Gothic letterforms. Later, when German printers migrated to Italy, they used the humanistic scripts as models for their type.

Gutenberg invents movable type and prints his 42-line Bible.

1450

Leaf from Gutenberg's 42-Line Bible.
Photo courtesy of The Newberry Library, Chicago,
Inc 56 01 recto.

The Invention of Paper

Books became cheaper to produce with the invention of rag paper in 1085. Prior to this, all writing was done on parchment or vellum, which were made from animal skins. Paper made from rags brought down the cost. Paper mills began to appear and watermarks were used to identify the papermakers.

Gutenberg's Bible

The first book Gutenberg printed with his new technique was the Bible. It was printed between 1450 and 1456, and is called the 42-Line Bible because each page contains two columns of 42 lines each down the page. He printed a limited number of copies on rag paper and some on vellum. Very few survive.

PRINTING AND TYPE IN ITALY

When Mainz, in what is now Germany, was attacked and partly burned in 1462, some of the printers left the city and went to other countries. Sweynheym and Pannartz set up their shop in a monastery in Subiaco, Italy, near Rome. The type they used is considered to be the first roman type. Although it has some Gothic characteristics, it uses Roman capitals and is widely spaced.

1462

Mainz burns, causing many German printers to move to Italy.

S eruauit trepidam flagranti ex æde Mineruam,
P rotinus ad cęnſum, de moribus ultima fiet
Quæſtio, quot paſcat ſeruos, quot poſſidet agri
I ugera, quàm multa, magnáq; paropſide cœnat.
Quantum quiſque ſua nummorum ſeruat in arca,
T antum habet & fidei, iures licet et Samothracum,
E t noſtrorum aras, contemnere fulmina pauper
C reditur, atq; Deos, Dÿs ignoſcentibus ipſis.

Aldus Manutius' italic type.
Photo courtesy of The Newberry Library, Chicago, Wing fac ZW 535 L9612.

doloſoſam profecto materiam, ſed pro cognitione illorum temporum neceſſariam. Neq; enim Xenophontem Athenienſem ſummo ingenio virum, cũ obſidionẽ, & famem, ac diruta mœnia Athenarum deſcripſit, non dolenter id feciſſe reor: ſcripſit tamen, quia vtile putabat, illarum rerum me-

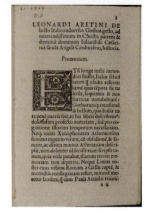

Jenson's roman type from a book published by Nicolas Jenson.
Photo courtesy of The Newberry Library, Chicago, Case F 352 116.

Nicolas Jenson (1420–1480)

Jenson was a French engraver and mintmaster to the king, sent to Mainz in 1458 by Charles VII to learn the art of printing. Because of problems with the new king, Louis XI, when he returned to France, Jenson went to Italy to set up his business. In Venice, Jenson cut what is considered the first true roman typeface. It was called *Eusebius*, and was based on the Humanistic formal script from the Carolingian period with little contrast between the thick and thin strokes, heavily bracketed serifs, and oblique stress.

Aldus Manutius (1450–1515)

Aldus Manutius was an Italian scholar who wanted to use printing as a means to revive classical knowledge. He founded the Aldine Press in Venice in 1494 and strived to produce the most beautiful script possible in metal form. He hired Francesco Griffo (1450–1518) to cut a roman type for his press. They created *lettera antica*, which was used throughout the 16th century.

The First Italic Type

Manutius' major contribution to printing was the creation of pocket books, similar in size to modern paperbacks. To do this, he had to solve the problem of fitting a large quantity of information into a smaller format. Manutius had

Jenson opens his print shop in Venice and cuts the first roman typeface.

Aldus Manutius founds the Aldine Press in Venice.

| 1470 | 1476 | 1494 |

William Caxton opens his press in England.

Caxton's Type from Chaucer's
Canterbury Tales published by William Caxton.

Photo courtesy of The Newberry Library, Chicago, Inc
9626 no 01.

two solutions, the first being the creation of a type smaller than the existing typefaces, in essence, creating the concept of type sizes. Next, he discovered that by slanting type (copying cursive writing), more letters could fit into a given space. He created the first italic type, *Aldine*, inspired by the writing of Petrarch and based on the humanistic cursive writing called *cancellaresca corsiva*. It was introduced as a lowercase typeface with Roman caps.

PRINTING AND TYPE IN ENGLAND

William Caxton (1422–1491)

Caxton began working in Bruges, Belgium, and it was there in 1475 that he printed the first book in English. He returned to England in 1476 and opened his press, the Sign of the Red Pale. The typeface he used was a cursive Gothic called *bâtarde,* which continued the trend of using Gothic typefaces in England for some time.

Geoffroy Tory prints his *Champfleury.*

1501	1529

Francesco Griffo cuts the first italic typeface
for the Aldine Press.

Aa Bb Cc Dd
Ee Ff Gg Hh
Ii Jj Kk Ll Mm
Nn Oo Pp Qq

Adobe Garamond

Tory's *Champfleury*
Photo courtesy of The Newberry
Library, Chicago, Case Wing Z4035 .879.

PRINTING AND TYPE IN FRANCE

Geoffroy Tory (1480–1533)

Tory was a genius of many talents. Born in Bourges, France, he was a philosopher, proofreader, typographer, engraver, and printer. He moved to France after studying in Italy and took the style of Aldus Manutius with him. He printed his *Champfleury* in 1529, one of the first books devoted to type design. His types were based on geometric principles.

Claude Garamond (1480–1561)

Not much is known about Garamond's early history. He started as a punch-cutter, probably working on Gothic fonts. Although he must have worked for numerous printers, he later became influenced by Geoffroy Tory. He cut a cursive type based on the handwriting of Angelos Vergetios, the king's librarian, called *Grecs du Roi*. Completed in 1541, it was initially cut in three sizes, but several more sizes were cut later. It was first used in Robert Estienne's *Ciceronis Opera* in 1544. From that point on, Garamond's types were used by the majority of printers at the time. Garamond was the first to break away from calligraphic forms as a model for his type designs.

Civilité is cut by Robert Granjon.

1541	1577

Claude Garamond cuts *Grecs du Roi*.

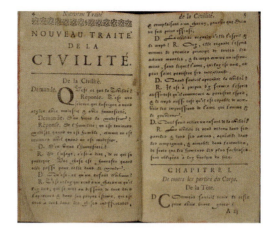

Civilite type

Photo courtesy of The Newberry Library, Chicago, Case K79 886.

Robert Granjon (1513–1579)

Granjon was a punchcutter who worked with Claude Garamond in the mid-16th century, cutting 10 italic fonts that were not based on handwriting as previous italics were. In 1577, he cut the first typeface to emulate cursive handwriting of the time. It was called *Civilité* and led to the development of more "script" typefaces.

THE NEW TECHNIQUE SPREADS THROUGHOUT THE WORLD

The 17th century saw the introduction of printing to countries outside of continental Europe including Colonial America, the Philippines, Bolivia, Iran, China, Finland, and Norway. This was also the period when censorship and movements for freedom of the press began. Printed material spread revolutionary concepts of freedom and liberty, threatening the established norm.

Newspapers

The first newspaper was printed in Strasbourg, in what is now France by Johann Carolus in 1605. Previously they took the form of single sheets heralding individual events and were not printed on a regular basis. England's

First newspaper printed in Strasbourg.

1600–1700	1609

The system of printing with movable type spreads to the rest of the world.

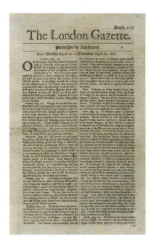

The London Gazette, August 1677.
Photo courtesy of The Newberry Library, Chicago,
Case A645 5216 aug1677.

PUB. VIRGILII MARONIS
BUCOLICA.
TITYRUS. ECLOGA I.
ARGUMENTUM.

Virgilius fub perfona Tityri paflovis, quo arietem majorem, aut hircum fignificari afjunt, ut evidentius fortunam fuam, beneficiaque Cafaris explicaret, ex adverfo Melibaum, id eft, qui curam agit boum, introducit, a patria, adempto agro, pulfum.

MELIBOEUS. TITYRUS.

M. Tityre, tu patulæ recubans fub tegmine fagi, Silveftrem tenui Mufam meditaris avena: Nos patriæ fineis, & dulcia linquimus arva, Nos patriam fugimus: tu Tityre lentus in umbra Formofam refonare doces Amaryllida filvas, T. O Melibœe, deus nobis hæc otia fecit. Namque erit ille mihi femper deus: illius aram. Sæpe tener noftris ab ovilibus imbuet agnus. Ille meas errare boves, ut cernis, & ipfum Ludere quæ vellem calamo permifit agrefti. M. Non equidem invideo: miror magis: undique totis

Philippe Grandjean's type.
Photo courtesy of The Newberry Library,
Chicago, Wing ZP 739 P2141.

first news publication appeared in 1622, and in America, *Publick Occurrences Both Forreign and Domestick* was published in 1690 by Benjamin Harris of Boston. As with the censorship going on in England at this time, Harris' publication was shut down by the governor after the first issue came out.

THE FIRST MATHEMATICALLY BASED FONT

During the 17th century, the most elaborate and expensive books were produced by government printing houses such as the Imprimerie Royale, which was established for Louis XIII in 1640. It used roman types that were based on those of Garamond.

In 1691, the new director of the Imprimerie, Jean Anisson, wanted a new typeface cut. The job was given to a group of scholars headed by Nicolas Jaugeon, a mathematician. They constructed an alphabet based on rectangles divided into a grid of 2,304 squares. The punches were cut by Philippe Grandjean (1666–1714). It was a transitional face known as *Romain du Roi Louis XIV*.

The serif brackets were less prominent now, and ascenders had serifs on both sides of the stem creating horizontal emphasis. The contrast between thick and thin strokes was more pronounced and they appeared overall to be lighter than Old Style fonts.

Romain du Roi is a big influence on printing throughout the century. Calligraphy is no longer a model for letter forms.

1691	1700–1800

Philippe Grandjean creates the first
mathematically based typeface,
Romain du Roi.

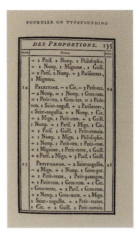
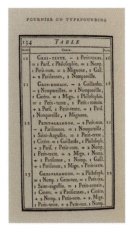

Pages from Fournier's *Manuel Typographique.*
Photo courtesy of The Newberry Library, Chicago, Wing Z 407 31.

THE 18TH CENTURY

The First Standard Form of Type Measurement

Pierre Simon Fournier Le Jeune (Junior), a French printer, standardized the measurement system for typefaces in 1737. He named the different sizes of type and later put forth the idea of a type family where compatible fonts could work together in one printed piece. Fournier created a scale of 6 ciceros or 72 points to the Paris inch, his cicero measuring 12 points.

He published his *Manuel Typographique* in which he writes about styles and sizes of type, and also shows samples of fonts from other European sources, some of which were provided by his older brother, Jean Pierre Fournier, also a printer.

The Didots

The Didot printing dynasty began in 1713 in Paris with François Didot. Various members of the family were engaged in printing but it is his son, François Ambroise, and grandsons Pierre l'aîné and Firmin, who stand out the most.

François Ambroise introduced the smooth wove paper, similar to John Baskerville's, to France, but his most important contribution to type and printing is the European point system of measurement. He saw faults in Fournier's system that could make it inaccurate. He divided the French inch

Pierre Fournier creates the first standardized form of type measurement and publishes his *Manuel Typographique.*

1734	1737

William Caslon publishes type specimen of his *Old Face.*

Caslon type specimen sheet, 1798.

Photo courtesy of The Newberry Library, Chicago, Case Wing Z40545 1538.

Book printed by Francois-Ambroise Didot and Firmin Didot.

Photo courtesy of The Newberry Library, Chicago, Wing ZP 739 D5622.

into 72 points and his *point* became the predominant type-measurement unit throughout Europe and the colonies. François' point was named the *didot* after him. He is also the person who started naming type sizes by the measurement of their body in points rather than the names used previously—nonpareil, cicero, etc. François' sons carried on in the printing field, Pierre with printing and publishing, and Firmin in type-founding, continuing to carry on the Didot style.

William Caslon (1692–1766)

The art of printing in England had not been as highly developed as in other parts of Europe until William Caslon began to cut type around 1720. Caslon had been a gun engraver, which made him knowledgeable about working with steel. He used the technique of counter-punching to stamp names into gun plates.

Caslon used Dutch models as a source for his *Old Face*, and published his first type specimen sheet in 1734. Caslon's typeface was introduced to the American colonies and was the font used to print the Declaration of Independence.

François Ambroise Didot creates the European point system of type measurement.

1762

1783

John Baskerville issues his type specimen for his *Transitional* typeface.

Page from 1818 reprint of Bodoni's *Manuale Tipografico*.

Photo courtesy of The Newberry Library, Chicago, Case Wing Z40535 10511.

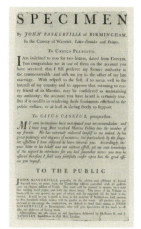

First known specimen of Baskerville's type, 1756.

Photo courtesy of The Newberry Library, Chicago, Wing ZP9831 41.

John Baskerville (1706–1775)

Baskerville was a writing master who became interested in typography later in life. He opened a foundry and print shop at the age of 44. His type designs were *Transitional* in style, and in 1762 he issued a type specimen sheet.

He is thought to be one of the first type designers to draw, and refine, his forms on paper first before cutting them in metal. Every part of the printing process was important to him for maintaining the quality of the fonts. He developed his own ink and hot-pressed his paper to make it smoother, a prelude to the calendered papers in the 19th century.

Giambattista Bodoni (1740–1813)

Bodoni worked in Parma, Italy, where he cut the first Modern typeface influenced by the work of the Fourniers, Didots, and John Baskerville, his contemporaries. His fonts had very extreme differences between thick and thin strokes, the letters were narrower, and the serifs were very thin lines with no brackets. The typeface *Bodoni* first appeared in 1790. At the same time, he published his *Manuale Tipografico*, a collection of roman, italic, Russian, Greek, and other fonts.

The age of industrialization.

1790	1800–1900

Giambattista Bodoni designs his *Bodoni* typeface, and soon after publishes *Manuale Tipografico*.

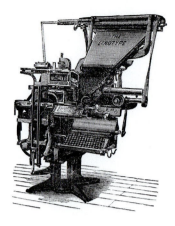

Linotype machine.

From *Everybody's Cyclopedia* (New York, NY: Syndicate Publishing Company, 1912). Downloaded from http://etc.usf.edu/clipart/15500/15538/linotype_15538.htm

THE AGE OF INDUSTRIALIZATION

The beginning of the 1800s brought the start of the industrial age, and with it, many advancements in typesetting and printing. Aloys Senefelder invented the printing process of stone lithography. Friedrich Koenig created the first steam-powered press, which used a cylinder to ink the form on a flat bed. It was first used to print *The Times* of London.

At the end of the 18th century, a machine was developed by Nicolas Louis Robert that could make a continuous roll of paper. This machine was taken to England where it was further developed by brothers Henry and Sealy Fourdrinier. The Fourdrinier paper-making machine created a *wove* paper with no patterns. If watermarks or laid marks were required, they could be pressed into the paper at a wet state.

This period also saw the birth of photography and, later, photoengraving. This led to the innovation of printing photographic images on printing presses and, finally, photo-mechanical color images once color separations were perfected.

Type Grows in Size

The industrial age brought about the need for larger letter forms to be used on billboards and large advertising posters. Type had to "shout" to be noticed

1803

Robert Thorne invents *fat faces*.

Specimen of slab serif type, *Adstyle Wide*.
Preferred Type Faces, Barnhart Brothers & Spindler, Chicago, 1918.

Specimen of sans serif type, *Modern Gothic Condensed*.
Preferred Type Faces, Barnhart Brothers & Spindler, Chicago, 1918.

among all of the printed material being produced. Decorative fonts and large typefaces cut in wood began to emerge. Wood was used to keep the cost and weight down, with lead being heavier and more expensive.

Fat Faces As letters became fatter and bigger, a new type category was invented, around 1803, by Robert Thorne. It was called *fat faces*. These were roman typefaces whose thick stroke weights were increased dramatically, creating more contrast with the thin strokes.

Slab Serifs It is not known who developed *slab serifs*, typefaces that had heavy, even stroke widths with thick, square, or rectangular serifs, but by 1815 they were appearing in type specimens. They were called *Antique* by Vincent Figgins, and *Egyptian* by Robert Thorne, which is the name still used. It probably originated from England's fascination with archaeological discoveries in Egypt.

Sans Serifs In 1816, William Caslon IV (1780–1869) issued a type specimen book that introduced a sans serif typeface, made up of single-weight strokes with no serifs on the ends. It is assumed he designed it by taking an Egyptian face and removing the serifs. This is reinforced by the fact that he named it *Two Lines English Egyptian*. In Europe, this type was referred to as *grotesque* because its look was strange.

Thorne and Vincent Figgins create slab serif typefaces.

1815

1816

William Caslon IV issues a type specimen book that includes a sans serif typeface.

Kk Ll Mm Nn Oo Pp Qq Rr Ss Tt Uu Vv Ww Xx Yy Zz

Akzidenz Grotesk

By the end of the century, Berthold, a German firm, had released *Akzidenz Grotesk,* which became the basis for later sans serifs like *Helvetica*.

The Victorian Style

The last half of the 19th century saw the rise of a style that was noted for elaborate and intricate details in its design. In typography, this meant heavily embellished type designs featuring a lot of ornamentation and decoration. Some of the fonts were hard to read, but others were beautiful. Many of the typefaces work for initial caps and some for heads.

Advances in Typesetting

Linotype From the time Gutenberg first cut type in lead, the process of type casting and setting basically remained unchanged. Each letter was cast in lead and placed in a composing stick, one letter at a time. It was tedious and time-consuming. Newspapers, especially, were looking for a way to streamline this process and therefore cut the cost.

In 1886, Ottmar Mergenthaler designed the Linotype machine. It could cast an entire line of type at one time, in a single piece (slug) of metal. It was operated through a typewriter keyboard that controlled molds of the letters in which molten metal was poured to cast the line of type.

The height of the Victorian era in art and design. Elaborate details and embellishments reign.

1850–1900

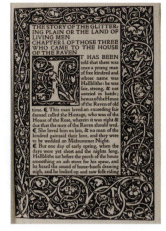

Page from *The Story of the Glittering Plain*, printed by William Morris and set in the *Golden* typeface.
Photo courtesy of The Newberry Library, Chicago, Wing ZP 845 K295a.

Monotype Tolbert Lanston invented the Monotype machine in 1893. Unlike the Linotype machine, which was controlled by one operator, the Monotype consisted of two parts, a keyboard and a casting machine, with two operators. The keyboard created a perforated tape that was fed into the caster, which cast individual letters that were then put into a channel and set into lines.

THE ARTS AND CRAFTS MOVEMENT

The Industrial Revolution influenced every aspect of life in the 19th century, including book design and printing, with quality and previous standards going by the wayside. As a reaction against the mass production of objects that was going on at the time, a group of artists led by William Morris (1834–1896) started the Arts and Crafts movement. Its purpose was to return to crafting by hand and creating items that were not only functional but also beautiful and well-designed.

The Kelmscott Press

In 1889, William Morris founded a small private press, the Kelmscott Press. He used medieval manuscripts and printing for his inspiration. Morris' first typeface, *Golden*, was based on Nicolas Jenson's roman faces. His second

Ottmar Mergenthaler invents the Linotype machine.

| 1880 | 1886 | 1889 |

William Morris and other artists start the Arts and Crafts movement.

William Morris founds the Kelmscott Press.

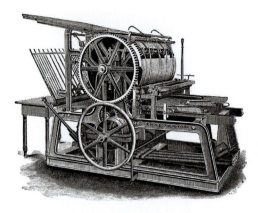

Single large cylinder press.
From Hill, Henry Chase *The Wonder Book of Knowledge* (Philadelphia, PA: John C. Winston Company, 1921). Downloaded from http://etc.usf.edu/clipart/72700/72757/72757_cyl_press.htm

typeface, *Troy*, was influenced by the Gothic types of the 15th century, and *Chaucer*, his third and last typeface, was a smaller version of Troy.

Morris was committed to creating books that captured the essence and beauty of medieval books. Woodblock illustrations and initials, handmade paper, and hand printing all contributed to the style of the Kelmscott Press editions. The philosophy of the movement—handcrafting, being true to the materials, and fitting design and beauty to function—was also adopted by the Bauhaus School, which came later.

PRINTING AT THE TURN OF THE CENTURY

The dawn of the 20th century brought significant advancements in technology. Electricity, the automobile, radio transmission, and the Wright brothers' airplane all happened within the first decade.

The turn of the century also saw the growth of private presses, both in England and the United States, that continued the art of beautiful book design started by William Morris.

The Doves Press

Private press started in 1900 by T. J. Cobden-Sanderson (1840–1922) and Emery Walker (1851–1933) in Hammersmith, London. Their best-known book

The Monotype machine is invented by Tolbert Lanston.
Daniel Updike establishes the Merrymount Press.

1893	1895

Hornby opens the Ashendene Press in London and Pissarro starts the Eragny Press.

Original designs for the Doves Press typeface.

Photo courtesy of The Newberry Library, Chicago, Case MS Wing Z 4035 .238 (Vault).

is the *Doves Press Bible*, which contains initials designed by the calligrapher Edward Johnston. Their books are noted for the use of beautiful type, quality paper, and expert presswork.

The Ashendene Press

In 1895, C. H. St. John Hornby (1867–1946) started the Ashendene Press in London. The type it used was inspired by the Gothic types of the 15th century, and many had colored initials.

The Eragny Press

Lucien Pissarro (1863–1944) started this press in 1895. He collaborated with his wife on the design and printing of the press' books. The type he used, *Brooke*, was inspired by Nicolas Jenson.

The Merrymount Press

Daniel Berkeley Updike (1860–1941) established the Merrymount Press in 1893 in Boston. He began commissioning his own fonts by noted type designers of the day. *Montallegro* was designed by Herbert Horne in 1904, the same year Updike purchased the Caslon typeface. Updike is known as a liturgical printer because of his work for the Episcopal Church, but he also did a lot of commercial printing catering to the upper classes.

The private press movement grows in the U.S. and England.
T. J. Cobden-Sanderson and Emery Walker start the Doves Press.

1900–1940s

Cc Dd Ee Ff Gg
Hh Ii Jj Kk Ll
Mm Nn Oo Pp
Qq Rr Ss Tt Uu

Hh Ii Jj Kk Ll
Mm Nn Oo Pp
Qq Rr Ss Tt Uu
Vv Ww Xx Yy Zz

Centaur

Goudy Old Style

The Invention of Offset Lithography

Ira Rubel, a New York lithographer, introduced rotary offset lithography using metal plates in 1904. It used the same principles as traditional stone lithography (oil and water don't mix), but with a thin metal plate that wrapped around a cylinder. The metal plate was used to run against a second cylinder that was covered in rubber and offset print onto the rubber, which then transferred the image to paper.

TYPE AT THE BEGINNING OF THE 20TH CENTURY

Albert Bruce Rogers (1870–1957)

Rogers was one of the best-known and most influential designers of the early 20th century. He began by working for the Riverside Press, designing Arts and Crafts-style books, followed by a series of limited editions. He became a freelance book designer in 1912 and, in 1915, designed his *Centaur* typeface, which was inspired by Nicolas Jenson.

Frederic W. Goudy (1865–1947)

Goudy was a bookkeeper in Chicago when he started in printing. After opening two small presses that were short-lived, he designed his first typeface, called *Camelot*. After working as a freelance type designer and lettering artist,

Ira Rubel invents offset lithography.

1903	1904

Frederic Goudy opens the Village Press.

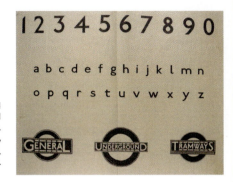

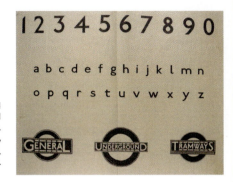

Typeface designed by Edward Johnston for Central Underground Tramways.

Photo courtesy of The Newberry Library, Chicago, Wing Z4035 4557, sheets 1 & 2.

he opened the Village Press. The press was destroyed in a fire in 1908, which led him to focus on the design of typefaces. During this period, he designed 122 typefaces (some never produced), among them *Kennerley Old Style*, his first successful one. Goudy worked until his death at the age of 82.

Edward Johnston (1872–1944)

Studying early manuscripts for inspiration and techniques, Johnston was a calligrapher of the Arts and Crafts movement and teacher of calligraphy and the lettering arts. He trained and influenced some of the finest letterers of the 20th century.

Johnston designed the typeface used in the London Underground in 1916, which is said to be the first modern sans serif typeface. It is credited as being the inspiration for later type designs such as Eric Gill's *Gill Sans*.

Frederic W. Goudy designs *Kennerley Old Style*, his first popular typeface.

1909	1911

Filippo Marinetti writes his *Futurist Manifesto*.

Original alphabet drawn by Eric Gill.
Photo courtesy of The Newberry Library,
Chicago, Case Wing Z 40545 3395 02.

Eric Gill (1882–1940)

Gill was a student of Edward Johnston and then started working as a stone cutter and lettering artist. He was also a sculptor, typeface designer, graphic designer, and woodcut artist. The first typeface he designed, *Perpetua*, was a classic roman serif. In 1928, he designed a sans serif face called *Gill Sans*, which was enthusiastically embraced for its calligraphic details and roman serif roots.

Gill wrote a book, *Essay on Typography*, in which he pushed the use of unequal line lengths (flush-left, ragged-right alignment) in typesetting, arguing that it is more legible than justified alignments with uneven word spaces.

THE INFLUENCE OF MODERN ART MOVEMENTS ON TYPOGRAPHY

Futurism

In 1909, Filippo Marinetti (1876–1944) wrote his *Futurist Manifesto,* in which he declared the beginning of the art of the future and rejecting the art of the past. He also promoted violence, war, speed, and industrialization. The Futurists introduced a new style of poetry that was expressive and emotionally charged in its grammar and design. They also rejected the traditional book design of the past, page harmony, and ornamentation in favor of a new

Edward Johnston designs the typeface used at the London Underground.
Dada begins at Cabaret Voltaire in Zurich, Switzerland.

1915

1916

Albert Bruce Rogers designs *Centaur*.

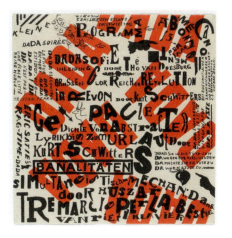

Theo van Doesburg with Kurt Schwitters (German), *Kleine Dada Soiree*, 1922. Lithograph, Sheet: 11 7 /8 x 11 7 /8″ (30.2 x 30.2 cm).

Gift of Philip Johnson. The Museum of Modern Art Digital Image © The Museum of Modern Art/Licensed by SCALA I Art Resource, NY

form of typography. Numerous fonts, weights, styles, and sizes were used to express noises, verbs, and nouns. They deconstructed the traditional linear form of compositions.

Dada

New York Dada was at its height in 1915. Dada began in Europe in 1916 at Cabaret Voltaire in Zurich, spreading to Berlin shortly thereafter. Like the Futurists, the Dadaists rejected the traditional form of type on a page. Visual impact was their main goal, wanting their work to "shout" at the viewer. They would use random placement of type and symbols on the page, along with vertical and horizontal settings. It was chaotic and confusing, which represented the era.

Constructivism

This was an avant-garde art, design, and architecture movement that started in Russia in the 1920s. It used abstract, geometric elements to create dynamic compositions. The Constructivists mainly used sans serif typefaces, combining different fonts to create literal meanings.

One of the most prolific designers in this movement was El Lissitzky (1890–1941). He is known for combining typographic elements into a new, dynamic style.

The Bauhaus School begins in Weimar, Germany.

1917	1919

Theo van Doesburg and his associates start the De Stijl movement.

Gg Hh Ii Jj Kk Ll
Mm Nn Oo Pp
Qq Rr Ss Tt

Peignot

De Stijl

Founded in 1917 by Théo van Doesburg (1883–1931) and other Dutch artists, De Stijl used abstract geometric shapes and black bars to organize space with the goal of achieving balance. Kurt Schwitters (1887–1948), and Vilmos Huszár (1884–1960) collaborated with van Doesburg on typographic projects.

Proponents of De Stijl used asymmetric balance and composed in rectangular blocks. In 1919, van Doesburg designed *An Alphabet*, a typeface design based on a square, which eliminated curved and diagonal strokes.

Art Deco

The Art Deco movement is known for its geometric designs that incorporate frames and linear elements. One of the most famous designers of this period was A. M. Cassandre (1901–1968), who combined words and images into a total composition. He designed a number of typefaces for the Deberny and Peignot type foundry, the most famous being *Peignot* in 1937. It is a sans serif typeface that combines thick and thin strokes with small caps interspersed with the lowercase letters.

1920s

Constructivism starts in Russia.
The Art Deco movement flourishes.

a b c d e
f g h i j k
l m n o p
q r s t u v
w x y z

Modern version of Bayer's *universal type,*
Bauhaus.

The Bauhaus

In 1919, with the merging of two German schools—the Weimar Arts and
Crafts School and the Weimar Art Academy—the Bauhaus was born. Walter
Gropius was appointed the new director and his goal was to unite art and
technology in the hope of solving design problems created by industrialization,
and also to increase the aesthetics and functionality of mass-produced items.
The artists and designers of the Bauhaus believed in clean design, devoid of
decorations, and "truth to materials."

Gropius collaborated with László Moholy-Nagy to produce a Bauhaus
publication that emphasized legibility and communication as priorities for
typography. This publishing practice would continue for years in various forms.

In 1925, Herbert Bayer, a student of the school, took the Bauhaus ideals
even further in type design by designing a sans serif typeface called *universal
type*. He took the letters to their most basic form and eliminated capital
letters, which he thought were unnecessary.

Rudolph Koch designs *Kabel*.

1927	1928

Eric Gill designs *Gill Sans*.
Die Neue Typographie published by Jan Tschichold.
Paul Renner designs *Futura*.

29

Hh Ii Jj Kk Ll
Mm Nn Oo
Pp Qq Rr Ss
Tt Uu Vv Ww

Kabel

PRE-WORLD WAR II TYPE DESIGN

The New Typography

Jan Tschichold (1902–1974), a designer influenced by the Bauhaus and Constructivism, took the tenets of these movements and carried them further with his 1928 book, *Die Neue Typographie* (*The New Typography*). The principles he put forth were dynamic asymmetric layouts, sans serif type, the use of grids for structure, and, above all, clarity.

Rudolph Koch (1876–1934)

Koch was a German calligrapher, and the majority of the typefaces he designed were based on calligraphic forms. He worked as a designer during the height of the Art Nouveau (Jugendstijl) movement, which he enthusiastically embraced.

In 1896, he was hired as a designer by a small type foundry that later became the Klingspor Type Foundry. Koch designed numerous typefaces for Klingspor, among them *Neuland, Klingspor Schrift*, and one of its most famous, *Kabel*.

Kabel is a sans serif designed at the same time as Paul Renner's *Futura*. Unlike Futura, Kabel has roman forms as a basis and some of the letters have oblique ends on the strokes.

Times New Roman is used for the first time.

1932	1937

A. M. Cassandre designs *Peignot*.

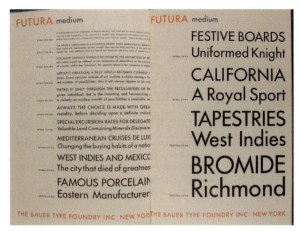

Spread from *Futura: The Type of Today and Tomorrow*, Bauer Type Foundry, 1930.

Photo courtesy of The Newberry Library, Chicago, Wing Z 40583 0811 medium.

Paul Renner (1878–1956)

Renner was a German who studied art and became involved in typographic design by working for a publisher. His experience with typefaces and texts led him to the conclusion that *Blackletter* was not really a German typeface, being that it came from northern France. He decided that sans serif needed to be developed further as a way to move forward in typography.

After leaving publishing and returning to painting, Renner was commissioned by a publisher to develop a new roman typeface. Once the drawings were done, and not getting a response from the publisher, he sent the drawings for *Futura* to the Bauer Type Foundry.

The earliest version of Futura was very different from the version we have today. Renner used geometric shapes to base his letters on, which resulted in some strange shapes for the lowercase letters. The version of Futura released in 1928 doesn't contain any of the unusual characters and is the typeface we have today.

Palatino is designed by Hermann Zapf.

1948

1950s

Phototypesetting technique is perfected, allowing type to be set at a faster speed.

Nn Oo Pp
Qq Rr Ss Tt
Uu Vv Ww
Xx Yy Zz

Times New Roman

Stanley Morison (1889–1967) and *The Times*

Stanley Morison worked as a typographic adviser for the Monotype Corporation. He was challenged by *The Times* of London to design a type-face for the newspaper. The face he designed was *Times New Roman* and it was used for the first time in October 1932. By using shorter ascenders and descenders, heavier strokes, and slightly narrower letter forms, he was able to create a font that was more legible and was able to fit more characters in a line of type. *The Times* had exclusive use of the typeface for one year, after which it was released to the public. It has become one of the most widely used typefaces, especially due to its placement on almost all personal computers.

THE MODERN ERA

World War II not only devastated the world, it also destroyed many type foundries, especially in Germany. With the support of the United States and other countries, West Germany prospered and was able to rebuild its type foundries.

Zapf designs *Optima.*

1952	1954

Adrian Frutiger designs *Univers* and a new system for indicating typeface weights and styles.

Aa Bb Cc Dd Ee Ff Gg Hh Ii Jj Kk Ll Mm Nn

Palatino

Ff Gg Hh Ii Jj Kk Ll Mm Nn Oo Pp Qq Rr Ss Tt

Univers

Hermann Zapf (1918–2015)

A German calligrapher and lettering artist, Zapf produced many of the best-known typefaces of the 20th century. After he was released from the army following World War II, he became art director for the Stempel Type Foundry and designed the typeface *Palatino*. This was followed by *Melior* and *Optima*. He continued to design type well into the 21st century.

Adrian Frutiger (1928–2015)

In 1952, Frutiger joined Deberny and Peignot when they began to move into phototypesetting. Frutiger's job was to adapt classic typefaces to the new system and, at the same time, work on his own new designs. He had begun designing *Univers*, a sans serif, while still a student. It was one of the largest typefaces ever designed, containing 21 fonts, and he created a numeric system to replace the standard weight and style names. The first number in the double digits specified the weight of the typeface, and the second number indicated how condensed or wide it was.

Frutiger designed the typeface *Frutiger*, originally called Roissy, for the Charles de Gaulle Airport. His other typefaces include *Centennial*, *Serifa*, and *Egyptienne*.

New Haas Grotesk, designed by Max Meidinger, released by the Haas Type Foundry.

1956 **1961**

Letraset launches dry transfer type.

Jj Kk Ll Mm Nn Oo Pp Qq Rr Ss Tt Uu Vv Ww

Helvetica designed by Max Meidinger.

Helvetica

In 1956, Max Meidinger (1910–1980), a designer for the Haas Type Foundry in Switzerland, was asked to design a new sans serif typeface by updating the existing *Haas Grotesk* typeface. Rather than making changes to the old design, Meidinger made a whole new one. It was called *Neue Haas Grotesk*, but it was changed to *Helvetica*, the Latin name for Switzerland, when it was later released by Stempel, Haas' parent company.

TYPE DESIGN AND PHOTOTYPESETTING

Since the 1920s, many attempts had been made to combine photography and typesetting, but it wasn't until the 1950s that a successful process was developed. It used a negative of the type character, which was placed between an enlarging lens and photosensitive paper. By being able to adjust the point size to any size, one negative of the font could be used on either a disc or ribbon, and rotated and exposed at high speed by an operator using a keyboard. Phototypesetting is referred to as "cold type," as opposed to "hot type" for metal type that was formed by melting lead to put in character molds.

Wim Crouwel designs the *Neue Alphabet*.

1967	1970

International Typeface Corporation starts and Herb Lubalin releases the *Avant Garde* typeface.

Neue Alphabet designed by Wim Crouwel.

Avant Garde Gothic designed by Herb Lubalin.

Letraset

In 1961, Letraset launched its dry transfer lettering, which enabled designers to produce decorative display type and other design elements, and save time and money. The type characters were provided on translucent plastic sheets. Designers would place a character where they wanted it and rub over it with a burnisher to transfer the letter onto the paper. They not only produced licensed fonts from type foundries, but also their own original designs.

Wim Crouwel (b. 1928)

Dutch designer Wim Crouwel believed that eventually the computer screen would become the main source of communication, which would require appropriate type designs to be developed. In 1967, he introduced his *Neue Alphabet,* which consisted of horizontal and vertical strokes with no diagonals or curves. There were no capital letters and all of the letters were the same width. Because of this, the *m* and *w* were indicated by a line below the *n* and *v*.

Herb Lubalin (1918–1981) and ITC

Lubalin is best known for illustrating with type, using it to express emotions and elicit surprises in his designs. His most famous typeface is *Avant Garde*, based on the nameplate he designed for *Avant Garde* magazine.

Apple launches the Macintosh.
Adobe invents PostScript.
Rudy VanderLans and Zuzana Licko start *Emigré*.
Neville Brody designs *Industria*.

1984

Aa Bb Cc Dd
Ee Ff Gg Hh
Ii Jj Kk Ll
Mm Nn ſp ꜩ
iþ Æ TT

Mrs Eaves designed by Zuzana Licko.

In 1970, Lubalin, Aaron Burns, and Ed Rondthaler founded the International Typeface Corporation (ITC). They wanted to take older typefaces and redesign them for better legibility in phototypesetting. ITC introduced new typefaces by some of the best modern designers—Tom Carnase, Ed Benguiat, Hermann Zapf, and Aldo Novarese, to name a few.

THE IMPACT OF COMPUTERS ON TYPE

Apple launched the Macintosh computer in 1984, and soon after Adobe Systems invented PostScript, which became the language of page layout software and computer-generated typography.

The first Macintoshes had bitmapped type and graphics made up of pixels at a resolution of 72 dots per inch. PostScript allowed type characters to be vector-generated (as outlines) and then filled in as solid shapes. Curves are formed by *Béziers*, allowing the type to be displayed and printed smoothly as generated forms.

Emigré

In 1984, two California graphic designers started an experimental typography magazine called *Emigré*. Rudy VanderLans (b. 1955) and Zuzana Licko (b. 1961)

Trajan, Charlemagne, and *Lithos* designed by Carol Twombly.
Adobe Garamond is released.

1987	1989

Adobe *Stone* is created by
Sumner Stone.

Aa Bb Cc Dd Ee Ff Gg Hh Ii Jj Kk Ll Mm Nn Oo

Insignia designed by Neville Brody.

used it as a forum for commenting on contemporary type design, challenging legibility in type design and layout, and the possibilities for type design in the new printing technology.

Licko saw the fonts on the Apple computer as poor copies of classic typefaces and that the current technology couldn't accurately reproduce them. She began designing bitmapped fonts that had stepped diagonals in place of curves and straight diagonal lines. Emigré started its own type foundry, and its fonts became more polished as technology improved.

Neville Brody (b. 1957)

One of the more influential figures in type design during the 1980s was British designer Neville Brody. His work on the British magazines *The Face* and *Arena* showcased his hand-drawn display faces. Two of these were *Industria* and *Insignia*, which both have Constructivist influences and worked well among bitmapped fonts.

DIGITAL TYPE IN THE 1990s

With the release of font design software for desktop computers, the business of type design took off in the 1990s. Not only large type foundries but also individual designers began to release a multitude of fonts.

Mantinia is designed by Matthew Carter.

1992 **1993**

Robert Slimbach designs *Poetica*.

Ee Ff Gg Hh
Ii Jj Kk Ll
Mm Nn Oo
Pp Qq Rr

Ee Ff Gg
Hh Ii Jj Kk
Ll Mm Nn
Oo Pp Qq

Above left: *ITC Stone Serif*
Above right: *ITC Stone Sans*
Both designed by Sumner Stone.

Adobe Systems and Sumner Stone (b. 1945)

Sumner Stone was the type director for Adobe and designed *Stone*, one of the first PostScript typefaces released by Adobe. The Stone type family has three different typefaces within it—serif, sans serif, and informal. He left Adobe in 1990 to found the Stone Type Foundry, which continues to operate today.

Carol Twombly (b. 1959) A type designer for Adobe, Twombly designed a number of typefaces, most notably her display fonts. The most important are *Trajan*, inspired by the inscription on Trajan's Column, *Charlemagne*, modeled after the decorative capitals in Carolingian manuscripts, and *Lithos*, based on Greek inscriptions.

Robert Slimbach (b. 1956) Slimbach was also a designer for Adobe and his focus was on designing classic typefaces for digital technology. His best-known typefaces are *Adobe Garamond, Jenson, Poetica,* and *Myriad*.

Matthew Carter (b. 1937)

Carter began work as a punchcutter for a type foundry, then started designing typefaces, first for metal, then going to phototypesetting and then on to digital. He designed *Bell Centennial* in 1978 for use in telephone directories and

Adobe releases *Jenson*.
Mrs Eaves is released by Emigré.
Zuzana Licko designs *Filosofia*.

1994	1996

Big Caslon is released.

Aa Bb Cc Dd Ee Ff Gg Hh Ii Jj Kk Ll Mm Nn Mm

Bell Centennial designed by Matthew Carter.

Ll Mm Nn Oo Pp Qq Rr Ss Tt Uu Vv Ww Xx Yy

Filosofia designed by Zuzana Licko.

printing in very small point sizes. He formed Carter & Cone Type in 1992 and created designs based on older typefaces including *Galliard*, based on Robert Granjon's type, *Big Caslon*, and *Mantinia*, which was inspired by Renaissance capital letters.

Zuzana Licko

During the 1990s, Emigré began to receive font designs from independent designers. Many of the typefaces were unique and experimental, and Emigré became a distributor and licenser for these fonts. At the same time Licko designed a couple of typefaces based on 18th-century models, *Mrs Eaves* and *Filosofia*. *Mrs Eaves* is uniques for its large number of ligature glyphs, in which two or more characters are combined.

TYPE DESIGN TODAY

Today's type has to fill many applications. It's used not only for print, but also for screens. Some fonts work well in one of these formats but not others. With the advances in technology and software, there are many typefaces being designed, with new ones being put out almost daily. Now more than ever it is important to choose typefaces carefully. Consider the media it is to be used with, the message to be conveyed, how well it will work in text sizes and/or display sizes, and whether it will have to work across different media. Technology will continue to evolve, and type design will be adapting and changing with it.

Sample Type History Quiz

The earliest form of visual language was marks and symbols painted on cave walls that were called:

 a) pictures b) pictograms c) chalk drawings

Marks created by combining two or more pictograms are called:

 a) symbols b) phonograms c) ideograms

The people who lived in Mesopotamia and invented cuneiform writing are:

 a) Sumerians b) Phoenicians c) Egyptians

The alphabet that was adapted by other cultures for their own languages was the:

 a) Greek b) Egyptian c) Phoenician

Roman capitals also were called majuscules. What were the later lowercase letters called?

 a) minuscules b) uncials c) small letters

Who invented reusable metal type?

 a) Charlemagne b) Johannes Gutenberg c) an anonymous scribe

The first font cast in metal was based on:

 a) Roman capitals b) Humanistic letterforms c) Gothic letterforms

The first roman typeface was cut by:

 a) Nicolas Jenson b) Aldus Manutius c) Claude Garamond

The first italic font was called:

 a) Jenson b) Aldine c) Aldus

Robert Granjon cut the first typeface to emulate cursive handwriting of late 16th-century France. It was called:

 a) Civilité b) Caxton c) Grecs du Roi

The first standard form of type measurement was invented by:

 a) Geoffroy Tory b) Claude Garamond c) Pierre Simon Fournier

The European point system for type measurement was created by:

 a) Francois Ambroise Didot b) John Baskerville c) William Caslon

The first sans serif typeface appeared in whose type specimen book?

 a) Robert Thorne b) Vincent Figgins c) William Caslon IV

Ottmar Mergenthaler invented what typesetting innovation?

 a) Letterpress b) Linotype machine c) Offset lithography

The New Typography was written by:

 a) Frederic Goudy b) Rudolph Koch c) Jan Tschichold

Max Meidinger designed which iconic typeface?

 a) Times New Roman b) Helvetica c) Futura

Assignment: Research a Typeface and Its Designer

This research and text will be used later for a poster design assignment. You will want to collect as much information as you can.

Objectives

- To learn more about the history of typography and graphic design
- To become familiar with classic typefaces
- To practice research techniques
- To develop your ability to discuss typography

Assignment

Research one of the typefaces and its designer listed at the bottom of this page. Here is the information you should collect:

- The background of the designer—country, time period, education or training, professional work, etc.
- The purpose for designing the typeface—what typographic void or need did it fill, if any, and any other details about its creation.
- For typefaces based on older versions, make sure you find and research the original face from which it was drawn. Show both versions.
- Give some specific characteristics of the typeface and its relationship to other typefaces of its time period, what was happening culturally and politically during that period, and whether it influenced, or was influenced by, the time period. Include any other appropriate facts about the typeface and its designer.
- If available, collect a photo or picture of the designer.
- If possible, collect one or more quotes your designer made about type or typography.
- Collect design samples of the typeface in use.

Write at least 150 words each about the designer and the typeface. Include a list of sources—you must use printed publications, as well as the internet.

Your research will be used to design a type specimen poster later.

Choose one of the following designers and his typeface:
Bruce Rogers—Centaur
William Caslon—Caslon
Eric Gill—Gill Sans
Frederic Goudy—Goudy Old Style
Giambattista Bodoni—Bodoni
Claude Garamond—Garamond
John Baskerville—Baskerville
Nicolas Jenson—Jenson
Aldus Manutius—Aldine
Robert Granjon—Civilité
Hermann Zapf—Optima

02.
Letters and Their Characteristics

INTRODUCTION

Typography is the mechanical arrangement of words in a way that communicates meaning and content. It is concerned with both the creation of typefaces and their arrangement in a composition. The traditional definitions for terms used in relation to typography are:

Type	The physical object, a piece of metal with a raised face on one side containing the reversed image of a character. The digital form—individual glyphs or characters.
Font	A set of characters of a given typeface, all of one size and style.
Typeface	A set of fonts of related design or style—roman, italic, bold, bold italic, etc.

Today, there are many well-designed typefaces to choose from. The ways in which these typefaces are used is what will be addressed in this publication. Since the arrival of the personal computer, there are almost no constraints to working with type. Type can be manipulated in numerous ways, but printed words still need to be read—legibility is one of the main concerns when working with type. We still need to communicate the message and have it understood by a target audience. The fundamental principles of how we read remain the same.

However well a typeface is designed, it is impossible to take into account every text-setting situation. Word and letter spacing will need to be refined for maximum readability. To make type look good, one needs to have

an appreciation and understanding of type's qualities and characteristics, along with a knowledge of how to control the typesetting variables to achieve a legible and readable outcome.

You also have to look at your finished piece printed out, not on a computer screen. Proofread. Correct spacing. Don't trust the defaults of layout programs. If it looks good, is correct, and is consistent, it's right.

THE SHAPE OF LETTERS

The 26 letters of the English alphabet can be divided into four groups based on the dominant strokes of the letters: vertical, curved, combination vertical and curved, and oblique. Letters within each group have similar characteristics.

Upper halves of letters are more recognizable than the lower halves, and right sides of letters are more recognizable than their left sides.

Vertical	il	EFHILT
Curved	acegos	COQS
Combination	bdfhjmnpqrtu	BDGJPRU
Oblique	kvwxyz	AKMNVWYZ

The top halves of letters are more recognizable than the bottom halves.

The right sides of letters are more recognizable than the left sides.

Anatomy of Letterforms

When discussing the shapes of letters, the words used are a compilation of terms adapted over centuries from both typography and calligraphy. Some of the more important ones are shown below.

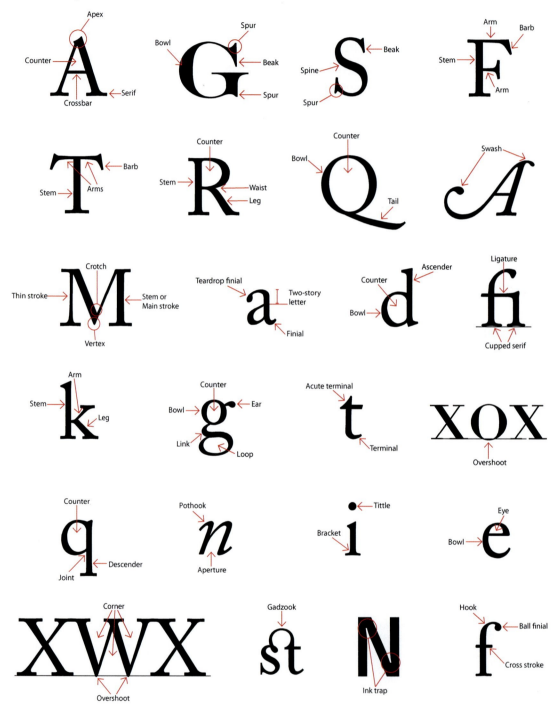

See the Glossary at the back of this book for definitions of the above terms.

STRESS OF CHARACTERS

The stress of typographic letters is the angle determined by the direction of the thicker stem strokes. This angle, or oblique stress, originally was caused by a broad nib pen, held at a consistent angle while writing. The direction of the thick strokes and curves in a typeface is referred to as either vertical, biased, oblique, or slanted. Italic faces usually have a greater stress than roman faces.

UNDERSTANDING TYPEFACES AND FONTS

With metal type, a font is a collection of metal pieces representing the complete set of characters for a particular type design, all of the same weight, style, and point size. Different point sizes of the same design are separate fonts.

In digital type, font refers to the complete character set of one style of a typeface in digital form. Because it is digital, it is size-independent, meaning any point size can be set from one font.

Type Families/Typefaces/Fonts

A *typeface* is a set of fonts of related design that may include roman, italic, bold, bold italic, etc. A *type family* includes all the variations of weights and

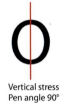

Vertical stress
Pen angle 90°

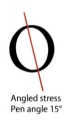

Angled stress
Pen angle 15°

ABCDEFGHIJKLMNOPQRSTUVWXYZ abcdef ghijklmnopqrstuvwxyz0123456789 ÀÁÂÃÄÅÆÇÈÉÊËÌÍÎÏÐÑÒÓÔÕÖØÙÚÛÜÝ ÞßàáâãäåæçèéêëìíîïðñòóôõöøùúûüýþÿŁłŒœŠšŸŽžƒ fifl!"#$%&'()*+,-./:;<=>?@[\]^_`{|}~¡¢£¤¥¦§¨©ª«¬®¯° ±²³´µ¶·¸¹º ¼ ½ ¾ ¿ × ÷ ¹ ^˅˘˙˚˜″——''‚""„†‡•…‰‹›/ ™ 0vwxyz00<>/?`~åçÅÇ†°¢£§•¶ß®©™^· ÆØ¥µðæø¿¡¬ ƒ«»…Œ œ– ÷/'‹›fifl‡·"„ ‘‰˘Á˜ÍÎÏ ˝ÒÔÓÚ ¸¡Â˚

All of the glyphs (characters) in one font.

styles that relate to one another by design. They are usually text, or text and display fonts, that have coordinating serif, sans serif, and other versions of the typeface. All type styles within a family share common characteristics, such as design, x-height, cap height, and length of ascenders and descenders, making them appear harmonious when used together.

Display or Titling Fonts These are designed to be set at 14 pt or larger. They have thinner, more delicate strokes that will look too light when set at smaller point sizes, but will blend better with their text font counterparts.

Text Fonts are designed to be set between 9 and 14 pt. Their strokes are bolder than their display font versions.

Caption Fonts are designed to be set between 6 and 8 pt. Their strokes are heavier than text fonts so that they look like the same weight as the text when set in smaller sizes.

Univers 39 Thin Ultra Condensed
Univers 49 Light Ultra Condensed
Univers 59 Ultra Condensed
Univers 47 Light Condensed
Univers 47 Light Condensed Oblique
Univers 57 Condensed
Univers 57 Condensed Oblique
Univers 67 Bold Condensed
Univers 67 Bold Condensed Oblique
Univers 45 Light
Univers 45 Light Oblique
Univers 55
Univers 55 Oblique
Univers 65 Bold
Univers 65 Bold Oblique
Univers 75 Black

Univers 75 Black Oblique
Univers 85 Extra Black
Univers 85 Extra Black Oblique
Univers 53 Extended
Univers 53 Extended Oblique
Univers 63 Bold Extended
Univers 63 Bold Extended Oblique
Univers 73 Black Extended
Univers 73 Black Extended Oblique
Univers 93 Extra Black Extended
Univers 93 Extra Black Extended Oblique

Typeface/*Univers*

TERMINOLOGY

Ascender

The part of a lowercase letter that extends above the meanline.

Baseline

The invisible line on which most characters sit. For optical reasons, letters that have curved strokes and vertexes sitting on the baseline extend a little below the baseline. The same goes for lowercase letters touching the meanline and the tops of capital letters. These extensions are called *overshoots*.

Bowl

A curved stroke that creates an enclosed space within a character (counter space).

Cap Height

The height of the capital letters.

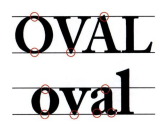

Letters with curved strokes or apexes that sit on the baseline or touch the meanline will actually extend a little beyond the baseline or meanline in order to optically appear to sit right on the line.

ITC Stone Sans Medium	ITC Stone Informal Medium
ITC Stone Sans Italic	*ITC Stone Informal Italic*
ITC Stone Sans Semibold	**ITC Stone Informal Semibold**
ITC Stone Sans Semibold Italic	***ITC Stone Informal Semibold Italic***
ITC Stone Sans Bold	**ITC Stone Informal Bold**
ITC Stone Sans Bold Italic	***ITC Stone Informal Bold Italic***
ITC Stone Serif Medium	
ITC Stone Serif Italic	

Type Family/*Stone* (includes sans serif, serif, and informal typefaces)

Counter Space

The partial or fully enclosed space within a character, formed by strokes.

Descender

The part of a lowercase letter that descends below the baseline.

Italic

Serif letters that are slanted to the right and cursive in form, distinctly different from roman letters. Originally, italic was a separate and equal style of writing. The first italic types were created for Aldus Manutius (see "History of the Alphabet and Type" in chapter 01).

Lining and Old Style (Non-Lining) Numerals

Numbers that are the height of the capital letters are called "lining numerals." They have equal space on both sides of each character. Some typefaces contain "non-lining numerals" that feature strokes which resemble ascenders and descenders. They are designed to visually balance with the lowercase letters in blocks of text.

Caslon Italic
Palatino Italic

123456abp

Lining numerals (Helvetica)

123456abp

Non-lining numerals (Meta)

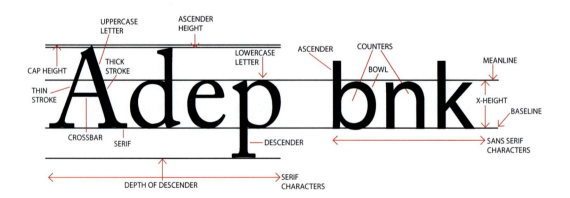

UPPERCASE LETTER · ASCENDER HEIGHT · ASCENDER · COUNTERS · MEANLINE · CAP HEIGHT · THICK STROKE · LOWERCASE LETTER · BOWL · THIN STROKE · X-HEIGHT · BASELINE · CROSSBAR · SERIF · DESCENDER · SANS SERIF CHARACTERS · DEPTH OF DESCENDER · SERIF CHARACTERS

Lowercase

The term for the small letters, not capitals, which dates back to the days of handset type when these letters were kept in the lower of the two wooden cases that held metal type.

Meanline

The imaginary line that defines the top of the x-height.

Oblique

Sans serif characters that slant to the right but resemble roman characters in structure. Unlike many italics, oblique characters do not have cursive design properties.

Roman

Denotes the standard, upright style of letters derived from the alphabet refined by the Romans. The regular text weight of a typeface is referred to as "roman."

Helvetica Oblique

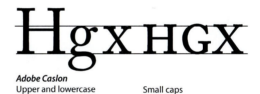

Adobe Caslon
Upper and lowercase Small caps

Sans Serif

Typefaces and fonts without serifs.

Serif

Typefaces and fonts that have projections extending off the ends of the main strokes. Serifs come in two styles: bracketed and unbracketed. Brackets are the supportive curves that connect the serif to the stroke. Unbracketed serifs are the type of serifs on slab or square serif fonts. They project off of the stroke at a right angle.

Small Caps

Capital letters that are sized and designed to work optically with the lowercase letters. They are generally the same size as the x-height of the font.

Stroke

The straight or curved lines that form parts of letters.

Uppercase

From metal type terminology, the term for capital letters, those letters that were kept in the upper of the two wooden cases used to hold the metal type.

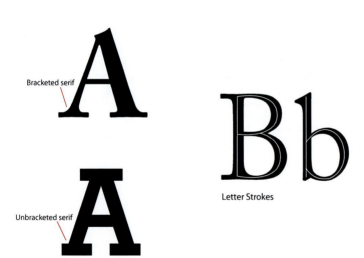

Bracketed serif

Unbracketed serif

Letter Strokes

X-Height

The height of the lowercase letters, excluding the ascenders and descenders. Typefaces with large x-heights have lowercase letters that are proportionally large in relation to the ascenders and descenders. Thus, the larger the x-height, the shorter the ascenders and descenders, and vice versa. The lowercase x is the only letter that touches both the baseline and the meanline, indicating the true height of the lowercase letters. Just because two typefaces are set in the same point size doesn't necessarily mean they will look the same size. This is because the x-height varies in size in different typefaces.

30 pt lowercase x set in six different fonts

TYPE CLASSIFICATION

Humanist (Venetian) Mid-15th Century

This category includes the first roman typefaces and those derived from 15th-century minuscule hands. There is not a great contrast between the thick and the thin strokes, and the axis of the curved strokes is inclined to the left due to the angle of the pen nib. The cross stroke of the lowercase e is also oblique. The serifs are bracketed, and the serifs of the lowercase ascenders are oblique.

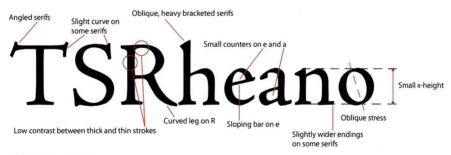

HUMANIST—JENSON

Old Style (Garalde) Late 15th Century to Early 18th Century

These typefaces lose some of the handwritten characteristics, the difference between the thick and thin strokes increases, and the axis of the curved strokes is less inclined to the left. The Y almost always has bracketed serifs, and the head serifs (the ones at the top of letters) are often angled. The crossbar of the e becomes horizontal. The x-height is still small but larger than the Humanist fonts.

Transitional Late 17th Century to Mid-18th Century

Typefaces in this classification have more pronounced weight contrast between the thick and thin strokes. The axis of the curved strokes may be slightly angled to the left, but generally they are vertical. Serifs are still bracketed but start to flatten out. These typefaces are historically the bridge between Old Style and Modern designs.

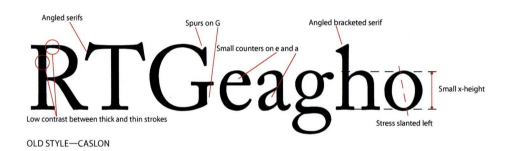

OLD STYLE—CASLON

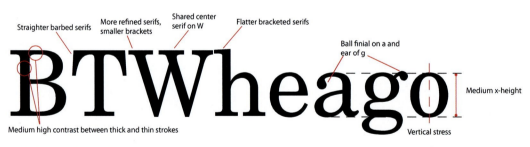

TRANSITIONAL—NEW CENTURY SCHOOLBOOK

Modern (Didone) Mid- to Late 18th Century

The typefaces are characterized by strong contrast between thick and thin strokes, very fine serifs with no bracketing, and strong vertical stress in the curved letter forms. The strong vertical stress tends to make text settings "sparkle," or vibrate, on the page, therefore they are not good for large amounts of text. They are best for large point sizes.

Slab Serif (Egyptian) Early 19th Century

These were the first typefaces designed as display type for advertising and posters. Typefaces with very thick, heavy serifs with no bracketing, or very slight bracketing. Sometimes the serifs are equal in thickness to the main strokes.

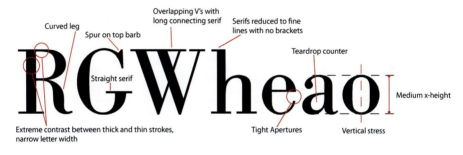

Curved leg
Spur on top barb
Overlapping V's with long connecting serif
Serifs reduced to fine lines with no brackets
Teardrop counter
Straight serif
Medium x-height
Extreme contrast between thick and thin strokes, narrow letter width
Tight Apertures
Vertical stress

MODERN—BODONI

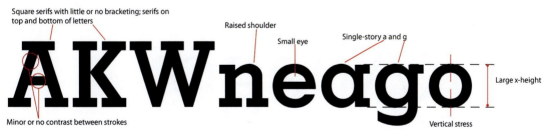

Square serifs with little or no bracketing; serifs on top and bottom of letters
Raised shoulder
Small eye
Single-story a and g
Large x-height
Minor or no contrast between strokes
Vertical stress

SLAB SERIF—MEMPHIS

Sans Serif Grotesque Early 19th Century

Typefaces of 19th-century origin, the first of which was designed in 1816 by William Caslon IV. They are characterized by a lack of serifs with some variance between thick and thin strokes. The curved strokes have a slight flatness to them. The R usually has a curled leg and the G is usually spurred. Early sans serif types were considered ugly and called Grotesque, a term still used today.

Sans Serif Humanist Mid-20th Century

Typefaces based on the proportions of the Roman capitals and Humanist lowercase. Have a more calligraphic basis, sometimes with flared strokes. They have higher stroke contrast with a two-story a and g.

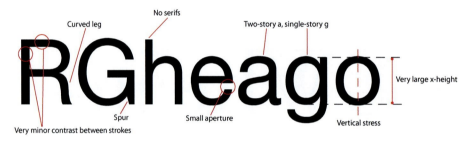

SANS SERIF GROTESQUE—HELVETICA

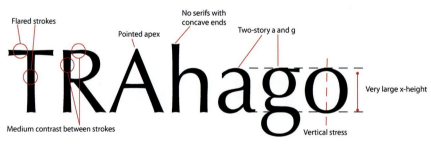

SANS SERIF HUMANIST—OPTIMA

Sans Serif Geometric **Early 20th Century**

Typefaces based on geometric shapes. Usually no contrast between strokes, and often a single-story a and g, optically circular counters and bowls, and little or no contrast between strokes.

Scripts

Typefaces based on handwriting, with letters that often are connected. They can be formal or very casual.

Glyphic (incised) Typefaces that look chiseled rather than calligraphic in origin. They are based on letters cut in stone.

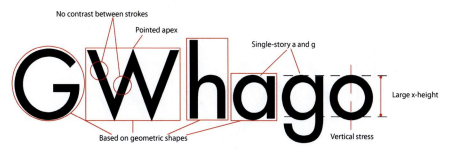

SANS SERIF GEOMETRIC—FUTURA

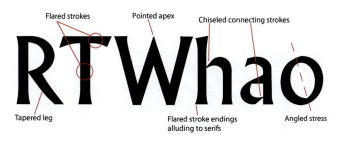

GLYPHIC—ALBERTUS

Calligraphic These are based on calligraphic writing and usually resemble lettering drawn with a flat-tipped instrument.

Casual Scripts Typefaces that look informal, as if they were drawn quickly with a brush or pen, and sometimes resemble handwriting.

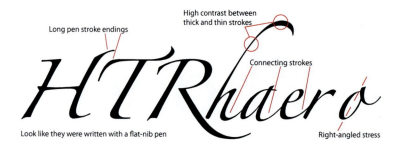

Long pen stroke endings

High contrast between thick and thin strokes

Connecting strokes

Look like they were written with a flat-nib pen

Right-angled stress

CALLIGRAPHIC—ZAPFINO

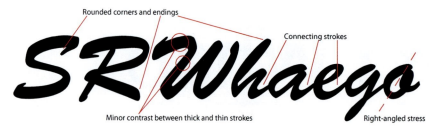

Rounded corners and endings

Connecting strokes

Minor contrast between thick and thin strokes

Right-angled stress

CASUAL—BRUSH SCRIPT

Formal Scripts Derived from 17th- and 18th-century formal handwriting styles. The letters are joined to adjacent letters by strokes. They are elegant and sophisticated, and should be used for formal designs, such as wedding invitations.

Blackletter (Gothic, Old English, Fraktur, Textura)

Typefaces based on medieval manuscript letterforms originating in Northern Europe and drawn with a wide nib pen. Blackletter is classified into four main groups: Textura, compressed and angular; Rotunda, the Italianate version of Textura with more rounded letters; Schwabacher, based on a cursive writing; and Fraktur, containing baroque flourishes and forked tops on the ascenders.

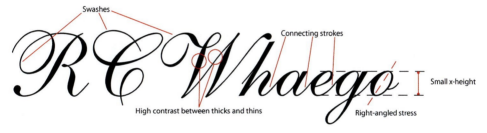

Swashes

Connecting strokes

Small x-height

High contrast between thicks and thins

Right-angled stress

FORMAL—SHELLEY ALLEGRO

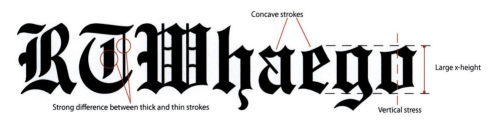

Concave strokes

Large x-height

Strong difference between thick and thin strokes

Vertical stress

BLACKLETTER—OLD ENGLISH

TYPE VARIATIONS AND MODIFICATION

In every classification of type, there are thousands of different typefaces and fonts available, useful for different types of design work. This is most apparent in logo design where fonts can be used in the design of the logo, as inspiration for designing letters from scratch, or they can be modified to make something new. To modify a font it must first be changed to outlines. Highlight the letter or letters you want to modify and go to Type > Create Outlines. Then, using the Direct Selection Tool , select individual points to modify the shape of the letter. Sometimes you may need to Ungroup the outline in order to select points.

Creating letters from scratch for a logo inspired by quilt patterns.

Designed by Daniel Morgenthaler for Tryon Farm, Modern Country Homes in Michigan City, Indiana.

Example of modification of type for a logo. The K has been enlarged and its leg modified, and the t, e, c, h have been connected by extending strokes and tightening space.

Designed by Eliza Rosen.

Sometimes the best approach is to mix different fonts to create an appropriate logo. Here a mixture of roman, italic, and sans serif are put together, along with a sans serif, lowercase a in the middle of serif caps create a unique logo.

Designed by Eliza Rosen.

Exercise: The Structure of Letterforms

The alphabet and typeface designs originated with handwritten, calligraphic forms written with broad-nib pens. Typefaces classified as Humanist and Old Style are copied from these calligraphic letters. Some of the other classifications also retain characteristics of these hand forms.

The Foundational Hand in calligraphy is based on the Carolingian Minuscule, which contained all lowercase letters. Today, Roman capitals are used with the foundational letters because of their similarity of forms. To understand the characteristics of typographic letters, it is important to understand the structure and form of their calligraphic models.

Supplies

Double pencil
- To make a double pencil, you need: two lead pencils (#2 or HB) sharpened, and two rubber bands
- Wind one rubber band tightly around both pencils toward the sharpened ends. Wind the other one toward the tops of the pencils. (See illustration.)
- Keep the two points level.

Lined practice sheet
- Measure the distance from point to point of the banded pencils. You can use inches, millimeters, or points.
- In InDesign or Illustrator, create an 11″ × 17″ document and draw a square with sides equaling this measure. Draw a line across the page horizontally. This is your baseline. Place the square on the left side of the baseline, and copy and paste it six times. Stack the squares in a checkerboard pattern up the left side, one on top of the other. Between the fourth and fifth squares, draw another horizontal line across. This is your meanline for the lowercase letters. At the top square, draw another line for the cap height. Duplicate this a couple of times to get a page of guidelines. Print out as many copies as necessary.

Ruled guidelines for double-pencil letters.

Hold the pencils at a 30-degree angle and copy the Roman capitals and foundational lowercase shown below. Follow the directions and numbers for the order of the strokes. Your O's should be almost circular. Repeat each letter across one set of guidelines.

Choose the best drawing for each letter and enlarge it 200% on a photocopier. Trace it with a fine-point black marker and color it solid black. Neatly write the distinct characteristics of each next to the letters.

22 pt square, the distance from point-to-point of two regular pencils.

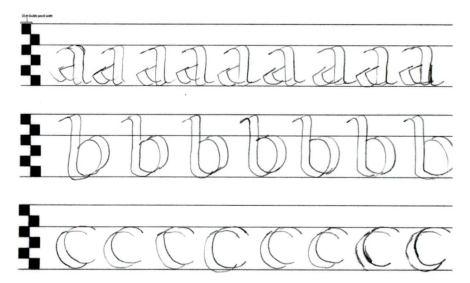

Sample double pencil lettering practice.

Sample Student Solutions

Ali Tomek

Elisa Cordovez

Elisa Cordovez

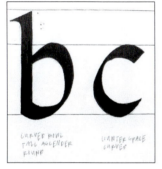

Ali Tomek

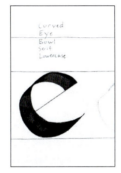

Evan Mack

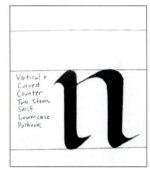

Evan Mack

Assignment: Type Anatomy and Characteristics

An understanding of typographic letter characteristics is directly related to an understanding of letter construction. The previous exercise showed the construction of letter forms. In order to gain a familiarity of the characteristics of typographic letters and their evolution, you will be drawing upper- and lowercase letters from the eight main classifications of type.

Through this assignment, you will see the visual characteristics of individual typefaces and classifications so that you can begin to recognize them when looking at fonts. This skill is necessary when choosing fonts for specific design jobs.

Supplies

Bristol paper pad, smooth finish (large enough to cut out 10˝ squares)

Pencil and eraser

Fine-point permanent black ink marker (Micron is best)

Black Pelikan Plaka or opaque black waterproof ink and brush, water container

Ruler with inking edge

Pair of dividers

Triangle with inking edge

French curves or bendable curve

Format

Eight 10˝ squares of Bristol paper

One pair of upper- and lowercase letters from each of the eight classifications of type set at 400 pt, showing baseline, meanline, and cap height

Upper- and lowercase A's from Humanist classification, set in Jenson Bold

Process

Redraw each pair of letters, freehand, on the 10˝ squares of Bristol paper. Make measurements and draw in pencil the three guidelines on the Bristol, then draw the letters in pencil using any of the listed tools. Craftsmanship is important; take your time and be as neat as possible.

Once the pencil drawings are done to your liking, outline the letters with a fine-point marker and paint in the inside with black Plaka or ink.

On the back of each square, neatly write, or type and paste, the answers to the following questions:

1) What are the unique characteristics of this typeface, and these letters in particular? Write as many as you can.

2) What changes in design/characteristics happened between this type classification and the previous one? What stayed the same? (In the case of Humanist, state the similarities and differences between it and the handwritten letters of the previous exercise.)

Be prepared to discuss with the class.

Sample Student Solutions

Sans Serif Grotesque,
Akzidenz Grotesk Medium.

Ali Tomek

Modern, Bodoni Medium.

Ali Tomek

Modern, Bodoni Medium.

Min Young Kim

Old Style, Garamond Semibold.

Melissa Wittenmeyer

Assignment: Ligature Design

Ligature means "laced together." They are type characters created by combining two or more letters to form one character. When some letters of the alphabet are set next to one another they can create awkward spaces in the word. Ligatures were created to help alleviate these space issues. Most fonts contain some ligatures.

In this part of the assignment, you are going to create two ligatures and use them in typeset words.

Format

Final prints will be on 8½″ × 11″ pages
Supplies
Tracing paper
Pencil and eraser
Black permanent ink pens
Drawing tools

Process

You will design two different ligatures. Choose two different letters for each ligature. You can use two caps, two lowercase, or a cap and a lowercase letter. You do not have to use the same case format for both.

1. Look at ligatures. See how they are put together.
2. Choose the font you want to use for both ligatures from one of the classifications used in Part 1.
3. Set each of your letters in Illustrator or InDesign at a size you want to use for tracing and sketching. It shouldn't be too large or too small. Print each out. Close the computer.
4. Start tracing the letters and putting the tracings together in different ways—overlap them, put them right next to one another, shift their height, etc. Find areas where strokes can be combined or cut, spaces that can be combined or made equal. Keep tracing and sketching until you have at least four that you think will work. Put these and all of your other sketches up for critique.
5. Based on the critique, you will choose the two to proceed with.
 Recreate your ligatures in Illustrator. You can scan your sketches and trace them, or set your letters and modify them as outlines.
 Keep refining until it is the form you want. Print out.
6. Based on the critique, make changes and refinements. Test out by setting them in words. Make adjustments as necessary. Print out the ligatures on pages by themselves, and the words on their own pages.

 mirage

Dakota Sherman

 France

Christiaan Jackson

by ruby

Ruby Baek

HE HERO

Xiao He

ep accept

Erika Park

03.

InDesign® Software Basics

Adobe® InDesign® software is what I use to teach typography and is referred to throughout this book. Therefore, I believe it is important to give a basic InDesign® tutorial here. I am assuming you already know how to use a Macintosh computer and mouse, so this chapter will only cover what I think you need to know to do the exercises and assignments in this book.

INDESIGN® TOOLS PANEL AND MENUS

Tools Panel

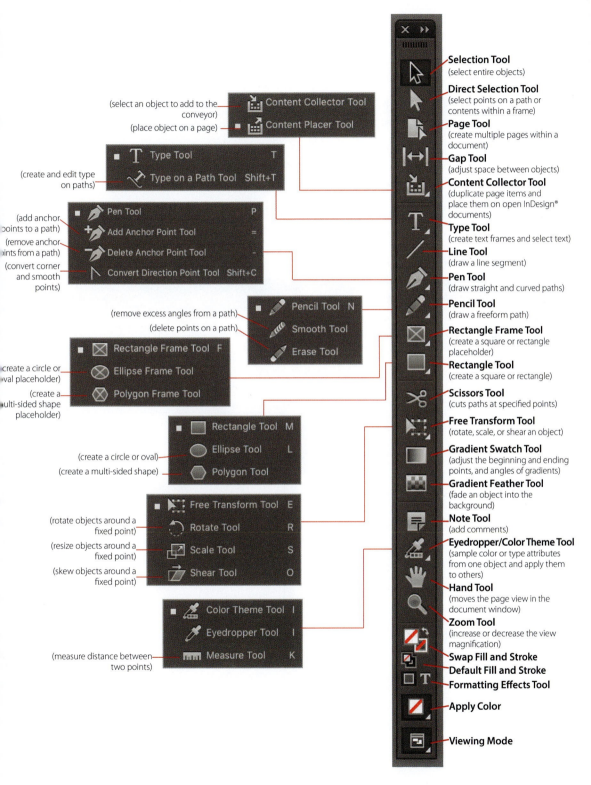

(select an object to add to the conveyor) — Content Collector Tool

(place object on a page) — Content Placer Tool

(create and edit type on paths) — Type Tool — T; Type on a Path Tool — Shift+T

(add anchor points to a path) — Pen Tool — P; Add Anchor Point Tool — =

(remove anchor points from a path) — Delete Anchor Point Tool — -

(convert corner and smooth points) — Convert Direction Point Tool — Shift+C

(remove excess angles from a path) — Pencil Tool — N; Smooth Tool

(delete points on a path) — Erase Tool

(create a circle or oval placeholder) — Rectangle Frame Tool — F; Ellipse Frame Tool

(create a multi-sided shape placeholder) — Polygon Frame Tool

(create a circle or oval) — Rectangle Tool — M; Ellipse Tool — L

(create a multi-sided shape) — Polygon Tool

(rotate objects around a fixed point) — Free Transform Tool — E; Rotate Tool — R

(resize objects around a fixed point) — Scale Tool — S

(skew objects around a fixed point) — Shear Tool — O

Color Theme Tool — I

Eyedropper Tool — I

(measure distance between two points) — Measure Tool — K

Selection Tool
(select entire objects)

Direct Selection Tool
(select points on a path or contents within a frame)

Page Tool
(create multiple pages within a document)

Gap Tool
(adjust space between objects)

Content Collector Tool
(duplicate page items and place them on open InDesign® documents)

Type Tool
(create text frames and select text)

Line Tool
(draw a line segment)

Pen Tool
(draw straight and curved paths)

Pencil Tool
(draw a freeform path)

Rectangle Frame Tool
(create a square or rectangle placeholder)

Rectangle Tool
(create a square or rectangle)

Scissors Tool
(cuts paths at specified points)

Free Transform Tool
(rotate, scale, or shear an object)

Gradient Swatch Tool
(adjust the beginning and ending points, and angles of gradients)

Gradient Feather Tool
(fade an object into the background)

Note Tool
(add comments)

Eyedropper/Color Theme Tool
(sample color or type attributes from one object and apply them to others)

Hand Tool
(moves the page view in the document window)

Zoom Tool
(increase or decrease the view magnification)

Swap Fill and Stroke

Default Fill and Stroke

Formatting Effects Tool

Apply Color

Viewing Mode

THE CONTROL PANEL

Character and Paragraph Formatting

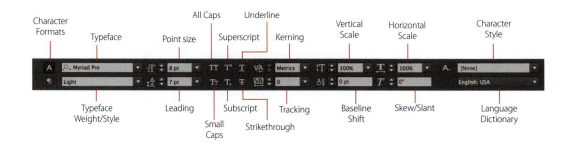

Character Formats · Typeface · Point size · All Caps · Superscript · Underline · Kerning · Vertical Scale · Horizontal Scale · Character Style

Typeface Weight/Style · Leading · Small Caps · Subscript · Strikethrough · Tracking · Baseline Shift · Skew/Slant · Language Dictionary

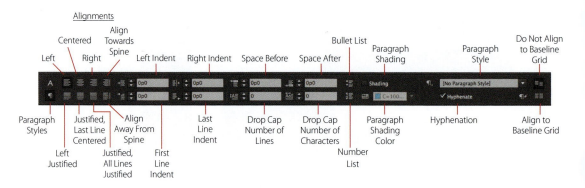

Alignments

Left · Centered · Right · Align Towards Spine · Left Indent · Right Indent · Space Before · Space After · Bullet List · Paragraph Shading · Paragraph Style · Do Not Align to Baseline Grid

Paragraph Styles · Left Justified · Justified, Last Line Centered · Align Away From Spine · Justified, All Lines Justified · First Line Indent · Last Line Indent · Drop Cap Number of Lines · Drop Cap Number of Characters · Number List · Paragraph Shading Color · Hyphenation · Align to Baseline Grid

Control Panel Menu

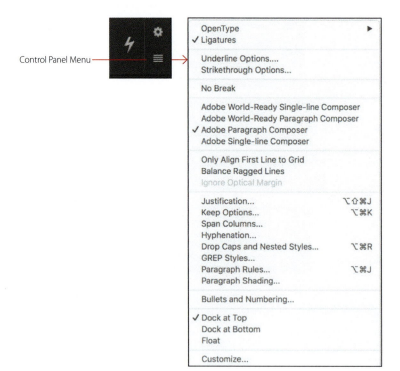

SETTING UP A DOCUMENT

Open the **New Document** menu (command + N). Select your page size, margin measurements, number of columns, etc. Any of these selections can be changed later but may create other issues that will need to be fixed.

Setting Margins

Traditionally, medieval scribes used mathematical principles, such as the Golden Section, to determine margin dimensions. Today, margins are determined in a number of different ways by the designer.

The margin at the top of the page is called the *head margin*; the one at the bottom of the page is the *foot margin*; the outside margin is called the *thumb margin*; and the inside (spine) margin is known as the *gutter margin*.

Margins are the spaces around the type area which help readers focus on the text. Besides providing a frame for the type, margins have other functions. The thumb margins (outside margins) are used for holding a book and for turning the pages. They also are used for subordinate elements like folios and running headers or footlines.

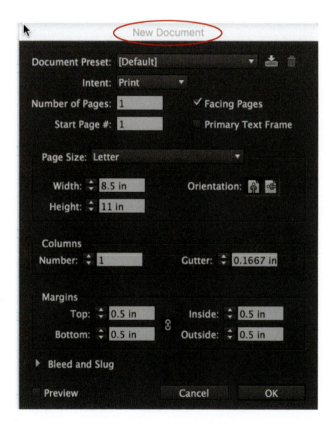

You must first determine the margin measurements, which will determine the size of the text/image area. Then decide if your margins are going to mirror each other (symmetrical), or if the left margins are going to be the same and the right margins will be the same, regardless of whether the page is a left or a right page (asymmetrical).

Smaller margins increase the usable area of the page, larger margins decrease the active area but increase the white space and direct the reader to the main area of the page.

Traditionally, the bottom margin should be larger than the top one to prevent the page from looking bottom-heavy or like the page elements are too close to the bottom. This is because the optical center of a page is slightly above the actual center.

Gutter margins (those at the spine) are narrower than the thumb margins because the two gutter margins together are read as one margin. The gutter margin must take into account the thickness of the publication, and the method of binding. For instance, loose-leaf binding or spiral binding requires gutter margins to be wider in order for the text area to clear the hole-punching or binding. On thicker books, part of this margin is going to be lost in the binding.

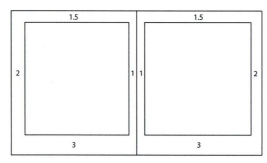

Traditional margin ratios based on the golden section.

One method for determining the text and margin proportions is based on the Golden Section. Begin with two blank facing pages. Draw all of the diagonals, both for the spread and for the two individual pages (1). Next, draw the text areas so that the upper-inside and lower-inside points align with the short diagonals, the upper-outside points align with a long diagonal, and the bottom outside points touch the short diagonals (2). In this way, the inside and top margins are one-ninth of the width and the height of the page, respectively, and the outside and bottom margins are double the size of the inside and top margins, respectively. Drawn this way, the text areas can be of any size, as the outside margin will always be twice the inside margin, and the bottom margin will always be twice the top margin. The gutter margin is one unit of measure, the top margin is 1.5 units, the outside margin is 2 units, and the bottom margin equals 3 units of measure. See pages 161–163 for more options.

Columns

The next step is to determine the number of columns. The width of the text columns, called the *column measure*, and the spaces between them (*alleys*, but commonly called *gutters*) is determined by the number of characters, spaces,

1

2

and punctuation in a line of the type. (See "Line Length" chapter 04, page 91.) Traditionally, the gutter space is equal to the size of the leading used for the text, or a multiple of this amount (× 1.5, 2, etc.). The wider the column, the bigger the gutter should be. On the other hand, the gutters should not be too wide that the columns seem unrelated to one another, nor too narrow as to cause the reader's eye to cross over columns. The column, or combination of two or more columns, should be the appropriate width to set the ideal number of characters per line, in the point size of the type you are using, to achieve optimum readability.

Start by setting some sample text in the font you intend to use, an average point size and leading amount, in the column measure you've chosen. Adjust the tracking, if necessary, for readability requirements. Set some other samples in different point sizes and amounts of leading. Count the characters, spaces, and punctuation in a line of each. Look at the ones that fall within the optimum number of characters per line and determine which point size and leading amount looks best for readability.

There can be primary and secondary column divisions. You may have a dominant structure of, say, two columns, but these columns may actually

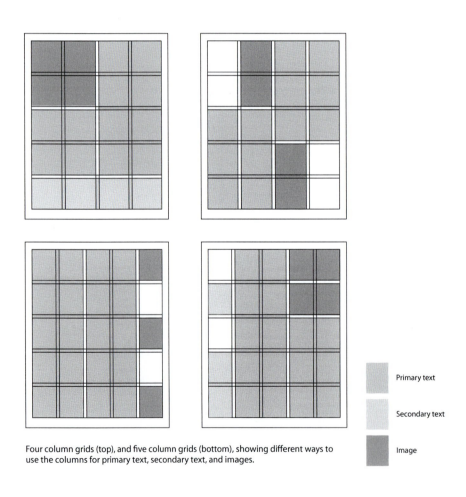

Primary text

Secondary text

Image

Four column grids (top), and five column grids (bottom), showing different ways to use the columns for primary text, secondary text, and images.

have a secondary structure by being divided into four columns. A six-column grid also can be used as two- or three-column measures. This allows for more flexibility in the layout.

MASTER PAGES

Any of the directions discussed here for items on master pages also can be used to place items on individual document pages.

Everything that is on a master page will be on every page in a document that is based on that master page. A document can have multiple master pages. For example, different pages, or sections, of a book can have different elements and/or layouts that would require a different master page to base them on. The Pages Panel will show all of the master pages in a document above the line at the top of the panel. A letter on each page below the line indicates which master that page is based on.

Master page items have borders of blue dots on document pages, instead of solid line frames, and are locked so they cannot be changed or removed. To change or delete a master page item on a document page, hold command + shift and click on the item to unlock it. To unlock all of the

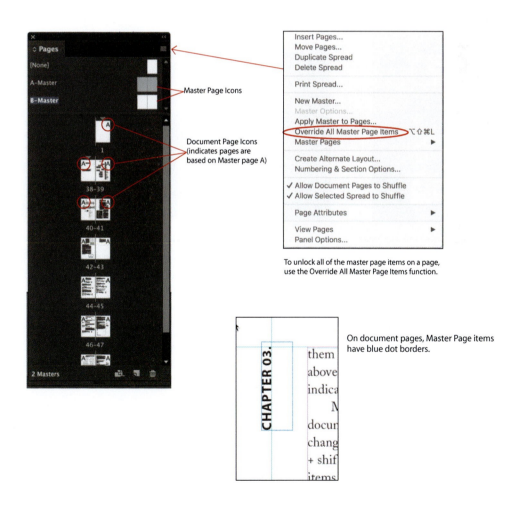

Master Page Icons

Document Page Icons
(indicates pages are
based on Master page A)

To unlock all of the master page items on a page,
use the Override All Master Page Items function.

On document pages, Master Page items
have blue dot borders.

master page items on a page, or pages, make sure the pages you want to change are selected on the Pages Panel (selected pages will have a gray background on the Pages Panel), then choose Override All Master Page Items from the Pages Panel menu in the upper-right corner.

MASTER PAGE ELEMENTS

Placing Additional Guides

Guides are non-printing lines that can be placed on pages either by dragging them out of the rulers at the top and left side of the screen, or by using the Create Guides function. These guides can be used to mark placement of additional elements or the starting point of new sections of text.

Guides from Rules The rulers must be visible to use this function. If they are not, go to View > Show Rulers, or click command + R. Click in either the top ruler (for horizontal guides) or the left ruler (for vertical guides) and drag out a guide to the point you want to put it and then release it.

Guides Using the Menu Click Layout > Create Guides. The Rows function controls horizontal guides, and the Columns function controls vertical guides. Type the number of guides you want in one or both boxes,

Selected document pages on Pages Panel appear as gray.

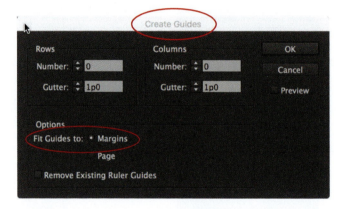

Use the Create Guides menu to add additional guidelines to a document.

check the Margins box under Fit Guides To, and set a gutter measurement or set it to 0 if you don't want any gutters between the guides. The guides will be equally spaced within the margin guides instead of between the edges of the page.

Placeholders

If your layout specifies text boxes and/or graphics in the same location on each page, you can create placeholders frames for these items on the master pages.

Text Frames Select the Type tool and draw a text box that fills the column width and length needed for the placeholder. Put as many text boxes as needed on both the left and right master pages.

Graphic Frames If your pages contain consistently sized graphics on each page, you can add placeholders for them on the master pages. Click on either the Rectangle tool or the Rectangle Frame tool (they are interchangeable), although the Rectangle Frame tool contains diagonal lines that will not print and can help distinguish the graphic frames from the text frames. Draw a frame that covers the length and width, and is in the position of the graphics in your layout. Place them on one or both master pages as needed.

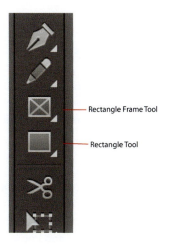

Rectangle Frame Tool

Rectangle Tool

04.
The Mechanics of Type

TYPE MEASUREMENT

The Point System

In 1737, Pierre Fournier le Jeune, a Parisian typefounder, proposed the first standard unit of measure known as the *point*. A point equals ¹/₇₂ of an inch, or .013836 inch. This measurement is used to indicate the size of type, and the space between lines of type, also known as *leading*. In 1785, Fermin A. Didot invented a larger point equal to 0.376 mm, which was adopted by the rest of continental Europe.

Picas

Picas are larger and are used to measure the length of a line of type and the width and depth of pages. A pica contains 12 points and is slightly less than ¹/₆ of an inch. There are 6 picas in 1 inch. Picas are used to indicate horizontal measurements such as column width and line length.

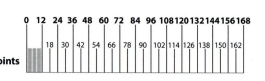

Type Sizes

The present method of measuring type is derived from metal-cast type used for letterpress printing. Two dimensions are relevant today: the width and the depth.

The width, called *set width*, determines the amount of space a character occupies and is in proportion to each letterform. M and W are the widest letters and i is the narrowest. The set width dimension includes a small amount of space on either side to prevent the characters from touching one another when set in a line of type.

In metal type, characters are constructed on a piece of metal. The dimensions of the type size include the distance from the top of the tallest ascender in the typeface to the bottom of the lowest descender, plus a small amount of extra space (the depth or height of the metal block called the body). This is to ensure that when type is set solid (no extra line spacing), there is no danger of ascenders and descenders from consecutive lines touching one another. The length of the block determines the size of the character. This dimension is referred to as the type size or point size.

1 inch = 72 pt
1 inch = 6 picas
1 pica = 12 pt

Points are written as pt
Picas are written as p

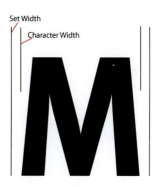

Set Width

Character Width

If the piece of metal measures 10 points, then the type size is 10 points. If it measures 36 points, the type size is 36 points. Although the body size of metal type is the same for all characters in a particular point size, the actual letters vary in size. Because no individual letter fills the entire surface of the metal. This is why just measuring a printed letter will not give you its true point size. In most cases, the actual measurement from baseline to cap height is about 70% of the actual point size.

EM AND EN

Em, or em quad in metal type, and *en* are space measurements. The em (for the letter M) is a unit of measurement that is the same size as the point size of the type being used, thus an em in 10-point type is 10 points, in 12-point type it is 12 points, etc.

An *en* (for N) is half the size of an em, so in 10-point type it is 5 points and in 12-point type it is 6 points, and so on.

CHARACTER WIDTH AND SIDEBEARING

Character width describes the width of the bounding box of a letter, which includes the variable space to the left and right of each letter. *Sidebearing* is the

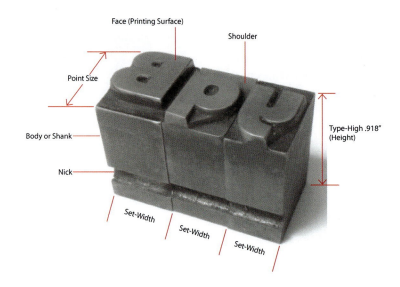

space between the edge of a character and the edge of its bounding box. When digital type is set, the sidebearings of two adjoining letters combine to form the letter space between them. All of these measurements are in units that are relative to the typeface and its point size.

Tolbert Lanston invented the unit system of measure in 1887 to allow greater precision in the spacing between letters and words. Units are determined by the em quad. They are established by dividing the em quad into 18 vertical segments, but sometimes the units are in increments of 16, 36, 72, and even 1,000, which is what is used for Postscript type. A letter and its surrounding space always occupy a whole number of units. The unit is used to adjust *tracking* in page layout programs. Tracking (the adjustment of a uniform amount of spacing in an entire word or text block) is calculated by adding or subtracting a specific number of units in the word or text block, i.e., −5 units or +5 units.

SPACING

When designing with type, there are three kinds of space the designer must take into account: letter, word, and line space. Without all three of these, the type would form a mass of overlapping shapes. Horizontal spacing—the

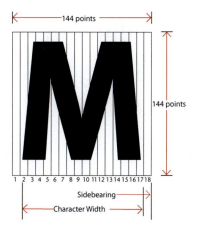

spacing between words and letters, or indents—usually is measured in ems and ens. When you change one spacing parameter, you almost always have to adjust the others also.

Tonal Value

When letters are placed side by side, particularly in a block of text, they lose their individual blackness and create a shade of gray. The lightness or darkness of the gray depends on the type style, it's weight, and the space inside and around the letters. Creating a consistent gray value depends on having an equal division of positive and negative within and around the words. *Tonal value* is affected by letter, word, and line spacing. A heavier typeface, consisting of letters with small counters, and very tight letter and word spaces, will appear to be darker in tonal value than a thinner typeface that has more open counters in the letters, and more open space around the letters and words. The goal is to have an even, medium gray tone to the block of text.

LETTER SPACING (TRACKING)

Tracking is the overall increase or decrease of letter spacing over a range of text. Proper letter spacing depends on many factors: the typeface, leading,

It's through mistakes that you actually can grow. You have to get bad in order to get good.

—Paula Scher

It's through mistakes that you actually can grow. You have to get bad in order to get good.

—Paula Scher

Tonal value is affected by positive and negative space around and inside the words. The regular weight of Myriad (top) looks lighter than the regular condensed weight of the same typeface (below) because of the smaller counters and tighter letter and word spaces.

point size, weight, and audience. In page design, the object is to keep the color of the text even to enhance readability. When letters in text are set too loosely, the words do not form groups, becoming unrelated signs that cause the eye to slow down. The words will cease to be perceived as words. When the letters are too tightly packed together, the lines become darker and the letters lose their distinct outlines, becoming hard to distinguish from one another. Letter spacing should be set so that words create clear groups that do not appear crowded together.

Most fonts set in text sizes have the right amount of letter space and don't require any adjustments. On rare occasions, text type needs to be tracked, either + or −, in order to create an even tone and enhance legibility, or to fix bad breaks, widows and orphans, or badly spaced lines in justified settings. Tracking applies a uniform space adjustment across an entire word, sentence, paragraph, or larger text block that is made in $\frac{1}{1,000}$ of an em space units. If you increase or decrease the space too much, the block of text will look lighter or darker than the rest of the text.

When letters in the text are set too loosely, the words do not form groups, becoming unrelated signs that force the reader to stop and mentally regroup.

10/12 Helvetica with +200 tracking

When letters are too tightly packed together, they lose their distinct outlines and can be hard to distinguish from one another, compromising readability.

10/12 Helvetica with -70 tracking

When letter space is too loose (top), words start to break apart and become less legible. When the letter space is too tight (bottom), the letters' outlines become less distinguishable, making them hard to read.

WORD SPACE

Word space is unique to each typeface design and can vary from font to font. Word spaces have to be gauged so the reader is able to see individual words and also to group them together for quick comprehension.

The spacing between words can affect readability. Too much word space breaks the line into separate elements causing holes, gaps, or "rivers" in the page, slowing the reading process. Words that are too crowded will cause dark blotches, also slowing reading.

LEADING/LINE SPACING

Leading is the amount of vertical space between lines of type and it is measured in points. Type can be hard to read without some space around it, so typesetters would insert thin strips of lead between the lines of metal type. Each strip was 1-point thick, or its thickness was measured in 1-point increments. This was called *adding lead*.

When specifying the size of type, particularly text type, it is written as two numbers, such as $9/10$—the first is the typeface's point size and the second is the leading, or baseline-to-baseline measurement in points.

Too much space between words will cause holes in the page and slow the reading process.

10/13 Helvetica, 250% word space

Words that are too crowded will cause words to blend together, also slowing reading.

10/13 Helvetica, 40% word space

Leading is probably more important to readability than type size. If lines are too close together, visual chaos is created, especially if ascenders and descenders from adjacent lines touch each other. They also will create a dark, uninviting color that may cause the reader to skip a line when scanning to find the next one. The space between the lines has to be large enough to prevent the eye from slipping to the next line before it is finished gathering information in the current one, but not so large that it makes it hard to locate the next line.

Average text sizes are usually set with 1 or 2 points of leading. Longer lines, and typefaces with larger x-heights, need more space between them for legibility. Text that contains superscripts, or a lot of all-cap settings, also should have more leading.

Auto Leading

If no space is inserted between lines, the type is said to be set *solid*. It will have a very dense appearance and be hard to read. *Auto leading*, or *default leading*, in your software program has a default value of 120%, or 20% extra leading over and above the type size. It is best not to use auto leading for the following reasons:

The first word of the first line is the critical word of that particular body of text. Let it start flush, at least.

—William Addison Dwiggins

Too much leading makes it hard to find where the eye should go next. Text is set 20/35.

The first word of the first line is the critical word of that particular body of text. Let it start flush, at least.

—William Addison Dwiggins

If the leading is too tight, ascenders and descenders will touch and will also cause the reader to jump lines. Text is set 20/19.

- Auto leading is proportional to the type size you are using—but specific to the largest point size of type in the line of text. This means if you have one word larger than the rest of the line, your leading value will match this one word for that line only, so that line will have more space above it than the rest of the lines in the paragraph.

- Auto leading doesn't give you the control you need. If you're using 10-point type, your auto leading is 12 point, but if your type is 11-point, the auto leading is 13.2 point, which is a difficult number to calculate in multiples if you want to work with a baseline grid.

- Auto leading looks bad when applied to display type, which generally requires less leading for larger sizes, especially if set in all caps.

Optical Leading

In some situations you may need to manually adjust the leading of individual lines to make the line space look *optically* consistent. This may occur if one line doesn't have descenders, such as when a word, or words, have been changed to caps.

Simplicity is not the goal. It is the BY-PRODUCT of a good idea and modest expectations.

—Paul Rand

20/25 text, with one word in all caps and with no adjustment. The space below BY-PRODUCT looks too big and above it looks too small.

Simplicity is not the goal. It is the BY-PRODUCT of a good idea and modest expectations.

—Paul Rand

The same text with individual lines adjusted so the leading looks optically consistent.

Design is a plan for arranging elements in such a way as best to accomplish a particular purpose.

—Charles Eames

20-point type with auto leading on and two words set in 24-point type, causing the first two lines to be more spaced out than the rest.

Design is a plan for arranging elements in such a way as best to accomplish a particular purpose.

—Charles Eames

The same quote set 20/24. The line space is more even but the two lines with the larger point sizes were adjusted individually to make them optically even.

ALIGNMENT

Flush Left

Flush left, rag right means the text is aligned flush along the left margin and puts all of the extra space within a line of type at the right end of the line, thus creating the rag on the right margin and allowing the letter space to remain the same throughout the paragraph. This is the most comfortable setting for type because we read from left to right and this allows the reader to begin each line along the same left margin.

Sometimes, an extreme rag can form, creating uncomfortable rhythm and drawing attention to the shape of the column. An ideal rag should look like a loosely torn piece of paper and should go unnoticed by the reader. You can fix a rag manually by forcing line breaks with a soft return, inserting discretionary hyphens where appropriate, or applying small amounts of tracking, either + or −.

In the InDesign® Hyphenation settings (accessed from the Control Panel menu or the Paragraph Style Options), the Hyphenation Zone helps to control the "rag" of unjustified text. The zone is measured from the

What an excellent example of the power of dress, young Oliver Twist was! Wrapped in the blanket which had hitherto formed his only covering, he might have been the child of a nobleman or a beggar; it would have been hard for the haughtiest stranger to have assigned him his proper station in society.

Flush left, rag right alignment.

Leading Guidelines
These are not rules, just suggestions for most situations.

Large x-height	Increase leading
Small x-height	Decrease leading
Long ascenders and descenders	Increase leading
All caps	Decrease leading
Bold type	Increase leading
Reverse type	Increase point size by 1 or 2 points, and also increase the letter space a bit.
Long lines	Increase leading
Wide letterspacing	Increase leading

right side of the column, and the specified width tells the software that no hyphenation is required as long as the line ends within the zone.

If auto hyphenation is on, but no hyphenation zone is specified, the last word in a line will be hyphenated according the normal rules that determine word breaks if it is too long to fit. This results in lines of more even length with a lot of hyphens. If no hyphens are permitted, the rag will be greater than if hyphens are allowed.

For a "good rag," with a small amount of variance, it is best to not allow more than two consecutive hyphens and to specify a Hyphenation Zone. A smaller Hyphenation Zone creates a softer rag with more hyphens, as opposed to a larger zone that will create a bigger rag and fewer hyphens. The designer has to find a good balance.

InDesign® also has the Balance Ragged Lines feature in the Paragraph Style Options. Checking this box can help produce a more even rag, along with the hyphenation settings.

The second line of a paragraph should be longer than the first to help with readability. A longer first line will create an unnecessary pause in reading.

Default settings in Hyphenation settings menu.

Rag is the pattern formed by the line breaks in a block of text. An ideal rag should look like a loosely torn piece of paper. Each line of text should break in a different place.

Bad rag on flush left alignment.

Rag is the pattern formed by the line breaks in a block of text. An ideal rag should look like a loosely torn piece of paper. Each line of text should break in a different place.

Rag adjusted using tracking and some soft returns to make it more even.

Flush Right

Flush right is text aligned flush along the right margin, leaving all of the extra space, or rag, on the left side of the column. Appropriate for small quantities of text only, (captions, for example) because the uneven starting point of each line adds time and effort to the reading process.

Justified

Justified text is aligned along both the right and left margins. This is the primary setting of choice for newspapers, magazines, and other publications where the copy must fit in the available space. The problem with this setting is that the letter and word spacing is forced into uneven patterns by the requirement that each line of text extend to the full column width, sometimes creating rivers of white space in the text, or lines with very little letter and word space.

Because each letter takes up a different amount of space on a line, the spacing between letters and words will vary from one line to the next. In order to justify the lines, the software program makes the shorter lines the same length as the longest lines, adding various amounts of space between the words of each line in order to achieve this.

What an excellent example of the power of dress, young Oliver Twist was! Wrapped in the blanket which had hitherto formed his only covering, he might have been the child of a nobleman or a beggar; it would have been hard for the haughtiest stranger to have assigned him his proper station in society.

Flush right, rag left alignment.

What an excellent example of the power of dress, young Oliver Twist was! Wrapped in the blanket which had hitherto formed his only covering, he might have been the child of a nobleman or a beggar; it would have been hard for the haughtiest stranger to have assigned him his proper station in society.

Justified alignment.

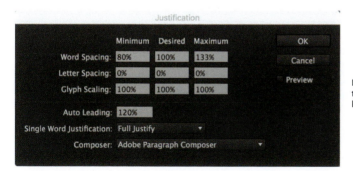

Default Justification settings. Change the numbers to see if you can correct the uneven word and/or letter spaces in justified settings.

A minimum of about 40 to 50 characters per line (or 8 to 10 words, or more, in an average line) is required to create a consistent texture in a block of justified type. Shorter line lengths don't provide enough word space to add or subtract extra space in order to justify the lines. Customize the Justification settings in InDesign® to set the allowable minimum and maximum amount of space to be added between words, and adjust the Hyphenation settings to control the number of consecutive hyphens. You also can manually add discretionary hyphens, or adjust the tracking, to help get rid of awkward spaces.

Centered

In this arrangement, lines of type are aligned centered along a central axis, rather than on a margin, leaving both the left and right sides ragged. Centered type has even word spacing and visual interest but reading can be difficult, so it is best suited for small amounts of text, such as announcements and invitations.

The lines should vary enough in length to make an interesting silhouette, and the line spacing should be generous to assist in reading. Try to keep the rag as even as possible, or at least make sure it has a pleasing shape.

What an excellent example of the power of
dress, young Oliver Twist was! Wrapped in the
blanket which had hitherto formed his only
covering, he might have been the child of a
nobleman or a beggar; it would have been hard
for the haughtiest stranger to have assigned him
his proper station in society.

Centered alignment.

Alignment Across Columns

Many people like to have the baselines of text in one column align with the baselines of the text in other columns on the page. It looks good when done right, but it is not always easy to accomplish. When you have heads, subheads, and paragraph spaces in the text, all of different sizes, the baselines of the different columns can become misaligned. One way to accomplish alignment is to design with a baseline grid.

Baseline Grids

InDesign® has a baseline grid function that lets you set a grid of equally spaced horizontal lines (the measurement based on the size of the leading you've specified for your text) to which all the baselines can be aligned. If you have different text elements with other leading values, you can choose to align to "First Line Only" in the Paragraph Style options for Align to Grid. (See illustration at the bottom of the next page.) This allows only first lines of paragraphs to snap to the grid. After that, the text will be controlled by the leading amount.

The human eye does not read words one at a time. It scans lines with pauses that record groups of three or four words. The length of line of type should be comfortable to read.

Line Length

When line length is too long, it tires the eye and makes it difficult to find the beginning of the next line. Too short a line breaks up the sentence structure and requires changing lines too often, which also tires the reader, disrupting the reading process.

Text set to the Baseline Alignment specifications.
Top left: 10/12 text, with 6-point space above subhead, making it go off the grid. First paragraph only is aligned to the grid.
Top right: 10/12 text with 24/36 head on a 12-point baseline grid.
Right: 8/12 text with a 9/12 head with only the first line aligned to the baseline grid.

Baseline Grids

InDesign® has a baseline grid function that lets you set a grid of equally spaced horizontal lines (the measurement based on the size of the leading you've specified for your text) to which all the baselines can be snapped. If you apply Snap to Guides to your text, all of the baselines will be forced to align on the grid, even if you've given different leading values to some paragraphs.

Most software programs have a baseline grid function that lets you set a grid of equally spaced horizontal lines (the measurement based on the size of the leading you've specified for your text) to which all the baselines can be snapped.

Baseline Grids
If you apply Snap to Guides to your text, all of the baselines will be forced to align on the grid, even if you've given different leading values to some paragraphs.

Designing for Baseline Alignment If your text type is 10 point with 12-point leading, you could then set major headings at 24/36 pt and sub-heads at 14/24 pt, with the spaces before or after paragraphs, and extra space above headings, also specified in 12-point increments. Then you can use the Baseline Shift command to float the headings to where you want to see them without altering the integrity of the baseline grid.

Other Alignment Functions

There are two other types of alignment on the Paragraph Control palette that can be useful for multiple page documents where you have page spreads and the design involves mirrored text columns on the facing pages. When moving text around, or from page to page, the type will mirror itself left-hand pages to right-hand pages and vice versa.

Align Towards Spine aligns text on a left page so that it is right aligned. Text on a right page will be left aligned.

Align Away from Spine does the opposite of Align Towards Spine—aligns the text on a left-hand page so that it is left aligned, and on a right-hand page it becomes right aligned.

Baseline Grid Alignment
Paragraph Style Options showing Align to Grid pull-down menu.

Align Towards Spine and Align Away from Spine on the Paragraph
Control palette.

Line Length

Line length is the measurement between the left and the right margins in a block or line of type, also called column width, or measure. Line length is measured in picas. The human eye does not read words one at a time in a line of text. It scans lines with pauses that register three or four words at a time. The length of a line of type should be comfortable to read. When line length is too long, it tires the eye and makes it difficult to find the beginning of the next line. Too short a line breaks up the sentence structure and requires changing lines too often, disrupting the reading process.

When designing with type, line length is determined by such factors as type size and amount of copy to be set. A method for determining the line length of typeset copy is to have 50 to 75 characters (counting letters, spaces, and punctuation), with 65 being the optimal. A length of 9 to 12 words per line also can be used as a guide.

What an excellent example of the power of dress, young Oliver Twist was! Wrapped in the blanket which had hitherto formed his only covering, he might have been the child of a nobleman or a beggar; it would have been hard for the haughtiest stranger to have assigned him his proper station in society.

Line length of a block of text measuring 25½ picas.

TEXT SEPARATORS

Paragraphs

Without paragraph breaks, text would be cumbersome and hard to read. Paragraph breaks mark a pause and set one paragraph apart from another. There are numerous ways to accomplish this.

History In the 3rd century, paragraphs were denoted by narrow symbols that scribes designed, with no one symbol consistently in use. The ancient Greeks used a horizontal line at the beginning of paragraphs, and some of the scribes adopted this while others used a K, for *kaput*, meaning "head" in Latin. It marked the head of a new argument. The K was abandoned around the 12th century and replaced with the C, for *capitulum*, meaning "little head." This eventually evolved into the pilcrow (¶), due to the inconsistencies of individual handwriting, and the addition of a vertical line added to the C to stylize it. The scribes would leave space at the beginning of paragraphs for the *rubricators*[1] to draw in the pilcrow. When books began to be printed, space was still left for the rubricators to put in the pilcrow, but they could not keep up with the printing press, so these spaces were often left blank, leading to the paragraph indents we use today.

A common way to distinguish paragraphs from one another is to indent the first line of each paragraph.

Extreme indents can add interest but also can become tiresome in long texts.

With hanging indents, the first line extends beyond the left margin of the column.

1 The rubricators were scribes who received manuscripts from the scribes who wrote the text and added additional text, or marks, in red for emphasis.

Here are some of the many ways to indicate paragraph breaks:

1. Traditionally, the first line of a paragraph is indented, generally 1½ to 2 ems. Paragraph indents shouldn't look more important than the text. The first paragraph of a chapter, or the first paragraph under heads and subheads, should not be indented because it does not need to be set apart from a preceding paragraph. Use tabs or first-line indent setting on the paragraph menu for indents, **not the space bar**.

2. Insert additional space between paragraphs, usually half the size of a line space. Using a full line space allows lines of type in adjacent columns to align with one another, but most of the time this is too much space.

3. Extreme indents are sometimes used for visual interest, but they can become tiresome in long texts. The first line is indented to a depth of half the column width or more.

4. Hanging indents, or outdents, also may be used. This is where the first line of a paragraph hangs out to the left of the paragraph into the left margin.

5. A dingbat, symbol, decorative element, or a paragraph mark can be used to separate paragraphs. The paragraphs run in to one another with the symbol separating them.

Paragraphs can be run together and distinguished by a paragraph mark or dingbat to separate them. ¶ This is an example of paragraphs separated by a paragraph mark.

Another way to distinguish paragraphs is by inserting additional space between them.

This is an example of paragraphs with additional space between them and no indent.

PARAGRAPHS can be set apart by setting the first word in all caps. Or, the first few words can be boldface.

Text Openings

Fleurons[2] (typographic ornaments) can be used to mark text openings. The first paragraph at the beginning of a chapter or section also can be indicated by setting the first word, phrase, or line in all capital letters, and/or with an oversized initial cap.

Initial Caps A single, large letter can create a focal point in a section opening. Its size and/or decorative characteristics can attract attention to it, thus drawing the reader into the text. Medieval scribes were aware of this design principle and made use of it with their decorative initial letters. Initial caps may take the form of *drop caps, raised caps, decorative initials, hanging initials,* or *boxed, reversed,* or *overlapped initials.* They do not always have to be capital letters; lowercase letters also may be used. Sometimes, the first word or phrase after the initial cap is set in all caps or small caps in order to bridge the large cap with the regular text.

A simple way to create a drop cap is with the Paragraph Control Panel. You specify the number of lines you want the cap to intersect, and the number of characters involved. If you need to adjust the space between the character and the text, use the kerning function. It will adjust the space on all lines involved in the indent for the drop cap.

✳ A sample of an opening paragraph with a fleuron at the beginning to help set it off from others.

This sample shows a Raised Cap at the opening of a paragraph.

Raised cap with kerning so the text goes under the arm of the T.

here needs to be enough contrast between the text and the overlapped initial for it to be an effective focal point to a section opening.

Drop cap colored, lightened, and placed under the text.

This shows a sample of a Drop Cap at the beginning of a paragraph and cutting into three lines of text.

A drop cap made by using the Paragraph Control Panel and kerning between the cap and text.

2 Fleurons are generally ornaments that are of a floral motif.

If the initial cap is an A or I, there can be confusion as to whether the initial letter is a word itself. The spacing of the text in relation to the cap is important for clarifying this.

Numbered and Bulleted Lists

Lists containing multiple lines of numbered or bulleted text can be aligned either flush with the number or bullet, or indented to align with the first letter of the text. Either way is acceptable and a matter of personal taste.

You can use the bulleted or numbered list function on the Paragraph Control Panel. To adjust the amount of indent, or types of numbers and bullets, open the Bullets and Numbering Panel from the Control Panel menu.

Bullets Bullets are traditionally solid round dots used to separate items in a list. Sometimes a dingbat character, or other symbol, is used instead of a bullet. The size you use depends on aesthetics and how strongly you want to emphasize the item(s). The bullet should be centered on the x-height of the type. If the bullet is large, it may look better centered on the cap height. In either case, use the Baseline Shift function to move the bullet to the correct visual placement.

- 14-point type with a 12-point bullet shifted up 1 point using Baseline Shift.

- 14-point type with a 14-point bullet using Baseline Shift.

- 14-point type with a 16-point bullet using Baseline Shift, shifted down 1 point.

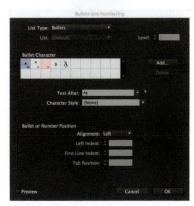

Bullets and Numbering Panel, where adjustments can be made to list formatting.

LEGIBILITY AND READABILITY

Readers are influenced immediately by what they see on a page. Both legibility and readability relate to the ease and clarity with which type can be read.

Legibility (character recognition)

Refers to the typeface and the ease with which a reader can discern the type on the page, based on the color of the type in relation to the background, and also how well the letters can be discerned from one another. Letters must be identified easily to be read. Readers discern letters mainly by their top halves. How legible a typeface is depends on its design characteristics: the size of its counters, x-height, character shapes, stroke contrast, serifs or lack thereof, and weight.

Legibility of Fonts When choosing a font for text setting, there has to be a good balance between the x-height and the ascenders and descenders. The ascenders and descenders must be distinct. The font also should have good, open letter shapes. Letter forms with larger x-heights are usually more legible than those with smaller x-heights.

Short ascenders and compact width = poor legibility.

Text set in all caps is harder to read because words are more easily recognized by their upper halves, which include a combination of ascenders and lowercase without ascenders. Settings of all capitals form a straight-line pattern offering no visual cues for word recognition.

SETTING TEXT IN ALL CAPS SLOWS READING SPEED AND USES AS MUCH AS 35 PERCENT MORE SPACE. WE READ WORDS BY THEIR SHAPES RATHER THAN BY INDIVIDUAL LETTERS, AND CAPITAL LETTERS FORM A STRAIGHT-LINE PATTERN ACROSS THEIR TOPS LEAVING NO VISUAL CUES TO RECOGNIZE THE WORDS EASILY.

Text is usually the most readable when set in a medium weight. If the font is too light, it becomes hard to distinguish it from the background. If it is too bold, the counter forms may be too small, causing loss of legibility. Fonts with extremely thick and thin strokes are also less legible. Thin strokes are hard to see and thick strokes decrease the counter spaces. When using them in long passages of text, fonts with greatly contrasting strokes create a sparkle effect that makes reading difficult.

Italic fonts also slow reading speed and should not be used for long blocks of text. Their purpose is to provide emphasis when used sparingly. There should be a little more leading to improve readability with italics.

T I S

Script fonts can be extremely illegible, especially the capital letters like T, I, and S.

ITALICS
slow the reading process and should not be used for long blocks of text. Their purpose is to provide emphasis.

Italics are harder to read not only because of the slant to the letters but also the decorative characteristics that many of the letters have.

Readability (blocks of text)

Refers to how easily words, phrases, or blocks of text can be recognized and read. It is dependent on how type is arranged on the page and the evenness of the tone of gray the text creates on the page. Readability is the quality that makes a page inviting and easy to read. The goal is to create an even texture of gray, with even line spacing that does not have dark and light areas to distract the reader's eye from the words or create stops in the reading process. A conscious awareness of the typography can slow reading speed and impede comprehension. The typography itself should be transparent, almost invisible, to the reader.

Research has found that we read in a series of eye fixations; that is, we read a group of words with one eye span then shift our eyes along the line to another group of words.

Readability of text blocks has been shown to be better when set in serif type because it's easier to read in large amounts of text due to the fact that the serifs are horizontal strokes, which tend to help horizontal eye movement. However, there is no evidence that sans serif type decreases legibility,

No art can live by merely reviving and reproducing past forms, and in reviewing the share taken by the type-founders of the past and of the present in the art of the book one cannot help considering by what means and from what quarter good types are to be designed and cut in the future. We have seen that the early printers took their inspiration from the best of the contemporary book-hands.
The invention of printing, however, killed the art of the scribe, and with it perished the source whence during the ages past life and beauty had been given to the letters of the alphabet.

12/13 Myriad Pro Condensed, +20 tracking

No art can live by merely reviving and reproducing past forms, and in reviewing the share taken by the type-founders of the past and of the present in the art of the book one cannot help considering by what means and from what quarter good types are to be designed and cut in the future. We have seen that the early printers took their inspiration from the best of the contemporary book-hands. The invention of printing, however, killed the art of the scribe, and with it perished the source whence during the ages past life and beauty had been given to the letters of the alphabet.

11/14 Myriad Pro Condensed, +20 tracking

No art can live by merely reviving and reproducing past forms, and in reviewing the share taken by the type-founders of the past and of the present in the art of the book one cannot help considering by what means and from what quarter good types are to be designed and cut in the future. We have seen that the early printers took their inspiration from the best of the contemporary book-hands. The invention of printing, however, killed the art of the scribe, and with it perished the source whence during the ages past life and beauty had been given to the letters of the alphabet.

11/13 Myriad Pro Condensed, +20 tracking

Three samples of a paragraph set in the same font and same column width but in different point sizes and amounts of leading.

Text from *The Art of the Book: A Review of Some Recent European and American Work in Typography, Page Decoration & Binding*, Bernard H. Newdigate, Douglas Cockerell, L. Deubner, E. A. Taylor.

and because of these typefaces' simpler letter shapes, some studies have proven them to be slightly more legible than serif typefaces. It seems to be more of a case of what the reader is used to reading.

Point Size Text type is most readable at normal reading distances when it is set between 8 and 12 points, depending on the font and the size of its x-height. If the type is too large (above 12 points), it is hard to read because your eye tends to stop on sections of words, interrupting the flow of reading. If it is too small, the reader won't be able to see it clearly and will not be able to distinguish individual letters from one another. You should set samples of the typeface in different point sizes and leading amounts to determine which one is best for that font in the column width you are using.

HYPHENATION AND LINE BREAKS
Justification Settings

Both Hyphenation and Justification have option panels, hidden in the Control Panel menu, that allow you to specify whether to hyphenate words at all, how to break words, and what the variance in word and letter space

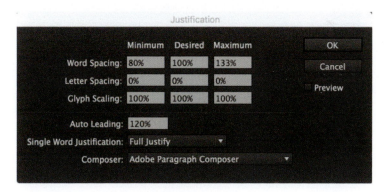

Default Justification settings on the Justification Panel
Highlight the text to be fixed, then apply the default justification settings by pressing OK. If that doesn't work, you can make gradual adjustments to the numbers until it does.

should be in justified text. The default settings for the justification options are shown below, and by applying these, you may be able to get rid of a lot of the bad spacing in justified text.

Hyphenation Settings

In justified text, having hyphenation turned on helps to limit the word space variations from one line to the next. In flush-left text, it helps to achieve a more even right rag. On the Hyphenation Panel, the Hyphenation Zone (for unjustified text only) is measured from the right edge of the column and helps control the raggedness of the right side of the text column.

Two successive lines ending in a hyphen is undesirable, and there should be no more than three hyphens in a paragraph. If the text has too many hyphens, an adjustment needs to be made in some way. As always, there may have to be exceptions to the rules, depending on the situation. There should be a minimum of two letters preceding a hyphen and three after. You also can check the Balance Ragged Lines function, under the Control Panel menu, to achieve a more even rag. You shouldn't allow capitalized words to break and don't hyphenate a head or subhead.

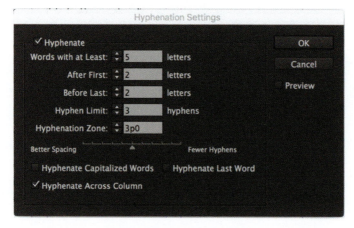

In the Hyphenation settings, you can set values for the smallest breakable word, a minimum number of characters to fall before and after a break, and also specify the number of hyphens allowed in a row. Also, keeping the "Hyphenate Capitalized Words" unchecked will prevent proper names from being hyphenated.

How to Avoid Bad Line Breaks

Connect mathematical, numerical expressions, and proper names with nonbreaking space (command + option + X) so they will not be hyphenated at the end of a line. To prevent any of the words in a phrase, or group of words, to hyphenate at the end of the line, select the range of text and apply No Break to it. No Break also is found on the Control Panel menu.

Fixing Bad Breaks

- Use a *Soft return* (Shift + Return) to move a word (or words) down to the next line without creating a new paragraph.

- *Discretionary hyphens* (Command Hyphen) will manually break words at the end of a line. (Putting a Discretionary hyphen in front of a hyphenated word will cause the word not to hyphenate at all. Use it to remove inappropriate hyphens, such as those in proper names, etc.)

- Use a *Nonbreaking space* (Command + Option + X). It is the same width as a space created by using the space bar but prevents two words from being split up at the end of a line.

- You also can fix bad breaks by using negative tracking on the paragraph, in small amounts, say -10 or −20 in InDesign®. A small amount will not affect the overall color of the paragraph and is barely detectable.

We, therefore, the Representatives of the united States of America, in General Congress, Assembled, appealing to the Supreme Judge of the world for the rectitude of our intentions, do, in the Name, and by Authority of the good People of these Colonies, solemnly publish and declare, That these united Colonies are, and of Right ought to be Free and Independent States, that they are Absolved from all Allegiance to the British Crown, and that all political connection between them and the State of Great Britain, is and ought to be totally dissolved; and that as Free and Independent States, they have full Power to levy War, conclude Peace, contract Alliances, establish Commerce, and to do all other Acts and Things which Independent States may of right do.

Above is a sample block of text with no adjustments.
The sample at right shows three different ways to fix bad breaks. The characters shown in red are invisible when typed on your pages unless you choose to "Show Hidden Characters" under the Type menu.

Text is from The Declaration of Independence.

Discretionary Hyphen placed in front of "rectitude" to prevent it from hyphenating at the end of the line.

Soft Return used to force "Congress" to next line.

Nonbreaking space inserted between "Absolved" and "from" and "Great" and "Britain" to prevent them from being split at the end of the line.

We, therefore, the Representatives of the united States of America, in General Congress, Assembled, appealing to the Supreme Judge of the world for the rectitude of our intentions, do, in the Name, and by Authority of the good People of these Colonies, solemnly publish and declare, That these united Colonies are, and of Right ought to be Free and Independent States, that they are Absolved from all Allegiance to the British Crown, and that all political connection between them and the State of Great Britain, is and ought to be totally dissolved; and that as Free and Independent States, they have full Power to levy War, conclude Peace, contract Alliances, establish Commerce, and to do all other Acts and Things which Independent States may of right do.

WIDOWS AND ORPHANS

A single word, or part of a word, by itself on the last line of a paragraph is known as a *widow*. Ideally, it is best to have at least three words in the last line of a paragraph. Leaving a widow on the last line of a paragraph creates the appearance of too much white space between paragraphs or at the bottom of a page.

The last line of a paragraph appearing at the top of a column or page, or the first line of a paragraph left at the bottom of a column or page, is called an *orphan*. You should have at least two whole lines of text at the bottom or top of a column or page.

You must make adjustments to the text to get rid of widows and orphans. To fix or adjust orphans in InDesign®, choose Keep Options from the Control Panel menu. Check the Keep Lines Together box. The start and end values will let you specify how many lines must stay together at the start or end of a paragraph. Keep at least two lines at the start and end of a paragraph.

Widows can be fixed by: decreasing or increasing the tracking in the paragraph (limit the tracking to +20 or −20 since any more will start to change the color of the paragraph); inserting a nonbreaking word space (Command + Shift + X) between the last word of a paragraph and the word before it; or re-ragging lines of the paragraph by using soft returns.

When the last line of a paragraph contains less than three words, it is called a widow. ← Widow

of a page. ← Orphan

A short line at the beginning of a column or page is called an orphan.

A first line of a paragraph at the bottom of a page or column is also an orphan.

Orphan → There should be at least two full

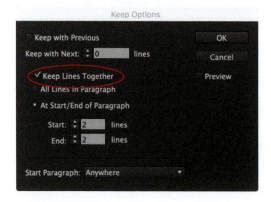

Keep Options Panel

Exercise: Text Setting and Readability

The purpose of this exercise is to become familiar with setting text blocks—type styles, point sizes, leading, and best settings for readability. The goal is to find a point size and leading amount in the typeface and column width you choose that allows for easy reading at arm's length.

If text is too tight between the lines, readers will lose their place and the legibility of the letters and words will be diminished. Type set too loose between lines can create stripes of the text and cause readers to lose their place from line to line.

Too short a line length allows only a few words to fit on each line, creating too many hyphens and a bad rag. Too long a line length makes it hard for readers to find their way to the next line.

Format

In InDesign® set up a document with a page size of 8½″ × 11″ with 3-pica margins on the top and bottom, a 6-pica margin on the inside, and a 7-pica margin on the outside. Specify 6 columns with the default gutter measurement. Each column will measure 6 picas across.

Part 1

Use the paragraph of text provided.

The typeface is Times New Roman.

Page 1/narrow width

1. In your InDesign® document, on the first page, draw a text box that measures 14 picas (across two columns) in width, and from the top margin to the bottom margin (the inside lines) in depth. Draw another text box in the next two columns, and also one in the last two columns.

2. Copy and paste your text block into the first text box, then change the typeface to Times New Roman regular weight, flush-left alignment.

3. Set this paragraph in the following point sizes and amounts of leading in these three columns:

7/8 Times New Roman × 14 pi	10/11 Times New Roman × 14 pi
7/9 Times New Roman × 14 pi	10/12 Times New Roman × 14 pi
8/9 Times New Roman × 14 pi	11/12 Times New Roman × 14 pi
8/10 Times New Roman × 14 pi	11/13 Times New Roman × 14 pi
9/10 Times New Roman × 14 pi	12/13 Times New Roman × 14 pi
9/11 Times New Roman × 14 pi	

Below each paragraph, type the point size, leading, typeface, and column width in a contrasting font in 6 or 7 point.

Page 2/average width

1. On the second page of your document, draw a text box across the first three columns, measuring 22 picas in width. Draw another text box across the last three columns on the page.

2. Set the paragraph in the following point sizes and leading amounts:

9/11 Times New Roman × 22 pi	12/13 Times New Roman × 22 pi
10/12 Times New Roman × 22 pi	12/15 Times New Roman × 22 pi
11/12 Times New Roman × 22 pi	14/16 Times New Roman × 22 pi
11/13 Times New Roman × 22 pi	

Below each paragraph, type the point size, leading, typeface, and column width in a contrasting font in 6 or 7 point.

Page 3/wide width

1. On the third page, draw a text box across the first five columns, which will measure 37 picas across.

2. Set the paragraph in the following sizes and leading amounts:

 10/13 Times New Roman × 37 pi 12/14 Times New Roman × 37 pi
 11/13 Times New Roman × 37 pi 12/15 Times New Roman × 37 pi
 11/14 Times New Roman × 37 pi

Below each paragraph, type the point size, leading, typeface, and column width in a contrasting font in 6 or 7 point.

Part 2

Repeat again using Helvetica Regular in place of Times New Roman.

On each page, indicate the best, second best, and worst settings for the column width. Be prepared to discuss your choices in class.

Part 3: Paragraph Settings

Using the text that has been provided to you which contains five paragraphs, copy and paste this text into a new InDesign® document.

Sample Paragraph Settings

Harpers Ferry and Gettysburg, shows use of text case and color change to separate information.
Designed by Frank DeBose.

Format

In InDesign® create a document with an 8½″ x 11″ page size, with one inch margins on all sides, and 6 pages in the document. Pick either a serif or a sans serif typeface from the font set. You will use this typeface for all your explorations.

Using all five paragraphs on each page, and a point size of 9 or 10 point with appropriate leading, show four different variations for paragraph delineation. You are not allowed to use normal paragraph indents or spaces between paragraphs. Create alternate ways of separating paragraphs, ranging from conventional to completely outrageous. Notice how the different settings affect readability.

Sample Text Settings

The earliest printed books, such as the Mainz Bible and Psalters, were printed in Gothic letter, which in its general character copied the book-hands used by the scribes in Germany, where these books were printed. In Italy, on the other hand, the Gothic hand did not satisfy the fastidious taste of the scholars of the Renaissance, who had adopted for their own a handwriting of which the majuscule letters were inspired, or at least influenced, by the letter used in classical Rome, of which so many admirable examples had survived in the old monumental inscriptions.

[The page shows multiple sample text columns repeating the above paragraph at various type sizes, with labels including: 7/8, 9/10, 7/9, 8/9, 8/10 Times New Roman x 14 pi; 8/11, 9/10, 10/11, 11/12, 12/13 Times New Roman x 14 pi; 9/11, 10/12, 11/12, 11/13 Helvetica x 22 pi; 12/13, 12/15, 14/16 Helvetica x 22 pi; 10/13, 11/13, 11/14, 12/14, 12/15 Times New Roman x 37 pi. Labels marked: BEST, SECOND BEST, WORST.]

05.
Setting Display Type

SELECTING DISPLAY TYPE FOR LARGE POINT SIZES

Display type uses many of the same design principles as text type, but since its primary purpose is to attract attention, additional factors must be considered, especially, its usage and its audience.

Also, consider the relationship between the text type and the display type. If a harmonious relationship is desired, select type from the same family as the text type for the heads, but set it larger and in a bolder weight. For contrast, use a typeface from a different family of type, but make the contrast obvious—a bold sans serif with a roman serif text font, a bold serif with a roman sans serif text font, or a decorative font with either a serif or sans serif text font.

KERNING

Kerning is the adjustment of space between two letters to create a visually even texture and color between all characters, and improve readability. With metal type, notches were cut out of the metal blocks to allow the letters to fit more closely together. With digital type, kerning space is measured in percentages of an em.

Because of inconsistent letter spacing, words in all caps need spacing adjustments in order to look like the letters are evenly spaced. You must open up some letter combinations and tighten others. Certain letter pair combinations will not achieve equal optical spacing. In these cases, the only option is to open up the entire line so that all spaces match the widest space, like "TY" and "TT."

Considerations

We see and read letters through contrast, which consists of the background and the object that is against the background. The most common form of this

is black letters on white paper. Since letters are not solid shapes, but shapes made up of various thicknesses of lines, we can see through them. There is space inside of them as well as between them. When you space type, you take into account the space inside of the letters (the counters) and the space outside of the letters. If you take out all of the space between the letters, you lose the spatial balance and the words become harder to read.

Guidelines

Think of the distance between two straight-sided characters as one value. The distance between a straight and round character should be slightly less than two straight characters to look visually similar. The distance between two round characters is slightly less than a straight and a round for the same visual similarity.

Straight-sided serif characters shouldn't touch each other, nor should two round characters. Don't over-kern. Too tight is worse than too loose.

One way to help with letter space adjustments is to imagine a colored

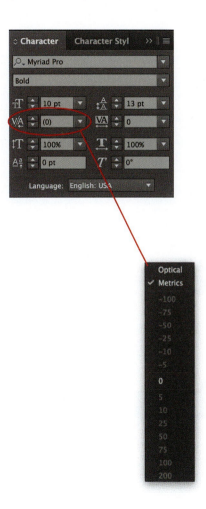

liquid being poured into the spaces between the letters. Then adjust the letterspacing so it appears that there is the same amount of liquid between each letter. Look at the type on paper (make laser prints), not on the computer screen. To see the spaces in a more abstract way, either hold the page upside down, or squint slightly, to figure out which spaces need adjustments. This way, you are not looking at letters but abstract shapes and spaces.

InDesign®'s Auto Kerning

InDesign® has two kinds of auto kerning methods: Metrics and Optical. Either one works well at small point sizes, and you can apply them as part of a style sheet definition.

Metrics Kerning Uses the metrics values built into the kerning pairs contained in a font. Most fonts have them, but often the inexpensive, or free fonts found online, do not. They are value instructions to adjust the space between certain letter combinations, which were determined by the designer.

Optical Kerning Adjusts space between adjacent letters based on their shapes. It ignores kerning pairs. Optical kerning should give more consistent spacing because every pair of letters is kerned based on the letter shapes. Some common kerning pairs are: LA, To, Tu, Ty, WA, Wo, Yo.

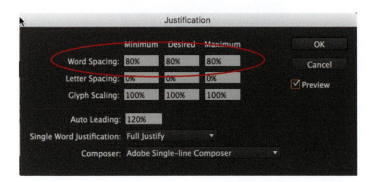

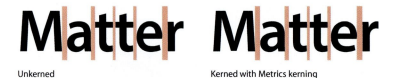

Unkerned

Kerned with Metrics kerning

Kerned manually

Kerned with Optical kerning

For either manual or optical kerning, place the type cursor between two letters and select either Metrics or Optical. Then use the arrows or drop-down menu to select a positive or negative number.

Manual Kerning in InDesign® To kern manually (display sizes, 14 pt or larger), insert the cursor between two letters and press Option + left or right arrow to decrease or increase the space between the two letters. You will see the number go up or down in the kerning menu as you press the arrow. This method uses the measurements set in your Units and Increments preferences—the default setting being 20/1000 of an em (based on an em square of 1000 x 1000 units, which postscript fonts are designed in). Most of the time, this is too big of a space increment. You might want to bring it down to 5 or 10/1000 of an em in the application preferences.

ADJUSTING WORD SPACES

The word space (the amount of space added by pressing the space bar) is a fixed value dependent on the point size and width of the lowercase i. It can appear too large or too small sometimes. If only some of the spaces need adjusting, you can kern the word spaces as you would the letter spaces by

Type and Typography

40 pt Centennial Roman with no word space adjustment. There seems to be a little too much space between the d in the word and, and the T in Typography. The space between Type and and also can be adjusted a little.

Type and Typography

40 pt Centennial Roman with manual kerning done on the word spaces.

Type and Typography

40 pt Centennial Roman with word space adjusted using the Justification menu. Minimum, Desired, and Maximum word spacing was set to 80% on all three.

using the keyboard commands, or kerning menu. Even if you are not using justified text alignment, you can use the Justification menu to set word space amounts for a range of text in any alignment.

LINE SPACING DISPLAY TYPE

Headlines or display sizes can have less leading than blocks of text. With upper and lowercase type, some lines may have few or no ascenders and descenders, while others have many. Lines with no ascenders and descenders, such as those set in all caps, will appear to have more space below them.

In general, as type gets larger, the negative spaces associated with line space and letter space appear progressively too large. All caps can be set with little or no leading, if necessary, because they have no ascenders or descenders.

There are some instances where the leading can become inconsistent within a paragraph. The height of the line space is determined by the largest point size of type on that line. There are a couple of ways to fix this.

1. In the text preferences, check Apply Leading to Entire Paragraphs. This will ensure that only one leading value will be applied to any paragraph.

Mention this ad and you can get 3 FREE ISSUES of this magazine!

Text set with consistent leading, 24/27, but the line space of middle lines looks too tight because of the capitals. The first two and the last two look too large.

Mention this ad and you can get 3 FREE ISSUES of this magazine!

When the leading is adjusted 20/26, 20/27, 20/28, and 20/26, the lines look optically even.

2. In some cases, you will want to have control over the leading in each line. In this case, you don't want to use the Type preferences. You can manually adjust individual lines of leading to achieve the right optical leading amount. In order to do this, you have to put soft returns at the ends of the lines you want to change.

BREAKING LINES

Headlines or titles must be broken so that they make sense when read—line breaks should be determined by rules of grammar and by the shape formed by the lines of type. You shouldn't have hyphens or widows in titles or headlines.

Keep adjectives with their nouns, break after punctuation, keep proper names or hyphenated words on the same line, etc., and don't allow hyphens in subheads. Keep the lines as balanced as possible—avoid very short lines, widows, and unbalanced lengths. You can use the Balance Ragged Lines function on the Paragraph menu as a start. When in doubt, or if you must break a proper noun or name, do it between the names and consult *Merriam-Webster's Collegiate Dictionary* for proper breaks.

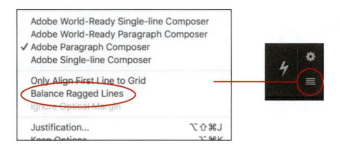

The Wonderful Wizard of Oz

Title as set in the column measure with no hyphenation.

The Wonderful Wizard of Oz

Title rearranged by applying the Balance Ragged Lines feature.

Unexpected line breaks not related to the ones you are making manually in a paragraph are usually caused by the default setting in the Adobe Paragraph Composer. To correct this, highlight the text box or paragraph and change the setting to Adobe Single-Line Composer.

VERTICAL ALIGNMENT

When display type is set flush left, the vertical alignment of the first letters of each line may seem irregular, especially if they are capital letters. Letters with straight vertical strokes align perfectly, but irregular letters like A, T, V, and O will seem out of alignment even though they are set mechanically correct.

In InDesign®, you can optically align type by highlighting the block of type and going to Type>Story and checking the Optical Margin Alignment box. The font size in the box should be the same size as the text, but it could vary as needed. It's best to eyeball it.

The Problem For Alignment in Larger Settings

No adjustment.

The Problem For Alignment in Larger Settings

Adjusted using Optical Margin Alignment.

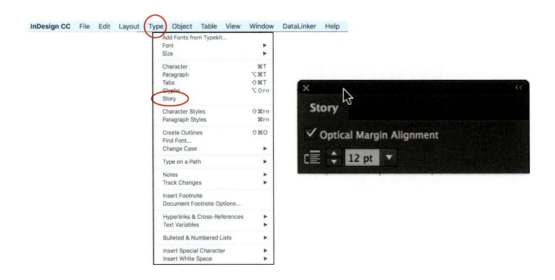

Exercise: Kerning Type

The term "kerning" refers to the removal of space between two letters, as opposed to "letterspacing," which refers to adding space between letters. The term kern comes from a German word meaning "to cut away" and dates back to the earliest days of metal type where parts of the metal block containing a type character were cut away to allow certain letters with sloped strokes or crossbars to fit more closely together.

Display type almost always has to have some adjustment made to certain letter pairs in order for the word(s) to look evenly spaced.

The following exercise will help you learn how to adjust space between letter pairs and how to recognize where adjustments need to be made. This is a learned skill that takes practice to develop good optical judgment.

Process

Create an InDesign® document with an 8 ½″ x 11″ page size with 1″ margins on all sides. Set the following words as specified, flush left on the left margin with at least three line spaces between each line. You will need to go to a second page to fit all the words.

Set your name in 11 pt type in the top right corner of the page.

Champion	60 pt Adobe Caslon Regular, initial cap
Banjo	48 pt Adobe Caslon Regular, initial cap
Adversary	60 pt Helvetica Bold, initial cap
WINDOW	48 pt Univers Bold, all caps, +60 tracking
HAMBURGER	60 pt Garamond, all caps
hamburger	60 pt Garamond, all lowercase
March 12–23, 1995	48 pt Adobe Caslon Regular, initial cap, Old Style numerals, with an en dash not a hyphen (Option+Hyphen)
Little	60 pt Adobe Caslon Regular, initial cap
ADJUST	60 pt Univers 55 Roman, all caps
Yawning	48 pt Bodoni BE Medium, initial cap
1772–1946	60 pt Garamond Semibold, with an en dash not a hyphen (Option+Hyphen)

Tips

• First, you will need to print out the page, look at the space, make adjustments, and print it out again, as many times as necessary until the words look right.

— The computer screen is never accurate for proofing spacial elements, so you always have to print out your page(s) to proof. The printouts always look different from the computer screen.

- Adjust tracking, if necessary (all caps), before doing any kerning.

- Letters are a combination of straight, rounded, and diagonal strokes. A way to start kerning is to consider the space between two straight strokes as one unit, the space between a straight and round stroke as slightly less than one unit, and the distance between two round strokes even less than between a straight and round stroke. Diagonal strokes are more difficult and require more attention, so do not use them as a marker for spacing the entire word.

- Place the cursor between the two letters you want to adjust space between. Use the arrows or type in a number in the kerning window.

 — You also can use the keyboard: place the cursor between two letters, hold down Option, and use the right or left arrow key to adjust the space. This will move the space by 20 in either direction.

- Kern between individual letter pairs, or open the space between individual letter pairs, where necessary to achieve optically even spacing in the entire word.

- Don't use the tracking menu on the Character palette for adjusting the space between two letters; use the kerning function.

- Don't use the default Metric or Optical kerning for display type. They adjust the spacing between letters based on their shapes. Manual kerning gives you more control.

- Squint when looking at the word to focus on the spaces and not the characters themselves.

- Turn the page upside down to focus on the forms and not the meaning of the words. The words become more abstract to enable you to focus on the white and black areas.

- Don't zoom in too much when kerning or the spaces will appear much larger than the true space.

- Less is more. Don't overkern.

- Don't kern the entire word. Only adjust space between the letters that need it.

- A cap and lowercase letter next to each other almost always need adjustment.

- Lining numbers, especially number 1, always need adjustment because they are monospaced.

You can continue to practice your kerning by playing the online game "Kern Type," at type.method.ac.

Champion

Banjo

Adversary

WINDOW

HAMBURGER

hamburger

March 12–23, 1995

Little

ADJUST

Yawning

1772–1946

Student kerning exercise.
Riley Gill

06.
Other Typographic Elements

LIGATURES

Ligatures are two or more characters that are joined to form a single character. They are meant to replace certain letter pair combinations that space poorly when typeset next to each other, such as fi and fl.

A ligature that has evolved into a glyph itself is the ampersand (&), which is the abbreviation of *et*, the Latin word for "and." It is the corruption of the phrase "and per se & (and)" meaning "and intrinsically the word and represented by the symbol &." The writing of it can be traced back to the 1st century A.D. in Roman cursive where the letters e and t were written together to create a ligature. It evolved over the next centuries to what it is today. The illustration below shows this evolution.[1]

Adobe Caslon Ligatures

Myriad Pro Ligatures

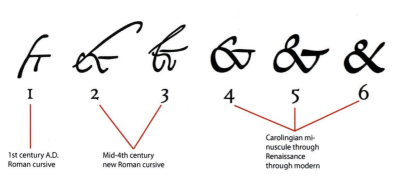

1 2 3 4 5 6

1st century A.D. Roman cursive

Mid-4th century new Roman cursive

Carolingian minuscule through Renaissance through modern

Evolution of the Ampersand.

1 Text and illustration on the history of the ampersand from *Wikipedia*, "Ampersand," last modified December 20, 2016, en.wikipedia.org/wiki/Ampersand.

Ligatures are used to keep different parts of characters from running into and/or overlapping each other when trying to set them properly. Set the type first without ligatures and replace letter pairs where necessary with ligatures in order to keep the space and color of the text even.

You can either manually insert the ligatures from the Glyphs window or turn on Ligatures in the Character menu. Even if Ligatures are turned on, you can still add additional ones manually.

Some fonts are designed with many ligature combinations not usually found in most typefaces. (Mrs Eaves is an example of one of these typefaces.) These fonts are meant to be used with ligatures turned on for special uses, so use accordingly. You also can use them without the ligatures turned on.

NUMERALS

Lining numerals or numbers, also called lining figures (12345), when used within text blocks can be distracting—they stand out too much because they are the same height as the capital letters. Lining figures are also called "tabular" figures because they have the same character width (the width of the numeral itself plus equal space on both sides of it). This is to enable them to

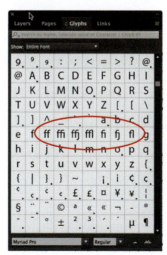

Glyphs panel.

align vertically when set in columns for tables. Because of this, the number 1 seems to "float" when placed in most other situations. In most instances, you will have to kern the space around the number 1, and sometimes around other numbers, as well.

If you want the numbers to blend in with the text, you need to choose a font that includes Old Style numerals, or non-lining figures (12345). These are numbers that contain ascenders and descenders, and are as high as the x-height, allowing them to blend in with the lowercase letters. Old Style figures are often combined with small caps for the same reason (400 BC).

Today there are typefaces that have tabular versions of the non-lining figures. Some typefaces have three-quarter-height figures (Monotype Bell), and almost-lining figures with very slight extenders (Miller). There are also typefaces that contain proportional figures. These are figures whose character width is that of the numeral plus a small amount of white space on each side. They can be lining or Old Style figures. Their varying widths make them more even in color when set in text and are not intended to be used in tables because they won't align vertically.

$2,500,000	$2,500,000
150,000	150,000
200	200
1,700	1,700
$2,651,900	$2,651,900

Example of tabular number setting showing how lining figures align in vertical columns.

The same numbers set in Old Style, or non-lining figures. The unequal letter spaces do not allow them to align vertically.

Some typefaces have three-quarter-height figures 12345, which enable them to blend in better with the text surrounding them.

Monotype Bell showing its three-quarter-height numbers.

SMALL CAPS

Used for:

- Acronyms and abbreviations (FBI, CIA, CBS), initials, historical designations (BC, AD), etc., where regular caps would be too large for the text around them.

- Traditionally they are used for AM and PM. There should be a space after the number, and usually no periods—10:00 AM.

Avoid using the small caps style command to create your small caps. All this does is shrink the full-size capital letters by a certain percentage, creating small, lightweight caps that don't match the weight of the rest of your text. Most open type fonts contain small caps. Use these whenever possible because they have been properly designed to match the x-height, and with stroke weights that match the weight of the lowercase and full caps of the same font.

An acronym is an abbreviation formed from the initial letters of compound words and pronounced as a word itself. Common acronyms are: NATO, ASCII, WYSIWYG. Also abbreviations formed from initial letters, such as, FBI, CIA, and RSVP.

Text set with capital letters for the acronyms. The acronyms stand out too much from the rest of the text and have too much emphasis.

An acronym is an abbreviation formed from the initial letters of compound words and pronounced as a word itself. Common acronyms are: NATO, ASCII, WYSIWYG. Also abbreviations formed from initial letters, such as, FBI, CIA, and RSVP.

The same block of text with small caps replacing the capitals which blend in better with the lowercase letters.

PUNCTUATION

Use only one space after any punctuation mark in a sentence. The practice of using two spaces after a period started with the typewriter. Typewriter characters are monospaced, meaning all of the characters have the same space on both sides, making it hard to see the ends of sentences. In typesetting, this practice creates holes in the text.

Typographer's Quotes

Always use proper quotation marks and apostrophes instead of the typewriter marks found on the keyboard. By default, typographer's quotes are on in the Type preferences. They are also an option in the Text Import options when using the Place function for importing text.

 Commas and periods go inside quotation marks; colons and semicolons go outside the quotation marks. Question marks and exclamation points should be outside the quote marks unless they are a part of the quote. For instances where you have actual feet, inches, seconds, and minutes, and need the prime marks, they can be accessed from the Glyphs panel.

After a time, she heard a little pattering of feet in the distance and she hastily dried her eyes to see what was coming. It was the White Rabbit returning, splendidly dressed, with a pair of white kid-gloves in one hand and a large fan in the other. He came trotting along in a great hurry, muttering to himself, "Oh! the Duchess, the Duchess! Oh! won't she be savage if I've kept her waiting!"

Double spaces create holes in text.

After a time, she heard a little pattering of feet in the distance and she hastily dried her eyes to see what was coming. It was the White Rabbit returning, splendidly dressed, with a pair of white kid-gloves in one hand and a large fan in the other. He came trotting along in a great hurry, muttering to himself, "Oh! the Duchess, the Duchess! Oh! won't she be savage if I've kept her waiting!"

Single spaces do not create holes in text.

Place options menu which comes up when you are placing text in an InDesign® document.

"Oh! the Duchess, the Duchess! Oh! won't she be savage if I've kept her waiting!"

Keyboard quotation marks.

"Oh! the Duchess, the Duchess! Oh! won't she be savage if I've kept her waiting!"

Typographer's quotation marks.

Typographers' quotation marks can also be accessed using the keyboard.

Opening Single Quote	Option +]
Closing Single Quote	Option + Shift +]
Opening Double Quote	Option + [
Closing Double Quote	Option + Shift + [

Hanging Punctuation

In a block of copy aligned flush left, punctuation like apostrophes and quotation marks, occurring at the beginning of a line, make the line appear to be slightly indented, which disturbs the alignment. The same thing could occur at the end of a line of flush-right text.

In order to preserve the visual alignment, extend the punctuation beyond the margin a bit to optically make the copy look aligned. This can be accomplished with the Optical Margin Alignment function. Select a text frame where you want to hang the opening quotation mark, for example, then choose Type > Story and check Optical Margin Alignment and set the amount of overhang (usually the same point size as the text, but you may have to play with it a little).

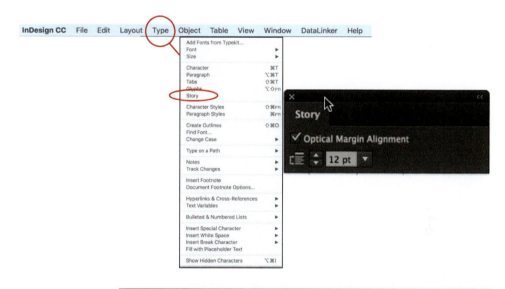

"To hang punctuation manually, you can use the Tabs panel, which offers more control over the spacing, moving the left indent to the right and setting the first-line indent the same negative amount, then placing a left tab on the left indent.

Using the Tabs panel to hang punctuation offers more control over the amount of space between the punctuation and the text.

Another way to hang punctuation is to use the Indent to Here function by placing the cursor after the quotation mark and going to Type > Insert Special Character > Other > Indent to Here, or typing Command + \. All subsequent lines of the paragraph will be indented to that point.

To hang punctuation manually, you can use the Tabs panel, which offers more control over the spacing, moving the left indent to the right and setting the first-line indent the same negative amount, then placing a left tab on the left indent.

In headlines, punctuation often appears too large. Commas, apostrophes, periods, quotation marks, etc., can be reduced a point size or two so that they look optically matched to the rest of the characters.

Hyphen/En Dash/Em Dash

Use hyphens, en dashes, and em dashes appropriately. Never use two hyphens instead of an em dash. Hyphens, en dashes, and em dashes should not have spaces on either side of them.

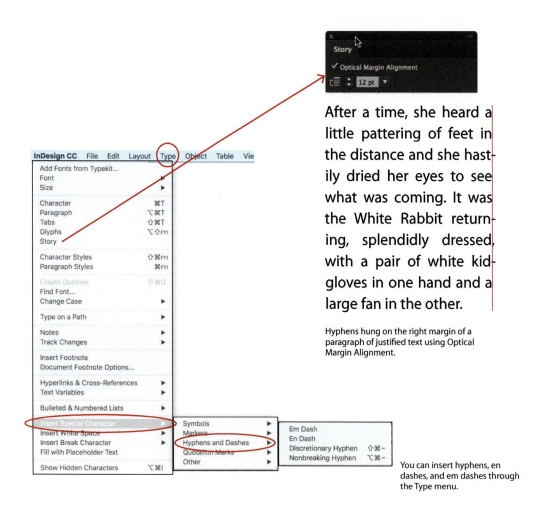

After a time, she heard a little pattering of feet in the distance and she hastily dried her eyes to see what was coming. It was the White Rabbit returning, splendidly dressed, with a pair of white kidgloves in one hand and a large fan in the other.

Hyphens hung on the right margin of a paragraph of justified text using Optical Margin Alignment.

You can insert hyphens, en dashes, and em dashes through the Type menu.

Hyphen (-) This is the shortest dash and is used for hyphenating compound words or line breaks. In the past, for *justified* text settings, the hyphens were hung in the right margin. This can be accomplished by highlighting the text or paragraph(s) and choosing Type > Story, then check Optical Margin Alignment.

Hyphens also are used in phone numbers where sometimes they may seem too low for the numbers (555-6666), so they need to be shifted up slightly using the Baseline Shift function on the Character panel (555-6666). This also applies to hyphens used with words set in all caps where the hyphen must be optically centered on the cap height because hyphens are set to be aligned with the x-height.

Discretionary Hyphen (Command + Shift + Hyphen) Used when you want to force a word to hyphenate at the end of a line, or break the word in a place other than that chosen by the software. It can also be used to prevent a word from splitting at the end of a line by placing it in front of the word you don't want to break. You can set one by placing the cursor where you want the Discretionary hyphen and using the keyboard command shown, or by going to Type > Insert Special Character > Hyphens and Dashes > Discretionary Hyphen.

We, therefore, the Representatives of the united States of America, in General Congress, Assembled, appealing to the Supreme Judge of the world for the rectitude of our intentions, do, in the Name, and by Authority of the good People of these Colonies, solemnly publish and declare, That these united Colonies are, and of Right ought to be Free and Independent States, that they are Absolved from all Allegiance to the British Crown, and that all political connection between them and the State of Great Britain, is and ought to be totally dissolved; and that as Free and Independent States, they have full Power to levy War, conclude Peace, contract Alliances, establish Commerce, and to do all other Acts and Things which Independent States may of right do.

Discretionary Hyphen used to force "British" to break and to prevent "Commerce" from hyphenating. The character will be invisible when typed on your pages unless you choose to "Show Hidden Characters" under the Type menu.

Text is from The Declaration of Independence.

Nonbreaking Hyphen (Command + Option + Hyphen) Nonbreaking Hyphens are used to prevent a line from breaking at the hyphen but will allow it to break in other places. This is useful for phone numbers or other hyphenated words you do not want to break at the end of a line. Use the keyboard command, or go to Type > Insert Special Character > Hyphens and Dashes > Nonbreaking Hyphen.

En dash – (Option + Hyphen) Half the size of an em dash, it is used between digits indicating a duration, such as hourly time, months or years, and stands for the word *to*. It may have a thin space on either side of it for a little room, but generally there are no spaces around it. They can be accessed by the keyboard command or going to Type > Insert Special Character > Hyphens and Dashes > En Dash.

Em dash — (Option + Shift + Hyphen) Roughly the size of an em space or the letter M, it is used to indicate a change in thought, or to separate a thought within a thought, which requires an em dash at the beginning and end of the phrase. There should be no spaces on either side of it, but a thin space may be added on either side based on visual preferences.

For questions or help with your new product, phone 555-666-2760, or email your questions to info@questions.com.

Nonbreaking hyphens prevent the phone number from breaking at the end of the line above.

April–May

8:30 a.m.–9:00 a.m.

6–9 years

En dashes used to indicate duration of time.

Let me see: that would be four thousand miles down, I think—' (for, you see, Alice had learnt several things of this sort in her lessons in the schoolroom, and though this was not a VERY good opportunity for showing off her knowledge, as there was no one to listen to her, still it was good practice to say it over) '—yes, that's about the right distance—but then I wonder what Latitude or Longitude I've got to?' (Alice had no idea what Latitude was, or Longitude either, but thought they were nice grand words to say.)

Em dashes are used to separate a thought within a thought in a sentence.

Three Em Dash—— Type three consecutive em dashes set with no spaces to form a longer midline dash. You may have to kern between the dashes to make a solid line. It is used in bibliographic listings to denote successive entries by the same author, editor, etc. The dash should be followed by a period or comma.

SPACE MARKERS

Different space characters can be inserted by going to Type > Insert White Space. Some also can be inserted by using key commands.

Em Space	Command + Shift + M
En Space	Command + Shift + N
Hair space	Command + Option + Shift + I

(1/24 the width of an em space)

Nonbreaking Space (Command + Option + X)

Measures the same width as a word space. Its purpose is to prevent two or more words from being broken between lines (for example, where you have a proper name that you don't want to be broken between two lines). It also can be gotten by going to Type > Insert White Space > Nonbreaking Space.

de Souzenelle, Annick. *La lettre, chemin de vie*. Paris: Albin Michel, 1993.

———. *Le symbolisme du corps humain*. Paris: Albin Michel, 1991.

Three em dash used in a bibliographic entry.

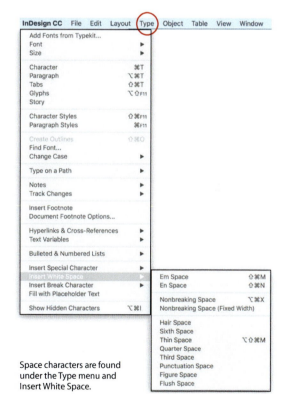

Space characters are found under the Type menu and Insert White Space.

Thin Space (Command + Option + Shift + M)
1/8 the width of an em space

Can be used on the sides of dashes, if some space is required, or between man-ually-made ellipses dots.

Punctuation Space

Equals the same width as a period, colon, or exclamation mark in the font. There are other spaces contained in the Type menu. Go to Type > Insert White Space and you will see a list of them. These spaces are referred to as fixed spaces because their width does not change unless the point size of the type changes.

FEET AND INCHES

Use double and single prime marks (″ ′), found in the Symbol font, for feet and inches, not the generic typewriter quote marks (" ') or typographer's quotes (" "). There should not be any space between the number and the prime mark. The key commands are Option + comma for the double, and Option + 4 for the single in the Symbol font.

12′ 5″ Proper Prime marks
 from the Symbol font.

12' 5" Keyboard single and
 double quotes.

12' 5" Typographer's quotes.

SUBTRACTION, MULTIPLICATION, AND DIMENSION SIGNS

For mathematical equations and specifying dimensions, use the genuine minus and multiplication signs. Don't substitute hyphens, en dashes, and lowercase *x*'s, even if using a serif font. They are located in Open Type fonts on the Glyphs panel or in the Symbol font. Mathematical symbols usually are preceded and followed by a space.

SUPERIORS / INFERIORS / ORDINALS

Most fonts contains some standard superscripts and ordinals, i.e., [2], [1], ®, ™, and expert fonts will contain subscripts, but you also can apply the superscript or subscript function to any character, although they will probably be lighter in weight than the rest of the characters in the font.

 These are the small glyphs, usually 50% to 70% of the point size being used, that align with the top of the ascenders (superscripts) or at the baseline (subscripts). The numbers are used for footnotes, mathematical equations, and numerators of fractions. You can specify the size and position in the Advanced Type preferences on the InDesign® preferences menu, but it's best to use the superiors contained in the font if you can.

$$4 \times 5 = 20$$

$$9 - 4 = 5$$

Adobe Caslon equations with the proper Caslon multiplication sign and minus sign from the Glyphs panel.

Rolo™, 22nd, 51st

Adobe Caslon with superscript glyphs from the Expert font set.

RoloTM, 22nd, 51st

Adobe Caslon with superscripts set by using the superscript menu function. The caps appear to be too large, and the others appear too light and small. Also, they are not in the right position on the line.

OTHER GLYPHS

Bullets • (Option + 8)

Bullets should be centered on either the cap height (if next to numbers or caps) or the x-height of the type, and followed by a space. Use the Baseline Shift function to center the bullets with the text surrounding them.

Ellipsis ... (Option + ;)

The ellipsis character consists of three evenly spaced dots and is used to indicate omissions in quoted text. It can be a word, a paragraph, or more. They also are used to indicate interrupted or suspended thought. If the ellipsis indicates omitted words, there is usually a space on either side. The three dots must always remain together on the same line. If the ellipsis is at the end of a sentence, type a normal sentence-ending period after the ellipsis, preceded by a space.

The ellipsis glyph is usually too tightly spaced. It is better to create your own by using periods separated by Thin spaces. Thin spaces are nonbreaking, so there is no chance of having the ellipsis break at the end of a line.

• apples
• oranges
• bananas
• grapes
• peaches

• apples
• oranges
• bananas
• grapes
• peaches

Bulleted lists set 14/20. On the left the bullets are 14 pt and sit properly centered on the line. On the right, the bullets were increased in size to 18 pt and needed to be lowered 1 pt using the Baseline Shift function so they sit properly centered on the line of type.

The problem ... is the dots are spaced tighter.

Example of ellipsis set by using Command + ;.

The problem...is the dots are spaced tighter.

Ellipsis made with periods and fixed thin spaces.

Parentheses ()

Parentheses are used to set items off from surrounding text. There are vertical and sloped (in italic fonts) parentheses. It is preferable to use the vertical ones, found in the roman fonts, even if the text they surround is set in italics. You also may need to add a thin space between the parentheses and the type they enclose if they are too tight, especially around italics.

Brackets []

Brackets are used to enclose text added by writers other than the original author of the text, and is not a part of the surrounding text. In quotes or other non-original material, they enclose explanations, foreign term translations, corrections, etc.

Braces { }

Braces (sometimes called curly brackets) are used in mathematical and other specialized texts.

Parentheses, brackets, and braces are used to group mathematical expressions. The order for them to be used is: {[()]}. Parentheses and brackets are

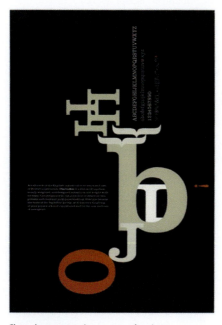

$$\{x_1, x_2, \ldots x_n\}$$

Braces enclosing a mathematical set.

Clarendon type specimen poster showing Clarendon's distinctive braces.
Designed by Dan McManus.

designed to be used with lowercase letters to bracket both the ascenders and descenders. When they are used with all caps or lining numbers, they sometimes appear to be set too low on the line. You can raise them a bit with the Baseline Shift function.

Virgule (/) and Solidus (/)

Fonts include two slashes of differing angles. The steeper slash is the virgule, made by using the slash key on the keyboard. It is used in dates (7/12/98) and within text in place of a comma or parentheses. The more angled slash is a solidus, or fraction bar ⅔ (Option + Shift + 1) and is used to construct fractions.

Fractions

Most fonts contain glyphs for common fractions (¼, ½, ¾), which can be found on the Glyphs panel. To manually make a fraction:

1. Type the numbers and fraction bar (Option + Shift + 1) without spaces between them (2/3).

2. In Advanced Type Preferences, set the superscript and subscript size to 60%, the superscript position to 33%, and the subscript position to 0.

3. Convert the numbers to superscript and subscript (²/₃).

4. Adjust the space between all characters as needed (⅔).

$$\frac{3}{4} \qquad \frac{5}{8}$$

Left: Myriad fraction from the Glyphs panel.
Right: Fraction made manually following the steps above.

Angled Brackets (<>)

The name for the "Less Than" and "Greater Than" mathematical symbols.

Dingbats

There are a number of fonts that do not consist of letters but contain pictogram glyphs. They contain such characters as bullets, check boxes, stars, crosses, and arrows. The most common of these fonts is Zapf Dingbats and Symbol.

Leaders

Leaders fill the distance between text and a tab. Leaders are set on the Tab Ruler. Highlight the text in which you want to put leaders. Open the Tab Ruler (Type > Tabs or Command + Shift + T). Click on the Right Tab Arrow, then click in the ruler (the space above the actual ruler) at the right margin, or wherever you want the leader to end. Then type a bullet or another glyph into the Leader box. If you want more space between the leader characters, type a space after the glyph.

Some sample glyphs from the Zapf Dingbats font.

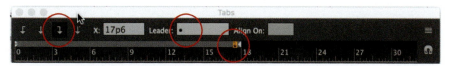

Tab Ruler showing settings for a dot leader.

Chapter 1..................3

Round dot leader.

Chapter 2 ---------- 8

Dashed leader.

STYLING URLs

Long URLs (internet addresses) can often be a problem in lines of text when they must be broken to fit the line length. One solution is to put the URL on a line by itself. If this isn't practical, you can break the URL after a slash or period, but do not add a hyphen. A broken URL can be set in italics or bold to help tie it together as a unit.

CHARACTER POSITIONS AND BASELINE SHIFT

The position of hyphens, en dashes, em dashes, and parentheses, when setting type in all caps, is set to align on the x-height of a font. You may need to adjust them so that they appear in correct alignment with the text around them. You can change the position of them by using the Baseline Shift function on the Character panel. Highlight the glyph you want to change and adjust the baseline position by putting a positive number in the box to raise it, or a negative number to lower it.

2012–2020
1776–1824
1776–1824

Lining numerals (top) and nonlining numerals (middle) with en dashes as typed. With the nonlining numerals, the dash looks too high. In the bottom example, the dash has been moved down a little using Baseline Shift.

KEY COMMANDS FOR COMMON CHARACTERS

Although any of these can be found on the Glyphs panel, sometimes it's easier to just use the keyboard commands to add something quickly as you type.

Bullet •	Option + 8
Copyright ©	Option + g
Trademark ™	Option + 2
Registered mark ®	Option + r
Degree symbol °	Option + Shift + 8
Cents ¢	Option + 4
Paragraph ¶	Option + 7
Division ÷	Option + /

Foreign Language Accents and Marks

Acute accent á	Option + e, then type the letter
Grave accent à	Option + ~, then type the letter
Umlaut ä ö ü Ë Ï	Option + u, then type the letter
Tilde ã	Option + n, then type the letter
Circumflex â	Option + i, then type the letter
Letter with ring above Å å	Option + a, or Option + Shift + A
Cedilla ç	Option + c
Uppercase cedilla Ç	Option + Shift + c
O with stroke Ø ø	Option + o, or Option + Shift + O
Spanish exclamation point ¡	Option + 1
Spanish question mark ¿	Option + Shift + /
left guillemet «	Option + \
right guillemet »	Option + Shift + \

When you first type the key commands for these accents, nothing will appear until you follow by typing the desired letter.

07.
Typographic Hierarchy

The purpose of typographic design is to organize all of the elements of a message into a unified and harmonious communication that allows the viewer to absorb the message in a logical order. This can be achieved either quietly by unifying similar elements, or more dynamically by using contrasts.

Visual hierarchy, grid structure, and context are the elements that form a composition and determine how well it conveys its message. Visual hierarchy refers to an ordering of parts that establish patterns similar to those found in nature and the arts.

Typographic hierarchy is established by the order of importance that elements are given on a page, based on their placement, size, and tone. Hierarchy determines what the reader's attention is drawn to first, depending on how the page is laid out, and which information the designer has given the most emphasis.

type The typographer's one essential task is to interpret and communicate the text.

Size: The most obvious way of emphasizing some elements.

The typographer's one *essential* task is to interpret and communicate the text.

Type

Typeface: Because of the difference in design between different typefaces, using two different ones can achieve emphasis.

The typographer's one

essential task is to
type
interpret and communicate the text.

Color: Using color and value contrasts is a good way to achieve hierarchical emphasis.

The typographer's one essential task is to interpret and communicate the text.

type

Direction: The direction in which elements appear to be moving can add emphasis.

134

Changes in size, contrast, texture, and relative position imply visual hierarchy and meaning that should echo the writing. A series of contrasts can be expressed as a series of visual relationships—large to small, dark to light, or blue to yellow. The distinctions among the parts must be deliberate and unambiguous to create the contrast.

As readers, we have learned to expect pattern. However, too much consistency can be boring and can cause the reader to lose interest. Elements such as subheads and large initial caps can provide sufficient variety to prevent this, and prevent large amounts of text from becoming tedious for the reader.

CHOOSING TYPEFACES

Your goal when choosing a typeface is to enhance the message you are trying to convey and influence how the audience is going to react to the text. Your typeface choice needs to have good legibility and also be appropriate for the audience and message.

Typefaces can convey a mood or personality, which also can reinforce the message being conveyed. Some typefaces, just from their use in certain situations or historical periods, have meaning attached to them. Some fonts may be associated with products or companies just from their use in advertising, logos, or on product packaging.

Examples of Type Characteristics

Name of Font	Style	Characteristics associated with the font
Adobe Caslon	Serif	high-quality, dependable, traditional, serious
Avenir	Sans Serif	contemporary, informal, common, trendy
Caslon Italic	Italic	warm, more lively than roman letters
Ehrhardt	Roman	stand-offish, less vitality than its italic version
ITC CHELTENHAM	Caps (Serif)	authoritative, formal
AVENIR	Caps (Sans Serif)	emotional, masculine, loud
Garamond	Lowercase	reasonable, quieter than caps
Centennial Bold	Bold	emotional, masculine
Univers Light	Light	high-quality, refined, classy, expensive, feminine
Bodoni Condensed	Condensed	upper class, snobby, aloof, high price

Appropriateness

The typeface you choose should be aesthetically appropriate to the message and for the audience it is intended for. Look at the characteristics of the typeface to decide if it is the right one to convey the message.

Mood

Typefaces have distinct characteristics that can evoke certain moods. When combined with the message to be conveyed, they can heighten the effect of the communication.

Technical Considerations

If your text contains a lot of numbers, you want to choose a typeface that contains the kind of numerals appropriate for the text—either Old Style (styled like lowercase letters) or lining figures (the height of the uppercase letters). Lining figures are better for columns of numbers or tabular material that have to align vertically. Old Style numerals work best within paragraphs of text.

If you intend to use small caps in your design, choose a typeface that contains true small caps. The same goes for ligatures, especially in large point sizes where ligatures help with letter-spacing issues.

Support	65,915		59,925
Grants		325,248	355,248
Federal Grants		265,331	265,331
Special Funds	90,238		92,238
Other	5,734		4,255

Lining figures work best in tables or charts because they align in vertical columns.

Some publications choose to capitalize only the first letter of acronyms, reserving all-caps styling for initialisms, writing the pronounced acronyms "Nato" and "Aids" in mixed case, but the initialisms usa and fbi in all caps. For example, this is the style used in *The Guardian*,[66] and BBC News typically edits to this style (though its official style guide, dating from 2003, still recommends all-caps[67]). The logic of this style is that the pronunciation is reflected graphically by the capitalization scheme.

Paragraph with small caps and Old Style numerals inserted to show how they blend in better with the rest of the text.

Some publications choose to capitalize only the first letter of acronyms, reserving all-caps styling for initialisms, writing the pronounced acronyms "Nato" and "Aids" in mixed case, but the initialisms "USA" and "FBI" in all caps. For example, this is the style used in *The Guardian*,[66] and BBC News typically edits to this style (though its official style guide, dating from 2003, still recommends all-caps[67]). The logic of this style is that the pronunciation is reflected graphically by the capitalization scheme.

The same paragraph without the caps and numbers being changed.

Guidelines

Hierarchy After analyzing your text, you should look for a typeface family that will cover the various elements—headings, subheads, callouts, captions—that are in your text. Can your choice provide enough weights and styles to cover the variations needed, or do you need to choose two or more typefaces?

Things to Avoid Don't use more than two or three typefaces in one design unless it is appropriate for the job. Avoid obvious and trite solutions. Don't use Comic Sans if your job contains humor.

COMBINING TYPEFACES

In every design, the elements must have a visual relationship. There are numerous ways in which to achieve this. The most reliable technique in typography is to use a "family" of type. Using related typefaces helps to avoid a chaotic effect that results from visually conflicting letter forms. Typeface choices also may be dictated by the need for special characters such as small caps, nonlining numerals, or mathematical symbols.

The easiest way to create contrasting relationships is to use different typefaces. The main thing to remember when choosing these typefaces is there must be a visual difference between them. Different typefaces are

CENTURY SCHOOLBOOK HEADLINE

A block of Caslon roman text used with a Century Schoolbook roman head.

16 pt Century Schoolbook head with 12/15 pt Adobe Caslon text. These typefaces are too similar to each other to show any contrast.

A HEAD IN UNIVERS

Helvetica roman text used with a Univers roman head.

16 pt Univers 55 head with 12/15 pt Helvetica 55 roman text. These typefaces are too similar to each other to show any contrast.

THIS IS ROCKWELL CONDENSED

Formata regular text used with a Rockwell bold head illustrating good contrast between the two typefaces.

16 pt Rockwell Bold Condensed head with 12/15 pt Formata text. These typefaces are different enough from each other to show a good contrast.

used to create emphasis or to visually separate a thought, phrase, or text. Choosing typefaces that are too close in style or design makes it hard to see enough of a difference to serve this purpose.

Typefaces can express emotions, or have associations with particular products, industries, or historical periods. These qualities can be utilized when choosing typefaces for a particular project. Some suggestions to consider when choosing typefaces:

1. It is better to mix obviously different typefaces rather than ones that are visually similar. Example: mixing Univers and Helvetica (both sans serif typefaces) probably just would look like a mistake and not create the desired effect.

2. Using fonts from one typeface family will ensure typographic harmony and still provide contrast, but by combining different typefaces you can add depth and interest to your design. It requires a balance of complementary and contrasting characteristics in the typefaces. Old Style typefaces tend to work well with some sans serif Grotesque typefaces like Franklin Gothic and Helvetica

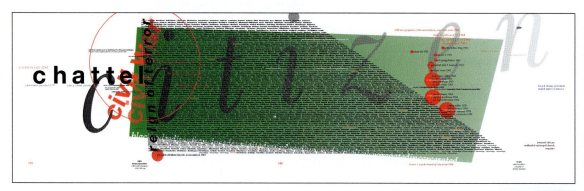

Property Citizen. This is a good example of mixing typefaces and hierarchy. Designed by Frank DeBose.

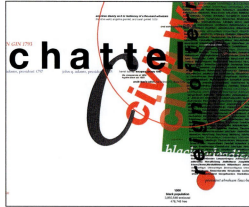

because Grotesque faces were designed by combining Old Style proportions and characteristics into simpler letter forms that have no serifs. Typefaces from each of these groups are very different yet share certain harmonious qualities.

3. Typographic settings for one typeface are not automatically correct for another, or even for different fonts in the same typeface. Set sample paragraphs and heads with various size and spatial settings before committing to one set of specifications.

TYPOGRAPHIC CONTRASTS

Serif/Sans Serif

The easiest way to combine typefaces is to use a serif font with a sans serif font. There are usually enough design differences between them to achieve the right contrast.

CASLON
FUTURA EXTRA BOLD

Similar characteristics, such as the circular quality of the O's, creates visual compatibility; the contrast of weights and size adds interest.

frutiger
BULMER REGULAR

As in the example above, a heavy condensed sans serif pairs well with a light serif font. The thin sharp serifs of Bulmer visually connect with the flat, square edges of Frutiger, making them a good match.

Helvetica
STENCIL

Some pleasing combinations happen by combining very different fonts, but it takes a lot of experience to know what works best.

TRAJAN
Shelley Script

A contemporary look can be achieved by mixing a hand-drawn font with a more elegant typeface.

Light/Heavy

A heavier, or much lighter, font creates strong visual contrast. Make sure to use a big enough weight change to achieve the contrast. Going to the next weight up from roman, say book or medium, usually will give a weak visual contrast.

Large/Small

Changes in point size create strong contrast. Reducing the size from large to small establishes a definite hierarchy.

Wide/Narrow or Regular/Condensed

There are typefaces designed with fonts of various widths, like Helvetica and Univers, which contain various condensed and extended fonts. Digital condensing or extending of a font using the Horizontal and Vertical Scale function is not acceptable because it distorts and degrades the letter forms.

An expanded headline font with an average-width text font creates a good contrast. For condensed or extended type, use the condensed or extended fonts, not the horizontal/vertical scale function found in software programs.

	Albertus	Caslon	Caxton	Garamond
Din	Din Albertus	Din Caslon	Din Caxton	Din Garamond
Helvetica	Helvetica Albertus	Helvetica Caslon	Helvetica Caxton	Helvetica Garamond
Univers	Univers Albertus	Univers Caslon	Univers Caxton	Univers Garamond

A type matrix like the one above can be used as a means of comparing typefaces to find a combination that works well together. The matrix can be any size depending on the number of typefaces you are considering.

Color

A paragraph can appear lighter or darker depending on the typeface used. To alter type color, change the line spacing, point size, justification, and/or tracking. You can accentuate the meaning of words by setting them in color (meaning red, blue, green, etc.).

The typeface you choose is important. Bold faces look best in larger sizes and can be printed in lighter colors or reversed out of a color; bold sans serifs and heavy serifs also work in these situations.

Display Fonts

Display versions of fonts have been specifically designed to be used in larger point sizes—they look more elegant in larger sizes (24 points or larger). Likewise, don't use display fonts for setting text type. They don't work well for small point sizes because they will appear to be too light due to their strokes and serifs being made slightly thinner.

After considering the audience, and once the design objective has been identified, the typeface choices can be narrowed down.

There was no possibility of taking a walk that day.
We had been wandering, indeed, in the leafless shrubbery an hour in the morning …

Putting Minion Pro (serif) with Helvetica (sans serif) is an easy way to show typographic contrast.

A breakfast-room adjoined the drawing-room, I slipped in there.
It contained a bookcase: I soon possessed myself of a volume …

Using different sizes of type shows a definite hierarchy.

I was glad of it:
I never liked long walks, especially on chilly afternoons: dreadful to me was the coming home in the raw twilight …

One typeface (Univers) but two fonts, light and black, show a definite contrast.

I mounted into the window seat: gathering up my feet, I sat cross-legged, like a Turk; and, having drawn the red moreen curtain nearly close, I was shrined in double retirement.

Hierarchy is shown by using Univers Extended with Univers Ultra Condensed.

Folds of scarlet drapery shut in my view to the right hand;

to the left were the clear

panes of glass, protecting,

but not separating me from

the drear November day.

At intervals, while turning over the leaves of my book, I studied the aspect of that winter afternoon.

Color contrast: Top, negative tracking and red color; middle, smaller point size and increased leading; bottom, increased tracking.

Headline

Display versions of fonts have been specifically designed to be used in larger point sizes—they look more elegant in display sizes.

36 pt Electra Bold head with 10/13 Electra Bold paragraph.

Headline

Display versions of fonts have been specifically designed to be used in larger point sizes—they look more elegant in display sizes.

36 pt Electra Bold Display with 10/13 Electra Bold Display paragraph.

CREATING EMPHASIS

Another important element in hierarchy is emphasis. It can help to strengthen the hierarchy or increase the understanding of the message or text.

Italics

One way to create typographic emphasis, both in text and display settings, is with italics. They are generally used for titles, technical terms, foreign words, etc., within text blocks, but they also are an effective and harmonious way to create light emphasis of words or phrases. They draw the reader's attention without a significant change in the color of the text. Don't set large amounts of text in italics because they tend to slow reading speed and become more of a distraction.

Use only the true italics or obliques that are created for the typeface you are using, not those created by using the skew function on the Character Control panel. Style-made italics distort character shapes by just slanting the roman font. If your typeface doesn't contain an italic font, don't use it. Choose another that does have italics if you need them.

Changing from roman to *italic* is a good way to create contrast *without* attracting too much attention.

Times New Roman Regular and Italic fonts.

Using *fake italics* is not a good way to create contrast. These *skewed italics* don't look right.

Times New Roman Regular with a 15° skew applied to some words. The stroke weights do not seem right and the letters look slightly distorted.

Watch the spaces before and after the italics. You may have to make some slight adjustments to these word spaces because italic characters are narrower than the roman, which sometimes creates extra space before them.

Weight Contrast

Using the bold version of a font is a good way to achieve strong emphasis, especially for subheads, stand-alone words, phrases, or quotes. Use them sparingly within a text block for a small number of words or a single sentence, and only where a strong emphasis is needed. Because of their very strong color, they can disrupt the flow of reading.

Generally, bold and extra-bold letters have greater weight in proportion to the space they occupy. The counter spaces of bold letters are smaller than the counters of their roman counterparts, which makes the weight take priority over the space and causes them to visually come forward. Conversely, thinner letters have more open counter spaces creating a greater feeling of space around them so that the words appear lighter and less intense, which also can create light emphasis.

Bold type is very assertive and can be used for heavy emphasis. Being a heavier version of the roman type, it attracts more attention than italics.

New Century Schoolbook Roman and Bold.

Changing Typefaces

If you are using two different typefaces in your design, one for heads and the other for text, you can use the headline typeface for emphasis within the text.

Spacing and Rhythm

By adding space between the letters of a word or a couple of words, you change their color, setting them off from the rest of the text. Changing the leading or line spacing in a couple of lines of text or a block of text sets them off from the other lines or blocks of text.

Depth

By varying the size and weight of letters and words in a typographic layout, a sense of depth can be achieved. Smaller, lighter letters appear to recede while larger and bolder letters advance.

Alignment and Orientation

By changing the alignment of an element, you draw attention to it by making it stand out from the rest of the text. The same goes for changing its direction or angle.

By varying the size and weight of letters and words in a typographic layout, a sense of depth can be achieved. Smaller, lighter letters appear to recede, while larger and bolder letters advance.

A sense of depth is achieved by varying the weight and size of type in a text block.

My Head Is a Bold Sans Serif

The text is a serif typeface so I can use the sans serif font for **emphasis** within my text block.

Myriad Pro Bold head with Adobe Caslon text.

The typographer's
one essential task
is to interpret
and communicate
the text.

typography

Changing alignments and orientations can draw attention to elements.

White on Black—Reversed Type

The majority of the text we read is set as black type on a white background. The opposite, "reversed type" (white type on a black or colored background), can have some drawbacks. It has a tendency to "sparkle" because the stroke weights become lighter and uneven, as the letters tend to fill-in, making it hard to read. The black ink spreads into the white type areas, making the strokes narrower and sometimes nonexistent. It is best to avoid small typefaces, typefaces with small x-heights, and typefaces with very fine strokes or serifs for reversed type. Using a bolder font, and tracking the text open a little can help to alleviate these problems.

Underscores and Rules

Rules can help to organize elements visually, emphasize words, separate units of information to achieve hierarchical clarity, and define typographic space. Rules do not have to be solid lines. They also can be composed of a series of dots, dashes, or other elements of varying weights. If you must use underscores, it is best to create them with the Rules function in the Paragraph

Choose typefaces
carefully when using
reversed type.
Avoid small typefaces or
typefaces with very
fine strokes or serifs, because they
tend to fill in when printed.

Reversed type tends to fill in, making it hard to read in small sizes or light typefaces, especially those with very light serifs like Bodoni shown here.

Garamond	Old Style
Baskerville	Transitional
Bodoni	Modern
Century	Slab Serif
Helvetica	Sans Serif

.5 pt
1 pt
1.5 pt
2 pt
3 pt

A list of elements showing how rules can help separate and organize the items. Different sizes and styles of rules are shown for comparison.

Emphasis

Emphasis

Top: Underscore created with the underscore function in the Style menu.
Bottom: Underscore created with the Rules function which allows you to adjust the weight, position, and length of the rule.

Panel menu. Underscores created with the underscore option on the Character Panel cannot be adjusted for weight or position, and usually cut through the descenders.

Boxes

You may sometimes want to emphasize a word or phrase by drawing a box around it. Boxes, or squares, can be generated as outlines or as solid with reversed type.

Point Size

Varying the point size of type to add emphasis should only be used in appropriate circumstances. The size will depend on how much emphasis you want. If the increase in type size is too great within the text, the lines of type will overlap. As discussed previously, adjusting the leading to fix this will create uneven line spaces in the paragraph, or too much leading in the entire block, for the one word set larger.

10-point type with a box used to frame **a word. 10-point type with a** reverse **box used as a frame.**

An outline box and a solid box with reversed type showing how they can be used to highlight words.

A large **change** in type size draws attention, but there is a limit to how much you can increase the size within text—it may **overlap** the line above and below it.

A large **change** in type size draws attention, but there is a limit to how much you can increase the size within text—it may **overlap** the line above and below it.

Left: Enlarging some words within a text block can cause some letters to overlap the line above or below them.
Right: Adjusting the leading causes that line's space to look larger than the others.

Peggy Shinner web site. This is an example of typefaces, sizes, color, and rules being used for hierarchy and separation of information.

Designed and coded by Mark Stammers.

Assignment: Hierarchy and Structure

Objective

Obtain familiarity with typographic alignments, spacing, hierarchy, and expressionism. Explore the many possibilities for layout and hierarchy within the restrictions of a given format, text, and fixed parameters. Discover how changing one element changes others, and what adjustments need to be made. How to increase the impact of the message being conveyed by enhancing the hierarchy.

Format

Page size: 7″ x 7″ square. You have been given an InDesign® template that has a grid on the Master Page, and also a .5 stroke box around the outside of the master page. (Created and distributed by the instructor.) This is on there so the page will print as a 7″ square on 8 ½″ x 11″ pages. Do not remove it.
Base typeface and size: 10/12 pt Myriad Pro Semibold
You been given the text at the end of this assignment. (Instructor should provide the text. I usually choose something that contains a head, subhead, text, and dates.)

Process

- The information cannot be reordered in parts 1–5.
- Pay attention to how you place the text on the page. You don't want to make it so static by placing it right in the center. Use alignments to structure; the grid helps with this.
- **Do not use italics** on any of the compositions.
- Black and white only.

For each of the following specifications, do 3 **different** compositions (18 total).
1. One weight (semibold), one point size (10 pt), flush-left alignment, choose how to place on the page (each page different). You may play with leading and line space.
 - Horizontal alignment only.
 - You may organize the info into groups.
2. One point size (10 pt), flush-left alignment, two additional weights besides semibold, play with leading and line space.
 - Horizontal alignment only.
3. Flush-left alignment, three weights, and three point sizes. Play with leading and line space.
 - Horizontal and vertical alignments may be used.

TYPOGRAPHIC HIERARCHY

147

4. Flush-left alignment, three weights, and **extreme** size changes using at least three point sizes. Play with leading and line space.
 • Horizontal and vertical alignments may be used.
5. Same parameters as number 4, but you may add rules to help with emphasis and hierarchy.
 • The rules are not to be used as decoration; they must serve a purpose if used.
6. You must use the same typeface but may use any of the above except the following:
 • No color.
 • No solid black backgrounds.
 • No images.
 • No decorative elements.

When printing out the pages, make sure to change the page position to "centered" under Setup in the Print menu.

Student Solutions

Riley Gill

Sarah Sidani

Brigit Hickey

Jenny Chu

Brigit Hickey

Jenny Chu

Min Young Kim

Sarah Sidani

Brigit Hickey

Riley Gill

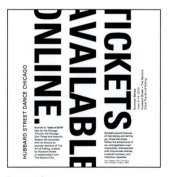

Brigit Hickey

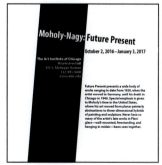

Riley Gill

08.
Layout and Structure

A typographic composition, or layout, consists of typographic elements arranged within a spatial field. The elements must all work together harmoniously to create a balanced composition. This balance can be achieved in a number of ways.

THE FOUNDATION: SPACE

Space is the area in which all of the elements sit. Project specifications place physical limitations on the space, the main one being size, which is the area the design occupies. The elements that are a part of the design must support the message and work well together within the given space.

PAGE NAVIGATION

The eye looks for a place to start, an entry or focal point, then follows the hierarchy through the rest of the design. The way we naturally read a page is to start at the top left corner, then the middle, and finally the outer edges. We read from left to right and top to bottom.

The foundation of any project, the blank space.

Focal Point

If there is nothing to draw the eye elsewhere, then the eye will naturally go to the top left corner of a design and start reading there, gradually working down through the page. The designer has the power to control how a viewer scans the design by creating a hierarchy of information beginning with the main element, or focal point. A focal point can be enhanced by size, weight, color, and position, or any combination of these.

The Rule of Thirds A compositional relationship where any page is divided into three horizontal and three vertical modules. Focal points, or hot spots, are formed at the axis points where the grid lines cross. An element, or elements, placed on or near any of these points will draw the eye.

STRUCTURE

Typographic design can be based on two types of structure: an informal, optically-created structure, or a formal grid structure. In any typographic design, the position of each element within the space is important to the message and the hierarchy. This visual hierarchy determines the size, weight, and placement of each element within the composition. Some factors that influence hierarchy are size, placement, and contrast.

A way to create a focal point is to place an element on one or more of the axis points of a 3 × 3 grid as shown by this painting.

Cattleya Orchid and Three Hummingbirds, 1871, by Martin Johnson Heade.
Courtesy of the National Gallery of Art.

Balance

Balance is the arrangement of elements in a design so that their visual weight appears to be equally placed within the space. Most compositions have a visual balance that is achieved in one of two ways: through symmetry or asymmetry.

Symmetrical Balance True symmetry is achieved when all elements are centered equally on a horizontal or vertical central axis. Symmetry can give a classic look to a design, but it also can be very static.

Asymmetrical Balance Balance through asymmetry is created when elements with different visual weights are placed in such a way as to visually balance the composition. They are not centered on an axis but placed in such a way as to equally balance one another in visual weight. Asymmetric balance can be more dynamic than symmetrical balance.

FORMAT

Proportions

All design formats are based on some kind of measurement system or proportions, which can be a commercial paper size, a grid structure, or geometry, for

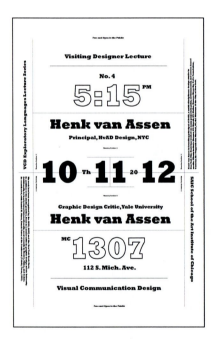

Poster for Visiting Designer Lecture Series at SAIC, a good example of symmetrical balance.

Designed by John Bowers.

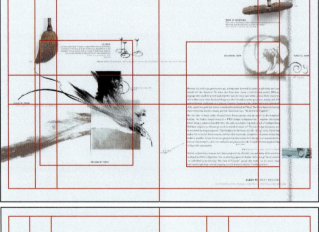

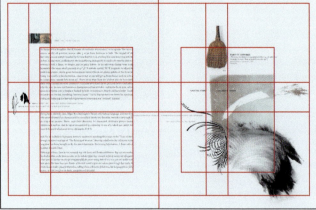

An example of asymmetrical balance. Spreads from *Visible Citizens*, a magazine feature.

Designed by Stephen Farrell.

example. There are some numerical systems and proportions that over time have come to be considered "beautiful proportions" and when used in designs will always look right.

The Golden Section The *golden section*, also known as the *golden mean* or *golden rectangle*, is one of the most widely used proportions. It occurs in a variety of natural forms and is considered visually pleasing to many cultures. Its ratio is 1:1.618, or 8:13, and the traditional way of constructing one is by dividing a square to find the center point (a), from which length (a:b) is found. From point (b) an arc is drawn to point (c) to create a rectangle with golden section proportions.

If a square is subtracted from the rectangle, a new golden section remains. This relationship between the square and the rectangle is always constant. Shown in a sequence, it creates a spiral.

The golden section can be used as a visual method for constructing grids or creating an asymmetric layout.

Fibonacci Sequence The Fibonacci sequence is a group of whole numbers named after Italian mathematician Leonardo Fibonacci who, in the 13th century, advocated it as evidence of a rational order in nature. Each

How to draw a golden rectangle.

Golden Ratio
Draw a line and divide it using the ratio 1(a) : 1.618(b) to get the *golden ratio*.

Golden rectangle spiral
Using the length of the sides of the squares of the subdivisions as a radius for a circle, strike and connect arcs for each square in the diagram. These divisions also are related to the Fibonacci numbers.

number in the series is the sum of the two that precede it (0, 1, 1, 2, 3, 5, 8, 13, 21, 34, 55, 89, 144, etc.). Any number in the series divided by the following number is approximately 0.618, and any number in the series divided by the previous number is approximately 1.618. This is the ratio of the golden section.

The Fibonacci numbers provide the designer with a tool for forming page proportions, asymmetric grids, and sizes for typographic elements.

The Rule of Three It has long been known that elements in threes are more interesting and dynamic than other numbers. Even words in threes are more memorable: "Friends, Romans, Countrymen," "Let It Go," "Go For It." It is also true that odd numbers make more interesting divisions than even numbers.

Other Numeric Series Similar to the Fibonacci Sequence, space can be divided in other numeric progressions:

Odd number ratios (1:3:5:7:9)

Double ratios (1:2:4:8:16)

Grid constructed on golden section proportions.

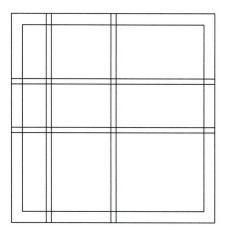

Grid divisions of an increasing ratio of 2-3-5 units, Fibonacci numbers.

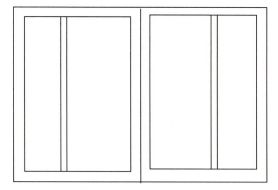

A page spread with column widths that are of a ratio 5:8, Fibonacci numbers.

The Root Rectangles

Root 2 Rectangle This rectangle has a proportional relationship similar to the golden section, having a ratio of 1 to the square root of 2 (1:1.414), which also can be derived from a square and its diagonal. This is the only rectangle whose half is exactly equal in shape to the whole.

Root 3 Rectangle Has a ratio of 1:1.732.

Root 4 Rectangle Has a ratio of 1:2.

Root 5 Rectangle Has a ratio of 1:2.236.

GRIDS

Grids are used to organize the elements of a design to make it easy for a viewer to access the message. They help to create balance and consistency, especially in documents consisting of multiple pages.

Grids can be thought of as imaginary lines that support the elements of the design or layout. These lines establish reference points from element to element, creating a format for relating adjacent elements and visual continuity from page to page.

They provide structure, separating types of information and making navigating through various information easier for the user.

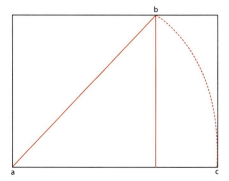

Root 2 Rectangle
Start with a square. From point (a) draw a diagonal to (b). Using the diagonal as a radius, draw an arc to point (c) then connect the sides to create a rectangle of root 2 proportions.

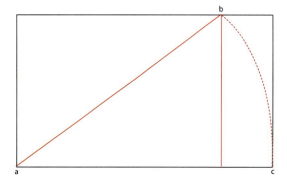

Root 3 Rectangle
Start with a root 2 rectangle (as shown left). Draw a diagonal from (a) to (b). Using the diagonal as a radius, draw an arc to point (c) then connect the sides to create a rectangle of root 3 proportions.

Informal Grids

An informal grid is created by arranging typographic elements in an aesthetically pleasing format based on alignments, as opposed to a more formally structured grid system of vertical and horizontal lines. Alignments create a sense of unity or relationship, and also create directional movement within the space. Whether you have few or many elements, there are numerous possibilities for arranging them. Think of the typographic units as solid shapes aligned by their edges.

In order to derive a meaningful solution, the designer must consider both the visual and communicative aspects of the composition. A design that is just visually pleasing but doesn't communicate its message well is ineffective.

A good way to begin any design is to visually structure the information that can be converted into a formal grid structure later if desired. Informal grid structures are based on the hierarchy of the information.

1. Start the process by deciding the hierarchy of your typographic elements—most important, which needs to be read first, then the sub-elements, and finally the least important.

Informal grid. Underlying grid structure for the layout on the left.

2. Place the most important word, phrase, or line of type in your space first, finding an optically pleasing spot. This will give you left and right vertical grid lines, as well as horizontal lines. Use one or more of these guides to place the next element. Use the new element to indicate additional grid lines. Continue this process, working with spatial relationships and using alignments to tie the structure together. As there are numerous possibilities for placement, do multiple arrangements, varying horizontal and vertical lines of type, diagonal, and even curved or circular lines. Look at all of your designs and decide which are the most aesthetically pleasing but also convey the message best.

Formal Grids

A *grid* is an under-structure employed to give a publication or layout a cohesive style by using a set of guidelines indicating vertical and/or horizontal divisions of the page. It is used to create consistency and visual harmony across multiple pages. It is a system for organizing text on a page and enhancing its meaning. The grid permits visual continuity from page to page.

Spreads from *The Texts No Title Can Entitle,* journal essay by Stephen Farrell. A sample of informal grids.

Designed by Stephen Farrell.

With regard to typography, it is essential to consider the following when designing a grid: choice of typeface(s), size of the type, type style, letter spacing, word spacing, leading, paragraph spacing.

There are different kinds of formal grids—single-column, multi-column, modular, and hierarchical.

Single-column Best for long, continuous text in books with few images, or where the images are given a full page to themselves.

Multi-column Useful for more complex material with a number of different types of material and/or images.

Modular These types of grids are useful when you have a lot of information such as timelines, time schedules, and calendars.

Hierarchical Uses horizontal divisions of the page to order information and create hierarchy.

Before a layout and grid can be designed for a project, it is essential to consider the following:

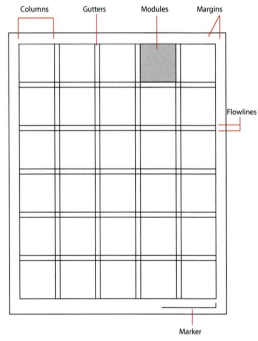

Grid components.

Single-column grid
Used for large amounts of text with few, or no, images.

Multi-column grid
Offers more flexibility than one- or two-column grids.

ANALYZE THE MATERIAL

How many pages will there be and what is the page size? Is the publication text-heavy or image-heavy; how many images? What is the optimum line length for the typeface and point size of the text (to establish column width)? How will it be bound? (Allow extra space in the gutter margin for a very thick book, or for wire and ring bindings.)

Grids do not restrict creativity—they assist the designer with organizing visual information in the most effective manner, and they can be broken out of for a dramatic effect.

The grid is useful in placing and arranging repetitive elements and for a variety of arrangements in a spatial context. Images are reduced to a few formats and sizes, with their size determined by their importance for the message.

Typographic elements (titles, heads, text, captions) placed clearly and logically on the grid in their order of importance, can be read more easily and quickly.

Designers follow a grid as long as it works. If an element seems awkward within a grid, it may be repositioned to look visually correct, thus "breaking" the format of the grid.

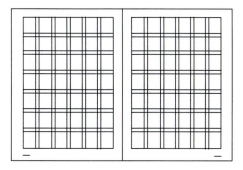

Modular grid
Used for complex information requiring smaller spaces for flexibility.

Hierarchical grid
Uses horizontal zones to designate placement of repeat elements.

Unconventional Grids
Grids can take any format dictated by the material.
Top: diagonal grid.
Bottom: circular grid.

FIRST STEPS

Before you can devise a grid, you must know:

1. What the message or communication problem is, its objectives, and the potential audience.

2. The constraints and physical requirements associated with the project: the visual material, the space it will occupy, the order of elements/content, and the degree of emphasis given to each.

 • Will it be heavy on text or heavily illustrated?

 • The amount of text and how it breaks down—lots of subheads, images, and/or pull quotes.

3. The design concept.

 • The hierarchy of the elements.

 • Will there be initial caps, rules, or other visual elements?

 • Are there similar types of illustrations or photo sizes? Can they be grouped by size or type?

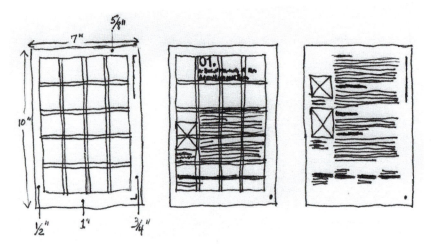

Original sketches of grid and layouts for this book.

Finished InDesign® page from this book.

Grids can range from simple to complex. They may only define margins and type columns, or they may provide a complex structure of modules for a wide range of typographic options and visual solutions. Grids do not always have to be conventional, with strict horizontal and vertical lines. In some instances, they may be more creative, based on diagonal or curved lines. The design of the grid is guided by the content and the design concept. The more columns and divisions the grid contains, the more flexible it can be.

CONSTRUCTING THE PAGE GRID

The "Perfect Page"

For centuries, certain laws, or canons, of page construction have been used by book designers to create harmonious page proportions and margins.

The Van de Graaf Canon J. A. van de Graaf was the first to formally construct the method used by medieval scribes and Johannes Gutenberg. It's called the Van de Graaf Canon. It works for any page size and will always create margins that are $\frac{1}{9}$ and $\frac{2}{9}$ of the page size. The inside margin will be half of the outside margin, and the top will be half of the bottom margin. This creates margins with a ratio of: inner margin 2, top margin 3, outer margin 4, and bottom margin 6, or 2:3:4:6. The construction is shown below.

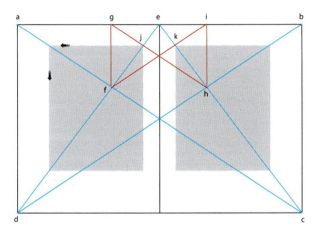

The Van de Graaf Canon
Draw both diagonals across the facing pages (ac, bd). Then draw the individual page diagonals from each outer bottom corner to the top inner corners (ce, de). Next, draw vertical lines from the axes where the two diagonals meet, in the upper part of each page, to the top edge of each page (fg, hi). Then draw diagonals from where the lines hit the top of the page to the points where the diagonals cross on each page (gh, fi). To create the text areas, draw a horizontal line from point j to the diagonal ac. Draw a vertical line down from the horizontal line to the diagonal de. Connect the lines to form the rectangle.

French Bible page that is based on the Van de Graaf Canon.

Photo courtesy of The Newberry Library, Chicago, Case MS 16 folio.

Villard's Figure Villard de Honnecourt, an architect and artist in 13th-century France, developed a similar method of page construction. The system divides a line into harmonious parts consisting of thirds, fourths, fifths, etc. It allows you to create a grid of 6 × 6, 9 × 9, 12 × 12, and so on. It also works with any page size.

Tschichold's Golden Canon In the 20th century, designer Jan Tschichold researched previous theories, which reaffirmed his belief in the perfect page ratio. Using modern drawing tools, he followed the previous works but came up with the page ratio of 2:3. He established that it falls within the Fibonacci Sequence and the golden ratio. It also makes margin ratios of 2:3:4:6.

Golden Ratio Margins One method for determining the text and margin proportions is based on the golden ratio. Begin with two blank facing pages. Draw all of the diagonals, both for the spread and for the two individual pages (1). Next, draw the text areas so that the upper-inside (a) and lower-inside (b) points align with the short diagonals, and the upper-outside (c) points align with a long diagonal (2). In this way, the inside and top margins are one-ninth of the width and the height of the page, respec-

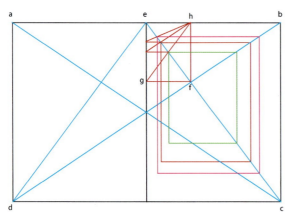

Villard's Figure
Draw the diagonals as in the Van de Graaf Canon. Next, draw a horizontal line from point f to point g, and a vertical line from f to h. Connect g and h with a diagonal. Where gh crosses ce, draw another horizontal line to the center line, then draw its diagonal to h. Repeat one more time where that diagonal crosses ce. Draw text boxes by making a horizontal line at the crossing points on ce to the right diagonal bd, then a vertical down to diagonal ce. Connect the other horizontal and vertical.

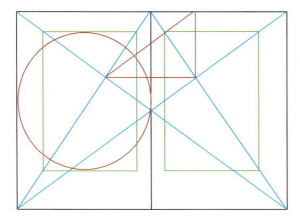

Tschichold's Golden Canon
Drawn in a similar fashion to the two previous page ratios, Tschichold's page ratio of 2:3 illustrates how the height of the text block equals the width of the page (illustrated by the circle).

tively, and the outside and bottom margins are double the size of the inside and top margins, respectively. Drawn this way, the text areas can be of any size, the outside margin will always be twice the inside margin, and the bottom margin will always be twice the top margin. The gutter margin is one unit of measure, the top margin is 1.5 units, the outside margin is 2 units, and the bottom margin equals 3 units of measure.

Asymmetric Margins All of the above methods create a symmetrical margin structure on facing pages. There is an alternative to symmetrical margins, or mirrored pages, where the same margin measurements are used on both left and right pages without flopping them on the right page.

Columns

The next step is to determine the number of columns for the grid.
The width of the text columns, also called the *measure*, and the spaces between them (alleys, but commonly called gutters) is determined by the number of characters, spaces, and punctuation in a line of the type. (See *Line Length*, chapter 04, page 91.) Traditionally, the gutter space is equal to the size of the leading used for the text, or a multiple of this amount (× 1.5, 2, etc.). The

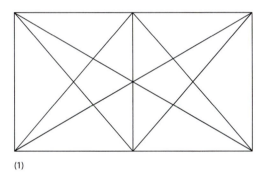

(1)

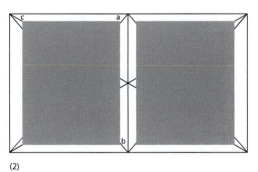

(2)

Golden ratio margins begin by drawing the diagonals as in the previous canons.

Asymmetric grid
Instead of the grids mirroring each other on facing pages, they are the same and have the same margin measurements, causing the facing pages to be asymmetrical.

wider the column, the bigger the gutter should be. The gutters should not be too wide, making the columns seem unrelated to one another, nor so narrow that the eye crosses over gutters to the other columns. The column, or combination of two or more columns, should be the appropriate width to set the ideal number of characters per line, in the point size of the type you are using, to achieve optimum readability.

Start by setting some sample text in the font, point size and leading you intend to use. Adjust the tracking, if necessary, for readability requirements. Count the characters in an average line of the sample text, drawing a pencil line down the right side, at a point that is an average of the line lengths.

There can be primary and secondary divisions. You may have a dominant structure of, say, two columns, but these columns may actually have a secondary structure by being divided into four columns. A six-column grid can be used as two- or three-columns. This allows more flexibility.

Modules

You can create spaces marked by horizontal lines on the grid. These lines create what are called *modules*. They may be placed at a distance equal to the

Start by setting some sample text in the font, point size and leading you intend to use. Adjust the tracking, if necessary, for readability requirements. Count the characters in an average line of the sample text,

Start by setting some sample text in the font, point size and leading you intend to use. Adjust the tracking, if necessary, for readability requirements. Count the characters in an average line of the sample text, drawing a pencil line down the right side, at a point that is an average of the line lengths.

Start by setting some sample text in the font, point size and leading you intend to use. Adjust the tracking, if necessary, for readability requirements. Count the characters in an average line of the sample text, drawing a pencil line down the right side, at a point that is an average of the line lengths.

Set some sample text in different point sizes and different line spaces on various column widths of the grid.

Two different types of modular grids.

column width, or they can be larger or smaller than the column width, with or without gutters between them. Any of the classic methods of aesthetic proportion may be used to determine these divisions, or a specific number of text lines may be used to determine the size of the modules based on the baseline grid of the document.

COMBINATION GRIDS

Depending on the complexity of the information that needs to be conveyed, it may be necessary to use multiple grid formats to organize the content of a publication. This can be accomplished in any number of ways. For instance, a 12-column grid can be used to create six-column, four-column, three-column, and two-column layouts. In this way, all of the column widths will have the same proportional relationship, which will allow different text and image widths to relate to one another. Also, the horizontal divisions can be used in different ways. Combination grids offer more flexibility.

Another type of combination grid is one that uses two or more grid formats that share the same margin sizes in one publication. This format can be used to make distinctions between sections or types of content.

Combination Grid
When you have more columns than you intend to use, it allows for different sizes of images, and different types of text. Above is a six-column grid using different numbers of columns for different spreads and sections.

Indo-American Center Annual Report designed by Mary Jo Krysinski.

Combining different grids on a single page is another option. They must be separated into different areas of the page. For example, the top three-quarters of the page might contain the main text and images in a two-column format, while the bottom quarter has a three-column grid for secondary information and captions.

USING GRIDS

Page elements do not have to be confined to individual columns or modules. For instance, if you are using a five-column grid, text confined to each individual, narrow column, will be too hard to read. Instead, you could set the text across two columns each, leaving an empty column for photos, pull-quotes, or captions. One grid can offer a variety of creative solutions. The illustrations on this page show how a 4 x 4 (20-module) grid system can be used in five different ways.

Some publications use more than one grid. For content that varies greatly from the rest of the pages, a different grid would be appropriate. InDesign® offers the option of having two or more Master Pages in one publication. The ways in which one grid is used may vary on one or more pages of a publication.

A 20-module grid used in two different ways.

WHITE SPACE

White space is built into the grid in the margins. Wider margins create more white space on a page, giving a more open look to the publication. White space is a very important element of the design. A page that is filled solid with text and images rarely looks good and feels too intimidating to the reader.

White space can create harmony between densely-filled and sparsely-filled areas of the design. You do not have to fill in every available area of the grid. You may even leave entire columns unfilled to allow the eye to rest, and to enhance the overall design and content.

Samples of Conventional Grid Use

Of Good Report, a biannual publication for Northwestern University Alumni Relations & Development, Volume 8 No.1 / Spring 1998, pages 10 – 11, designed by Daniel Morgenthaler.

Courtesy Northwestern University Alumni Relations & Development.

Spreads from *Mythopoeia*, a collaboration led by Stephen Farrell with Steve Tomasula and Don Pollack.

Designed by Stephen Farrell.

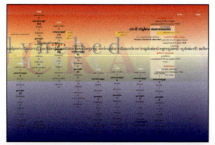

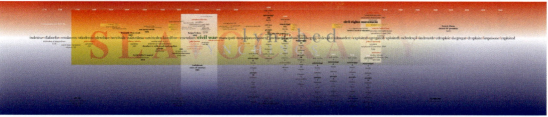

Slavocracy
Designed by Frank DeBose.

Assignment: Type Specimen Poster

Objective

- Learn the characteristics and details of a typeface
- Research and learn about a classic typeface and its designer
- Become aware of the appropriate uses of a typeface
- Begin to explore typographic layout and grid use

Using the information from the research assignment in Chapter 1, design a poster that highlights the typeface and educates viewers to its history.

Summarize your research on the designer and typeface in one concise paragraph that will be used on the poster.

Format

Page size: 16″ x 20″, vertical, color or black and white
Poster should include:

- Name of the typeface
- Name of the designer and the date of the original drawing
- Visual examples of at least four styles and weights in the family
- Body text (your written paragraph)
- Distinguishing characteristics of the design
- Different point-size settings, both text and headline
- Complete character set

There is to be no imagery on the poster.

Process

Start by sketching layout/design ideas. You may want to work on a grid. You are to create two different design concepts initially, and based on the critique, you will develop one further as the final design. Proofs of the two concepts should be tile printed at full size and taped together for the critique. Final output of the poster should be high-res at full size.

Sample Solutions to the Assignment

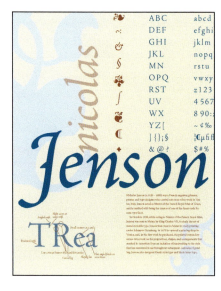

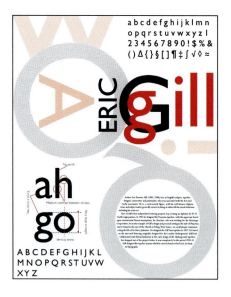

Assignment: Grid Studies

The purpose of this exercise is to explore the use of conventional and non-conventional typographic grids in order to open the creative channels and use multiple layout options for problem solutions. The concept for this assignment came from the book *Typographic Systems* by Kimberly Elam.

Format

- 6″ × 6″ squares.
- Grids provided as an InDesign® template with printouts attached to this assignment.
- Choose one typeface from the Basic Font Set, either a serif or sans serif only. You will use this typeface for all the compositions, but you may use as many styles and/or weights, and any number of point sizes.
- Text is provided by the instructor.
- Text lines may be broken and the order of the information can be changed. Do not break words and keep hierarchy in mind.
- You cannot use images.
- Rules/lines may be used to enhance hierarchy.
- Make extra copies or printouts of the grids to sketch ideas on first.

Problem

You have been given a document that has six different grids—modular (three different styles; you may use one, all, or change), modular diagonal, diagonal, and dilatational. Do **three different** compositions for **each grid**.

You must use the conventional modular grid as is, but the other two (circles and diamonds) may be changed.

Grids

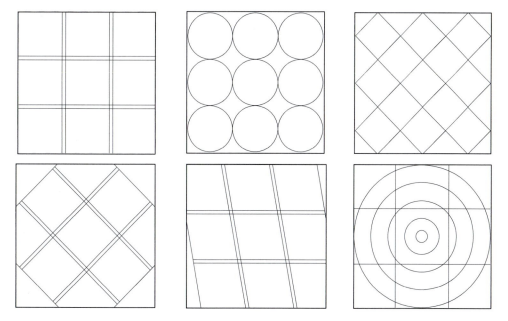

Sample Student Solutions

Kelsey Houlihan

Tyler English

Skylar Sun

Nan Jin Li

Kelsey Houlihan

Skylar Sun

Skylar Sun

Nan Jin Li

Tyler English

Kelsey Houlihan

Tyler English

Nan Jin Li

09.
Page Elements and Specifications

Before a grid can be designed, you must consider the hierarchy of the text, such as the title, subtitle, text blocks, subheads, captions, and so on. In order to ensure that the reader will understand the text, the designer must understand it first, which leads to informed decisions about an order and hierarchy. Most times the text is provided to the designer with all of these elements marked by the editor: heads, subheads, text, captions, footnotes, running heads, or footlines.

Once an order has been established, the designer can begin to formulate the visual hierarchy using the following:

1. Typeface choice

2. Type size

3. Spacing (paragraph indents, line spaces, etc.)

4. Alignment

HEADS AND SUBHEADS

These are the two largest elements on a page. Heads are the main dividers of sections in the text. Subheads are the secondary areas of division in the text. Heads should be easy to read and stand out on the page. Subheads should be set large enough, or bold enough, to clearly differentiate them from the text copy, but small enough not to be confused with the heads. The different levels of subheads are usually referred to by a letter to differentiate them, i.e., A Head, B Head, C Head, D Head, etc.

A subhead that falls near the bottom of the page should be followed by at least three lines of the next paragraph. If this can't be done, it should be moved to the top of the next column or page.

Line Spacing Heads and Subheads

There should be a little more space above subheads than below them to keep them visually connected to the text that they refer to.

A clear distinction between heads and subheads, and also between subheads and text, is necessary. Choose a typeface for heads and subheads that provides a strong contrast to the body text.

BODY TEXT

Refers to the main text, as opposed to the titles, heads, and other display copy. It should be readable, and sometimes must take into consideration the reading capacity of the audience—seniors, children, the reading-impaired, etc.

TABULAR MATERIAL

Elements within the text that are set as lists either in a table or chart format, or with numbers or bullets at the beginning of each line, are referred to as tabular material.

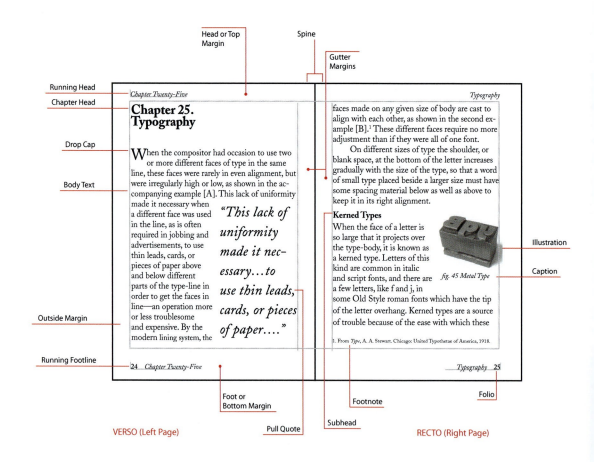

Head or Top Margin

Spine

Gutter Margins

Running Head

Chapter Head

Drop Cap

Body Text

Outside Margin

Running Footline

Foot or Bottom Margin

Pull Quote

Subhead

Footnote

Folio

Illustration

Caption

VERSO (Left Page)

RECTO (Right Page)

Chapter Twenty-Five

Typography

Chapter 25. Typography

When the compositor had occasion to use two or more different faces of type in the same line, these faces were rarely in even alignment, but were irregularly high or low, as shown in the accompanying example [A]. This lack of uniformity made it necessary when a different face was used in the line, as is often required in jobbing and advertisements, to use thin leads, cards, or pieces of paper above and below different parts of the type-line in order to get the faces in line—an operation more or less troublesome and expensive. By the modern lining system, the

"This lack of uniformity made it necessary...to use thin leads, cards, or pieces of paper...."

faces made on any given size of body are cast to align with each other, as shown in the second example [B].[1] These different faces require no more adjustment than if they were all of one font.

On different sizes of type the shoulder, or blank space, at the bottom of the letter increases gradually with the size of the type, so that a word of small type placed beside a larger size must have some spacing material below as well as above to keep it in its right alignment.

Kerned Types
When the face of a letter is so large that it projects over the type-body, it is known as a kerned type. Letters of this kind are common in italic and script fonts, and there are a few letters, like f and j, in some Old Style roman fonts which have the tip of the letter overhang. Kerned types are a source of trouble because of the ease with which these

fig. 45 Metal Type

1. From *Type*, A. A. Stewart. Chicago: United Typothetae of America, 1918.

24 *Chapter Twenty-Five*

Typography 25

CALLOUTS AND PULL QUOTES

Sentences within the text that are made to stand out by being set in boldface, italics, and/or larger point sizes are referred to as *callouts*. Sentences that are repeated, separated from the text, and set in a larger size, different fonts, etc., are called *pull quotes*. They can be inset into the text or hung partially in the column of type and partially in the margin. They can be put anywhere on a page that fits with the design.

EXTRACTS/BLOCK QUOTATIONS/EXCERPTS

Quotations within the text are usually set off from the text by being set in a smaller or a different font from the text, and also may have all lines indented from the left and sometimes from the right.

CAPTIONS

Sentences used to describe what is going on in photos or illustrations, to identify who is in the image, or the credits for it, are called captions. They should be set at least two point sizes smaller than the text.

AUTHOR BYLINES

Credit lines given to the person or persons who write the text. They are either placed at the top of the text to introduce the article, or placed at the end where they are often followed by a small biography.

FOOTNOTES/ENDNOTES

Footnotes are references designated by a number or asterisk within the text. Their details are located at the bottom of the page within the text box, set in a smaller point size than the text and on the same page as their reference number appears in the text. Sometimes they are all listed at the end of a chapter or article instead, in which case they are called *endnotes*.

- In the text, footnotes are indicated by a superscript number at the end of the text being referenced, but the footnotes at the bottom of the page use a full-size number.

- In the footnote, numbers should be separated from the note text by a single space and no punctuation.

- Footnotes are set one or two point sizes smaller than the body text and in the same typeface as the text.

- Footnotes should be separated from the body text area by at least the equivalent of a full line space and/or a thin rule.

Footnotes can be anchored to the page they belong on by inserting the cursor where you want the footnote reference number to appear and choosing Type > Insert Footnote. The footnote area expands at the bottom of the text box and a superscript number is placed in the text. Choose Type > Document Footnote Options to control the style of numbering, appearance, and layout of the footnotes.

When a footnote must continue to another page, at least three lines of text should be available, and it should begin in the middle of a sentence so the reader knows there is a continuation. A short, left-aligned rule is usually placed above the continued text.

RUNNING HEADS AND FOOTLINES

If used, the headers or footlines usually will be on every page and are located in the top (headers) or bottom (footers) margin area. Sometimes they also are located in the outer (thumb) margins. Margin elements are usually quiet in terms of size and color. They are called headers if placed in the top margin, and footers if placed in the bottom margin.

Headers and footers consist of chapter titles, section titles, and the publication title, appearing on all pages except display or opening pages.

FOLIOS (PAGE NUMBERS)

Folios are the page numbers of a publication. Odd numbers appear on right-hand (recto) pages and even numbers are on left-hand (verso) pages. They are usually located in the top or bottom outer corners of pages, sometimes in the center of the outside margin, or the bottom center of the page at least two line spaces below the bottom text margin. Since they are used as a navigational tool for the publication, you don't want to put them near the gutter where they would not be usable while flipping through the pages.

Auto Page Numbers

Click on the Type tool and draw a text box on either Master Page in the position you want the folios to be. Choose Type > Insert Special Character > Markers > Current Page Number. The letter A shows in the text box but on the document pages the correct page numbers will appear. Highlight the A and change it to the font and point size you want the folios to be. Repeat on the other Master Page.

MULTI-PAGE FORMATS

In books, magazines, and other multiple-page documents, hierarchy is linked to the following elements:

- Heading
- Subhead
- Text
- Footnotes
- Running heads or footlines
- Folios (page numbers)

Once the order of elements is determined, then begin to emphasize the hierarchy by using the following:

- Choice of typeface
- Point sizes
- Space around elements
- Paragraph spaces
- Use of type styles
- Alignments
- Placement within the space

Hierarchy of Headings

Many texts are divided into sections such as chapters, which need headings and sometimes division numbers, and also divisions within the text using various levels of subheads.

1. At the top of the hierarchy is the chapter opening.
 Chapter Title and Number—these are usually the largest and boldest elements on the page.
2. The first level of subhead indicates the beginning of a major division in the text.

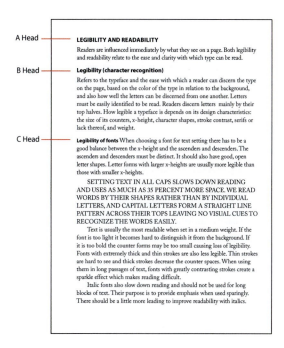

Multiple levels of subheads.

A Head—can be an increase in type size, case, weight, or complimentary typeface.

A HEAD **A HEAD** **A Head**

3. The second level of subhead indicates subsidiary sections of text, within the first level, where the sense calls for a clear break.

 B Head—can be same point size as the text but bold weight.

 B Head **B Head**

4. The third level of subhead functions as a pointer to the text topic and doesn't need to provide as much of a visual break as the A or B heads.

 C Head—same size as the text but in italics or all caps, set one point size down from the text.

 C Head *C Head* C HEAD

5. The fourth level highlights particular points within the text and shouldn't break the visual continuity.

 D Head—can be small caps, all caps, run-in, or bold a little smaller than the text and run-in.

 D HEAD run into text **D Head** run into text

6. There can be even more levels of subheads depending on the complexity of the text. The number of levels must be known before you can start designing the subheads in order to have distinct differences between all of them and the text.

The purpose of typographic design is to organize all of the elements of a message into a unified and harmonious communication. This can be achieved either quietly by unifying similar elements or more dynamically by using contrasts.

PACING

It is important in printed works, especially longer multi-page items, to create a pace that allows the reader to comfortably navigate through the piece. Breaks can be inserted into the text to provide pauses and keep interest, allowing the reader to stop occasionally without losing their place. If every page looks the same, the reader can become bored and lose interest.

The text contains a narrative that changes pace throughout depending on what is being conveyed. The pace can be enhanced or altered by the design and layout. When planning the layout of a text, it is a good idea to draw out a diagram of all the pages and plan where text and images will be placed to control the pacing. Pacing can be planned in different ways depending on what you are trying to accomplish. It can be a very moderate, even pacing, a rhythmic pacing, or it can build to a climax.

TYPE SPECIFICATION

When a job is sent to an outside source for production that includes setting the type, it must be marked up with either handwritten or digital codes that specify the type instructions. These instructions include:

- Type size and leading in points
- Name of typeface including weight, style, and width
- Length of the column in picas
- Alignment (justified, flush left/ragged right, flush right, ragged left)
- Paragraph indication (indent first line or space between paragraphs, and amount in ems, ens, or points)
- Variations and special instructions (italics; underscores; changes in size, weight, or typeface; hanging indents; etc.)

Layout Diagrams

Even pacing with alternate pages of text and image.

Rhythmic pacing showing facing pages of images and facing pages of text, interspersed with alternate layout pages.

MANUSCRIPT MARK-UP

10/12 Myriad Pro Bold x 25.5 picas flush left

TYPE

A Primer of Information About the Mechanical Features of Printing Types: Their Sizes, Font Schemes, & With a Brief Description of Their Manufacture

one line space

Compiled by — *8/11 Myriad regular*
A. A. Stewart — *9/11 Myriad italic*

one line space

boldface — Lining Type Faces — *2pts.*

When the compositor had occasion to use two or more different faces of type in the same line, these faces were rarely in even alignment, but were irregularly high or low, as shown in the accompanying example [A]. This lack of uniformity made it necessary when a different face was used in the line, as is often required in jobbing and advertisements, to use thin leads, cards, or pieces of paper above and below different parts of the type-

Text set 9/12 Myriad Pro Regular x 25.5 picas flush left

∧ em dash — line in order to get the faces in line—$\frac{1}{m}$ an operation more or less troublesome and expensive. By the modern lining system, the faces made on any given size of body are cast to align with each other, as shown in the second example [B]. These different faces require no more adjustment than if they were all of one font.

new paragraph indent 2 ems — On different sizes of type the shoulder, or blank space, at the bottom of the letter increases gradually with the size of the type, so that a word of small type placed beside a larger size must have some spacing material below as well as above to keep it in its right alignment.

new paragraph indent 2 ems — This necessary difference in the face-alignment of various sizes is graduated by points, in the lining system, so that when more than one size type is used in the same line the justification is made by using point-body leads. This makes the use of slips of card and paper unnecessary and secures greater accuracy and solidity of the composed page.

boldface — Kerned Types — *+6pts.* — *+2pts.*

When the face of a letter is so large that it projects over the type-body, it is known as a kerned type. Letters of this kind are common in italic and script fonts, and there are a few letters, like f and j, in some oldstyle roman fonts which have the tip of the letter overhang. Kerned types are a source of trouble because of the ease with which these projections break off during composition, proofing, etc. Yet they cannot be entirely dispensed with, especially in italic and script faces having a definite slope, where the long letters would have wide gaps on the side (as shown in the script line above) if they were cast on bodies wide enough to hold the entire face. In some styles of upright faces having extra long descending letters g, p, q, y, these descenders may be kerned.

boldface — Spaces and Quads — *+6pts.* — *+2pts.* — *italic*

Short metal spaces and quads (from quadrat, a square), used for blanks between words and elsewhere, are of various thicknesses, as illustrated below. An em is a square of type body of any size. This 10-point em [Symbol: hollow square] is ten points square; a 10-point three-to-em space is one-third of the em, a four-to-em is one-fourth, etc. The en quad is really a thick space, though called a quad, and is equal to half the em. Larger blanks are the two-em and three-em quads, used to fill the last lines of paragraphs and other wide spaces.

TYPE
A Primer of Information About the Mechanical Features of Printing Types: Their Sizes, Font Schemes, & With a Brief Description of Their Manufacture

Compiled by
A. A. Stewart

Lining Type Faces

When the compositor had occasion to use two or more different faces of type in the same line, these faces were rarely in even alignment, but were irregularly high or low, as shown in the accompanying example [A]. This lack of uniformity made it necessary when a different face was used in the line, as is often required in jobbing and advertisements, to use thin leads, cards, or pieces of paper above and below different parts of the type-line in order to get the faces in line—an operation more or less troublesome and expensive. By the modern lining system, the faces made on any given size of body are cast to align with each other, as shown in the second example [B]. These different faces require no more adjustment than if they were all of one font.

On different sizes of type the shoulder, or blank space, at the bottom of the letter increases gradually with the size of the type, so that a word of small type placed beside a larger size must have some spacing material below as well as above to keep it in its right alignment.

This necessary difference in the face-alignment of various sizes is graduated by points, in the lining system, so that when more than one size type is used in the same line the justification is made by using point-body leads. This makes the use of slips of card and paper unnecessary and secures greater accuracy and solidity of the composed page.

Kerned Types

When the face of a letter is so large that it projects over the type-body, it is known as a kerned type. Letters of this kind are common in italic and script fonts, and there are a few letters, like f and j, in some oldstyle roman fonts which have the tip of the letter overhang. Kerned types are a source of trouble because of the ease with which these projections break off during composition, proofing, etc. Yet they cannot be entirely dispensed with, especially in italic and script faces having a definite slope, where the long letters would have wide gaps on the side (as shown in the script line above) if they were cast on bodies wide enough to hold the entire face. In some styles of upright faces having extra long descending letters g, p, q, y, these descenders may be kerned.

Spaces and Quads

Short metal spaces and quads (from *quadrat*, a square), used for blanks between words and elsewhere, are of various thicknesses, as illustrated below. An em is a square of type body of any size. This 10-point em [Symbol: hollow square] is ten points square; a 10-point three-to-em space is one-third of the em, a four-to-em is one-fourth, etc. The en quad is really a thick space, though called a quad, and is equal to half the em. Larger blanks are the two-em and three-em quads, used to fill the last lines of paragraphs and other wide spaces.

PROOFREADERS' MARKS

 Delete

 Close up; delete space

 Delete and close up

 Let it stand (leave as is)

 Insert space

 Make space equal (between words / between lines)

 Insert hair space

 Letterspace

 New paragraph

 Indent type 1 em or insert 1-em space

 Indent 2 ems or insert a 2-em space

 Spell out

 Move right

 Move left

 Center

 Move up

 Move down

 Flush left

 Flush right

 Straighten type; align horizontally

 Align vertically

 Transpose (reverse this)

 Set in italic type

 Set in roman type

 Set in boldface type

 Set in LOWercase

 Set in capital letters

 Set in small capitals

 Wrong font

 Insert here or make superscript

 Insert here or make subscript

 Insert comma

 Insert apostrophe or single quotation mark

 Insert quotation marks

 Insert period

 Insert question mark

 Insert semicolon

 Insert colon

 Insert hyphen

 Insert em dash

 Insert en dash

 Insert parentheses

 Run-in; no new paragraph

When the face of a letter is so large that it projects over the typebody, it is known as a kerned type. Letters of this kind are common in italic and script fonts, and there are a few letters, like f and j,

Text mark-up for run-in.

Assignment: Type Specimen Book

Project

Design and produce a 20-page type specimen book for two typeface families. A type specimen book demonstrates the range of a typeface as applied to headlines and text in a variety of sizes. Type specimens have a long history, going back centuries, to help printers and designers pick fonts for a project. Traditionally, type specimens featured one typeface family on a sheet or broadside, and later turned into books featuring specimens of all of the fonts a type foundry or printer owned. You will be highlighting two typeface families in your book.

Format

5¼″ × 8″, 20 pages plus covers, modular grid used for layout:

- Create an InDesign® document with the proper page measurement; check Facing Pages.
- Change Units and Increments in the Preferences to Picas; on the Master Page A (both pages) set the margins: top: 1p6; inside: 1p6; bottom: 3p; outside: 2p3; 4 columns with 1p gutters.
- Still on Master Page—go to Layout > Create Guides: Rows 6, gutter 1p, Fit Guides to Margins.

Process

Choose one serif and one sans serif typeface from the list below.

Serif		Sans Serif	
Caslon	Cheltenham	Univers	Formata
Centaur	Bodoni	Helvetica Neue	Frutiger
Jenson	Bulmer	Akzidenz Grotesk	Gill Sans
Kepler	Centennial	Trade Gothic	Meta
Bembo	Didot	Antique Olive	Futura

Use the text provided. The text will be used for the text and heading samples. You do not have to use all of the given text.

Your book must include the following:
- Covers (title–you make up, author–you, and whatever else you want to put on it)
- Title Page—p. i
- Table of Contents—p. iii

Start Arabic numbering (these pages can be in any order that you want)
- Letters, numbers, and special characters, both upper and lowercase for both typefaces
- The entire typeface family for both faces
- A size range for both typefaces
- Anatomy of the typefaces using multiple letterforms and numbers, comparing the differences and/or similarities of the two typefaces
- Experimental settings using some of the given text in both typefaces

Sample Student Solutions

Cassie Kelsey

Cassie Kelsey

Cassie Kelsey

Cassie Kelsey

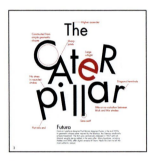

Xiaoying Ma

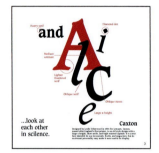

Xiaoying Ma

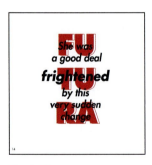

Xiaoying Ma

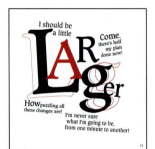

Xiaoying Ma

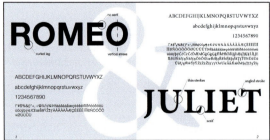
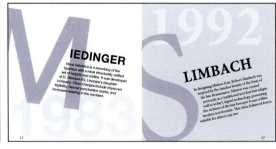

Jessica Halim

Assignment: Design History Booklet

Objective

To explore narrative text across multiple pages, explore grid design, and further enhance your skills with typographic hierarchy and structure. You will be introduced to formal page elements used in publications.

Assignment

Page size: 7½″ x 7½″ square. Spread size: 15″ x 7½″.

Choose one of the following design periods:
Constructivist
Futurist
Dada
The Bauhaus
De Stijl
Art Deco
Swiss Style
The New York School

Start by looking at *Meggs' History of Graphic Design*. You are going to write, collect high-res images, and design an 8-page booklet about the period you choose. Your book will focus on the graphic design and typography of the period.

Required Elements

Cover—Title, Author
Body Text—this must include subheads to break up the text
Main Head (and Chapter Heads, if applicable)
High-Res Images
Image Captions
Page Numbers (if you are doing a bound book)
Timeline (of the period, of designers of the time, or anything else you think interesting from the period)
Sources

Process

Using your research, design a book or accordion-fold book about your period. You must create a grid for the required page size.

1. Analyze your text and elements to determine the order and hierarchy. On paper, sketch layouts for opening spreads on the grid using lines and geometric shapes to represent all text elements and images. Your lines and shapes must fall on grid lines. All elements must start and stop on a grid line. (Make photocopies of the grid to sketch on.)

 Arrange for hierarchy but also keep in mind how all of the elements work together (scale, balance, proximity, color, rhythm) to create the "message." Consider how the eye moves across and through the pages.

 Try different things for contrast—scale changes, weight changes, verticals, diagonals, etc. Make three different layout sketches for the opening spread.

2. Do the text exercises after choosing typefaces. When a point size and leading have been picked, then lay out the opening spread you want to use on the computer. All required type elements must be included. Continue to lay out the rest of your pages. Print out black-and-white spreads.

3. Once all changes and corrections have been finished, print out color copies for binding. Demo for binding will be done in class.

Sample Student Solution

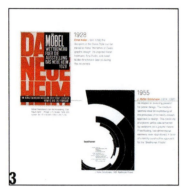

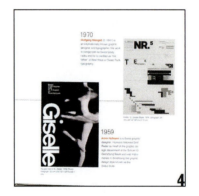

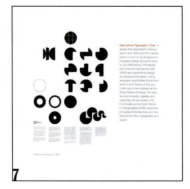

Katherine Walker

10.
Using InDesign® Styles

InDesign® styles are a useful tool for streamlining the production process of any project, but especially for the production of publications consisting of many pages and sections. With the styles you create, you quickly can apply specified type styles to repeat elements.

CREATING PARAGRAPH STYLES

Open the Paragraph Styles panel—choose Type > Paragraph Styles. The default style is [Basic Paragraph], which is automatically applied to any text you type in the document. You can edit it but you can't rename or delete it. It is best not to use it and instead create a new text style.

Creating a New Style

Open the Paragraph Style Options menu to create any number of styles for a document. From this menu you also can apply any typographic specifications to a style.

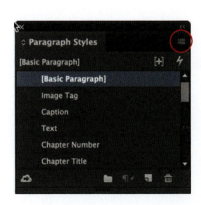

Creating a Style Based on Another Style

This method is useful when you have multiple levels of subheads in a document and you want to create all of them based on the largest, or first level, of the subheads. The advantage to this is that if you edit the base style, then any attributes shared with the other styles also will change. For example, say all of the subheads are set in the same typeface and you want to change that typeface to another. By changing the typeface of the base style, or first-level subhead, the typeface of all of the other subheads that are based on that style will change also.

Creating a Style Based on Specifications Set in the Text

- Highlight the paragraph or text you want to create a new style from.
- Open the Paragraph Styles menu and choose New Paragraph Style. The window will show the settings you have applied to that text. You can make changes or leave them.
- Name the style and select Apply Style to Selection to apply the new style to the text you have selected. Click OK. The new style is now in the list on the Paragraph Style panel.

To create a style based on a previous style you've created, choose the style you want in the "Based On" pull-down menu and create a name for the new style. Make the modifications you want in the Character Formats menus.

To create a new paragraph style based on type specifications you set in a block of text, open the Paragraph Styles menu and choose New Paragraph Style.

New style created based on the specifications applied to the paragraph above.

CREATING CHARACTER STYLES

Character styles are used to apply formats to specific words or pieces of text within paragraphs, but not to the entire paragraph. For example, if one of your subheads is a run-in subhead, meaning the subhead is a part of the paragraph and not on a line by itself, you need to put a style on the run-in head but not the rest of the paragraph. You can highlight just the subhead and apply a character style to it.

• Open the Character Styles panel, Type > Character Styles, and select New Character Style.

• Name the style and select the format attributes from the options on the left side of the panel. Click OK.

You also can highlight a selected word, or group of words, and create a character style based on it by opening the Character Styles menu and naming the style. You can check Apply Style to Selection to apply the new style to the selected text.

IMPORTING STYLES FROM OTHER INDESIGN® DOCUMENTS

This is a useful feature if you are creating a book or other publication where each part or chapter is in its own document. You can create all of the styles in the first document and then import them into each new document.

In either the Paragraph or Character Styles menu:

- Choose Load Paragraph Styles or Load Character Styles.
- Choose Load All Text Styles to import both paragraph styles and character styles.

Find the InDesign® document with the styles you want to import.

- In the dialogue box, make sure there is a check mark next to all of the styles you want to import.
- If an existing style has the same name as one you want to import: In the dialogue box, make sure there is a check mark next to all the styles you want to import, and choose one of the following under Conflict With Existing Style:

a) Use Incoming Style Definition—this will overwrite the existing style with the imported one and applies the new attributes to all text in the current document that has that style applied to it.

b) Auto-Rename—renames the imported style with the word "copy" at the end of it. For example, if both documents have a style named Main Head, the imported style will be named Main Head copy.

APPLYING PARAGRAPH STYLES

Click in the paragraph, or select a part or all of a paragraph or paragraphs, then click the style name in the Paragraph Styles panel, or select the paragraph style name from the drop-down menu on the Control Panel. If any formatting you don't want remains, choose Clear Overrides from the Paragraph Styles menu.

APPLYING CHARACTER STYLES

Select the characters that you want to apply a style to, then click the character style name in the Character Styles panel, or select the character style name from the drop-down menu on the Control panel.

Applying styles Use either the Paragraph Styles menu, or the Character Styles menu to apply pre-made formatting to particular paragraphs or words. Highlight the text you want to change and select the style from the proper menu to apply it.

Top left: Original paragraph as typed. Right: Paragraph with "Text" style applied to it.

Applying styles Use either the Paragraph Styles menu, or the Character Styles menu to apply pre-made formatting to particular paragraphs or words. Highlight the text you want to change and select the style from the proper menu to apply it.

Right: "Subhead C" Paragraph style applied to first two words of the paragraph.

Applying styles Use either the Paragraph Styles menu, or the Character Styles menu to apply pre-made formatting to particular paragraphs or words. Highlight the text you want to change and select the style from the proper menu to apply it.

Use either the Paragraph Styles or Character Styles panels (left) or the Control panels (above), to select styles.

Glossary

A

@ The "At" sign. In use since the mid–1500s to mean "each one for the price of."

AA (Author's Alteration) Used in proofreading to indicate any change or correction in the copy that is made by the author.

Accent A small mark added over, under, or through a letter indicating specific punctuation or pronunciation. (See also *Diacritical mark.*)

Acute accent (é) Used in the writing system of some languages to indicate that the vowel over which it is placed has a unique quality or that it receives the strongest stress in the word.

Agate Vertical unit of measurement used in newspaper columns. Equal to 5½-point type.

Alignment Having letters, words, or lines of type align along a left, right, center, top, or bottom margin or axis; or a combination of these.

Ampersand (&) The typographic character that represents "and."

Analphabetic Typographic characters that do not fall within the alphabetic order. Characters such as the asterisk and ampersand are examples.

Anti-aliasing The process of applying gray pixels to the pixels at the edges of characters to eliminate jaggedness and simulate smoothness.

Antiqua Old Style serif letterforms based on northern Italian manuscripts of the 11th and 12th centuries.

Aperture The opening at the end of an open counter space, such as n.

Apex The juncture of stems at the top of a letter, such as capital A, M, and W.

Arabic numerals The numbers 0 through 9, so called because they originated in Arabia. (See also *Roman numerals.*)

Arm A horizontal or diagonal character stroke that is unattached on one or both ends as in the uppercase F, L, K, and T.

Ascender The parts of lowercase letters that extend above the body or x-height as in b, h, d, and k.

Asterisk (*) Reference mark or sign at ascender height usually used in text to indicate a footnote.

Axis An imaginary line that connects the thinnest parts of a circular character's stroke, indicating its angle of stress.

B

Ball terminal A round-shaped end in characters such as c and f in certain typefaces, such as Bodoni.

Baseline The imaginary line upon which the base of all the characters in a given line of type sit.

Baseline grid An invisible grid of horizontal lines at user-defined intervals (usually based on the point size and leading of the type being used) where all of the text baselines on a page sit.

Beak The serif-like form at the end of the arms on characters such as E, L, F, and T in certain typefaces, such as Caslon.

Bevel In metal type the sloped surface rising from the shoulder to the face of the letter.

Beziér curves In a postscript drawing or layout program, a curved line that is defined by a starting point and an ending point with its path and shape controlled by one or more additional points defined by a mathematical equation.

Binary Anything made up of only two parts or units. A numbering system using two digits: 0 and 1.

Binding The fastening together of signatures made up of printed sheets into books, magazines, booklets, etc. It also includes the covers and spine of a book or magazine.

Bit The smallest unit of information in computer systems, representing one binary digit 0 or 1. It represents a single binary operation: yes or no, on or off.

Bitmap A computer image made up of dots that are "mapped" onto the screen directly from corresponding bits in memory (hence the name bitmap). A font whose characters are composed of dots such as those designed for dot-matrix printers and used for display on computer screens.

Blackletter Angular 15th-century European Gothic lettering with tightly spaced and heavy strokes. Gutenberg's first metal type was modeled on Blackletter script. The five categories of Blackletter are: Bastarda, Fraktur, Quadrata, Rotunda, and Textura.

Bleed The area of an image that extends beyond ("bleeds" off) the edge of the page.

Blurb A short summary of the contents of a book or author bio printed on the jacket or cover.

Body copy Also called text type, it refers to the primary text of the story, as opposed to headings and display type. Body copy usually is set in one typeface and point size below 12 points.

Body size The height of the type measured in points. Originally referred to the height of the metal block on which the letters were cast. The body size of digital type is measured slightly beyond the highest and lowest points of the characters as if they were still sitting on the metal block.

Boldface A font with thicker, heavier strokes than the roman version of the typeface.

Boustrophedon Early Greek writing where alternating lines are written in opposite directions. One line is written from left to right, then the next line's letters are reversed and written from right to left.

Bowl The curved stroke that forms an enclosed space within some characters such as the uppercase C, O, Q, and lowercase b, d, p.

Braces or curly brackets ({ }) Used to enclose listed items, or a series of like items, to indicate that they are a unit.

Brackets or square brackets ([]) Used to enclose explanatory or missing material, most often added by someone other than the original author.

Bullet (•) Usually a small, solid circle (it can also be square) used to mark the start of a paragraph or items in lists.

C

C and l.c. Denotes capitals and lowercase when marking up copy for typesetting, or when proofreading.

C and SC Denotes capitals and small capitals when marking copy for typesetting, or in proofreading. In typesetting, the lowercase letters are set in small capital letters that usually are 75% the height of the capital letters.

California Job Case A large tray or drawer with divided compartments used to store metal type. The individual compartments are arranged according to the frequency of use of the characters.

Calligraphy Hand-drawn letters or writing. From the Greek meaning "beautiful writing."

Cap height The height of the capital letters in a typeface, measured from the baseline to the top of the capital letters in a particular typeface.

Caption A title or brief description for an illustration, graphic, or photograph.

Caret (∧) The symbol used to indicate an insertion in proofreading. First used by 13th-century scribes.

Case A shallow, rectangular box (drawer) divided into compartments for holding each character in metal type.

Casting The process in which molten metal is forced into type molds (matrices) to cast single characters of type, or complete lines of type (Linotype).

Casting off The process of calculating the length of manuscript copy to determine the amount of space it will occupy when set in a given font and point size.

Cedilla (ı) The diacritical mark placed under a letter in foreign languages (such as French) to indicate an alteration or modification of its usual phonetic role.

Centered type Lines of type of varying lengths set centered along a central axis on the line measure.

Chapter head Chapter title and/or number on the first page of each chapter of a book.

Character Any letter, number, punctuation mark, or symbol of a font.

Character count The total number of letters, punctuation marks, and spaces in a line, paragraph, or block of text.

Character width The horizontal dimension of a character of type, which includes the white space on both sides of it. It is expressed in fractions of an em. Also the width of the bounding box of a character.

Chase A metal frame into which metal type is locked for printing. The type is held in place by furniture and quoins.

Cicero A European linear unit of measurement used to measure the width of a line of type. It equals 12 didot points, slightly larger than the American pica.

Cold type The general term for type that is created by means other than casting molten metal, such as photo or digital typesetting.

Colon (:) Punctuation mark used to introduce a list within a sentence; used to separate two major parts of a sentence; used to indicate a ratio or a time.

Colophon An inscription, usually placed at the end of a book, that contains facts about the book's production. It identifies designers, artists, and/or printers, and specifies typefaces and papers used.

Color (typographic) The tonal value (lightness or darkness; gray value) created by text on a page. It is affected by the type size, weight, and letter- word- and line spacing.

Column One of two or more vertical sections of text on a page separated by a rule or blank space.

Column inch A measure commonly used by newspapers representing a space that is 1-inch deep and a column wide.

Column rule A vertical line between two columns of type.

Comma (,) Punctuation mark used to separate words, or phrases, in a sentence.

Comp (comprehensive layout) An accurate representation of a printed piece showing all type and images in their true size and position. (See *Dummy*.)

Composing stick A small, handheld metal tray used to assemble metal type. It is adjustable for setting lines of different widths.

Condensed type Letterforms that have been designed with narrower character widths than the regular roman forms of the typeface.

Contrast (typographic) 1) The amount of variation between the thick and thin strokes of a letter. 2) In a designed piece, the planned differences in typographic size, color, weight, or placement used to show hierarchy and/or add visual interest.

Copy The written or typed text for a project to be marked up for typesetting.

Copyfitting The process of determining the area required for a given amount of copy to occupy when set in a specific font and point size.

Counter/Counterspace The space inside of a character of type, enclosed by strokes that form the letter, such as a, e, o, A, B, C.

Crop To eliminate portions of a photograph, illustration, or letterform by cutting them off or bleeding them off the edge of the page.

Crop marks Short lines shown in black, placed approximately 3mm outside of the print area of the document. They indicate where to trim down the pages after they are printed.

Crossbar A horizontal stroke connecting two stems as in A, H; or, a horizontal stroke cutting across the stem of a letter as in t, f.

Cursive Typefaces (also called *Scripts*) that imitate handwriting; often the letters are joined and slanted but sometimes they are disconnected.

D

Descender The stroke of a lowercase letter that extends below the baseline, as in p, q, y.

Diacritical mark A mark or symbol added above or below a letter to give it a particular phonetic sound, stress, etc.

Didot Typographic system of measurement used outside of the United States, established by Francois-Ambroise Didot around 1775. The didot point measures .0148″ compared with .0138″ for the American point.

Dingbat A decorative character, designed and sized as a font, or part of a font, consisting of icons, symbols, fleurons, ornaments, etc.

Diphthong A ligature that represents two vowel sounds in one syllable, such as Æ, Œ, œ, æ.

Discretionary hyphen A manually inserted hyphen to break a word that does not break automatically. No hyphen will be visible unless the word is broken. If a discretionary hyphen is inserted in front of a word, it will prevent the word from breaking or hyphenating.

Display type Type used for titles, headings, subheads, etc., and set at 14 pt or larger to attract attention.

Dot leader A series of dots used to guide the eye from one point to another. (See *Leader.*)

Dots per inch (dpi) The resolution at which a device, monitor, or printer can display text and graphics. Computer screens display at 72 dpi; laser printers at 300 dpi, 600 dpi, or more; and inkjet at 1270 dpi, 2540 dpi, or more.

Drop cap The first letter of a paragraph set in a larger point size than the text, whose baseline is lower than the baseline of the first line of the paragraph, usually going to the third line of the paragraph or beyond.

Dummy A sample of a layout, containing all of the elements and showing how the various elements will be arranged. (See *Comp.*)

Duotone A halftone photograph printed in two colors, usually black and one spot color.

E

Ear The small stroke that extends from the upper right of a two-story lowercase g, and also the angled or curved horizontal stroke of the lowercase r.

E-gauge A scale consisting of various point sizes of capital E's, used to determine the point size of typeset text.

Egyptian See *Slab serif.*

Ellipsis (…) A series of dots, or periods, used to indicate an omission in the text. Three dots (Option ;) are used mid-sentence, while four dots are used at the end of a sentence.

Em A unit of measure equal to the square of the point size of the text being set. An em for 10-point type is 10 points, for 14-point type it's 14 points, etc.

Em dash Also known as a *long dash*, it measures one em in length. It is used to attribute a quote to a specific author, and to separate thoughts within a sentence. It should not have any spaces added to either side of it.

Em indent Paragraph indent that is equal to an em.

Em quad In handset type (letterpress), a metal spacer that equals the square of the point size of the type being set. The name em comes from the fact that in early fonts, the M usually was on a square body.

Em space A fixed space equal to an em quad, or the square of the point size of the type being set. Its width doesn't change with hyphenation and justification settings.

En A unit of measure that equals half of an em. An en in 10-point type equals 5 points, in 14-point type it equals 7 points, etc.

En dash Also known as a short dash, it is one en in length. It is used to separate durations of time, or to replace "to" in text, as in 7–9 pm, and should not have any spaces added to either side of it.

En quad In handset type, a metal spacer that is one-half the width of an em quad.

En space A fixed space that is one en wide, or half the square of the point size of the type being set. Its width doesn't change if changes are made to the hyphenation and justification settings.

EPS (Encapsulated Postscript) Computer file format used to transfer Postscript files between applications.

Exclamation point (!) Punctuation mark used at the end of a sentence to show strong feeling or excitement.

Expanded or Extended font A font whose characters are wider than those of the regular roman font in a family of type.

Eye The counter space at the top of the lowercase e.

F

Face 1) The top side of a piece of metal type that contains the character and is inked for printing. 2) An abbreviation for typeface or type style.

Family of type See *Type family*.

Fibonacci sequence A series of numbers where each successive number in the sequence is equal to the sum of the two preceding numbers: 0, 1, 1, 2, 3, 5, 8, 13, 21, etc.

Figures Another term for numbers.

Finial The tapered end on the top of lowercase letters like the two-story a or the bottom of the lowercase c or e.

Fixed space A nonbreaking space that prevents an automatic line break at its position.

Flag The horizontal stroke on the numeral 5.

Flop To reverse the direction of an image so that it faces the opposite way.

Flush left A block of type that aligns along the left-hand margin with the right side being ragged.

Flush right A block of type that aligns along the right-hand margin with the left side being ragged.

Folio Another term for page number.

Font The complete set of characters (letters, numbers, punctuation marks, symbols, etc.) of one weight and style of a type family. In metal type, a font also means one point size and weight/style of a typeface.

Footer or footline A type element, such as a page number and/or chapter title that is set in the bottom margin of a page. If it is repeated on every page of a multi-page document, it is called a *Running footer*.

Format 1) The overall typographic and spatial design of a print or web job. 2) To digitally specify the size, weight, and position of elements on a page.

Foundry type Metal type used for hand composition.

Furniture The wooden blocks that keep the hand-set type, or plate, from sliding around on the press bed.

G

Gadzook The stroke connecting two letters together in a ligature. Not a part of either letter originally, it only exists in a ligature.

Galley 1) A photographic print of typeset copy, from a typesetter, that is run out as one long column of type, to be cut and pasted on a layout board. 2) In letterpress, the shallow, three-sided tray used to hold and lock up the metal type for printing.

Galley proof A proof pulled from metal type that has been assembled in a galley.

Glyph Any character (letter, number, symbol, etc.) that is part of a font.

Golden ratio/Golden mean A mathematical ratio of approximately 1:1.6180339887.

Golden section A line segment divided according to the golden ratio: The total length $a + b$ is to the length of the longer segment b as the length of b is to the length of the shorter segment a.

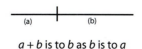

$a + b$ is to b as b is to a

Grain The direction that the fibers lay in paper. The grain dictates how easily paper will fold, and also if the finish or ink will crack when folded. You want to fold with the grain to prevent this.

Greeking Nonsensical type used to indicate body text in a layout or client comp.

Grid The underlying skeletal guide, determined by the designer, that is used to organize typographic and pictorial elements in a layout. The grid usually indicates column width, margins, and image size and placement, among other things.

Grotesque or Grotesk A classification name for some sans serif typefaces. The name started in Europe in the 19th century because the typefaces were considered ugly when they were first introduced.

Gutter or Gutter margin The vertical band of white space that separates columns of type on a page, and the inner margin (where two facing pages come together) of a page in multiple-page documents.

H

Hairline 1) The thinnest stroke, or serif, of a letter in the Modern classification of typefaces. 2) The thinnest line or rule, usually .25 pt, that can be reproduced in printing or digitally.

Hand setting Method of setting type by placing individual pieces of metal type into a composing stick.

Hanging indent A paragraph arrangement in which the first line hangs beyond the left side of the lines below it. Sometimes called an *Outdent* or *Reverse indent*.

Hanging initial The first letter of a paragraph, display size, set in the left margin next to the body text.

Hanging punctuation Setting where punctuation that falls at the beginning or end of a block of text, such as quotation marks, is set outside of the text column, allowing lines of type to align vertically either on the left or right margin.

Head/Heading/Headline The most important line of type on a page, usually the title, which is given emphasis over the body text through size, weight, color, and/or spatial changes.

Head margin The white space at the top of the page, above the top of the text area, or first line of type.

Height to paper In letterpress printing, the overall height of printing type and plates, standardized as 0.9186 inch.

Hierarchy A series of ordered groupings of typographical elements and/ or images arranged by order of importance in reference to the message being conveyed.

Humanist A classification term applied to typefaces derived from hand-lettered models. It applies to both serif and sans serif faces that have an angled axis and differences in stroke thickness.

Hyphen (-) Used to join compound words or parts of a word divided for any reason, such as at the end of a line of text.

Hyphenation The syllabic breaking of words at the end of a line of type in order to fill the line as close to the end as possible in flush-left type, or to prevent too tight or too loose a setting in justified type.

Hyphenation zone The user-defined area on the right side of a column of unjustified text. Hyphenation will occur only in words that fall to the left of this area. If a word starts within this area it will not be hyphenated but instead moved to the beginning of the next line.

I

Ideograph A symbol that represents an idea, not an object, often made by combining two or more pictographs.

Imposition The arrangement of pages in press form, or signatures, so they will be in the correct order when the printed sheet is folded and trimmed.

Incunabula (1450–1500 A.D.) "Cradle." Describes the first 50-year period of printing with moveable type.

Indent The space placed at the beginning of a block of text to indicate a new paragraph. Space used at the left margin to offset a selection of text or tabular matter from that above it.

Index An alphabetized list of items from a text, such as topics, and the page numbers where they can be found in the text.

Inferior character See *Subscript*.

Initial/Initial cap A letter or decorative element, set at a larger point size than the text, at the beginning of a paragraph for visual contrast and to indicate the beginning of a section of text.

Italic A slanted version of a font, distinct from the roman form, used for emphasis or distinction. They usually have a cursive, calligraphic quality for serif typefaces, but are slanted versions of roman sans serifs, called *obliques*.

J

Justified Blocks of text that are aligned vertically along both the left- and right-hand margins.

Juxtaposition The act of positioning elements close together, or side-by-side.

K

Kern/Kerning The process of adjusting the space between two characters in larger point sizes in order to achieve optically equal letter space.

Kerning pair Two letters whose shapes cause them to need kerning adjustment when they are set next to each other.

Kill The process of deleting unwanted text or copy.

L

Laid paper Paper with a pattern of parallel lines to simulate the look of handmade paper that has a texture created by the screen used to form it.

Layout A sketch, plan, or blueprint of a design showing the position and spacing of type and imagery.

Leader(s) A series of repeated characters, usually dots (but can be dingbats, hyphens, dashes, etc.), used to connect other elements or "lead" the eye across an area from one element to another. Most often used in tables of contents.

Lead-in The first few words in a paragraph or block of text that are set in a contrasting format (different typeface, weight, size, etc.) in order to set it off from the rest of the paragraph. Used most often as a lower-level subhead.

Leading The distance, measured in points, from the baseline of one line of text to the baseline of the next line (the space between lines of type). In metal typesetting, strips of lead were placed between lines of type to increase the interline spacing, which is where the term comes from.

Leaf Any of the sheets of paper bound in a book, each side representing a page or spread.

Leg The angled, downward stroke of a letter that is attached to a stem stroke on one end and free on the other end (K, R).

Legibility The quality in typography that determines how easily the characters and words can be recognized by the eye of the viewer.

Letterspacing Adding space between letters, in a line or block of text, in order to allow the line to fill a specific pica width, or to improve the appearance.

Ligature Two or three characters joined or combined into a single character in order to solve difficult spacing problems, such as ffi, fl, fi, ffl.

Light face A lighter version of a regular typeface made up of thinner strokes, and where the counter spaces are greater in mass than the weight of the strokes.

Linecaster A typesetting machine that uses hot metal to cast entire lines of type in one piece.

Line gauge Also called *type gauge* or *pica rule*, it is used for copyfitting and measuring depth in body copy.

Line length/Measure The width of a column of type, measured in picas.

Line spacing See *Leading*.

Lining figures Numerals that have a common character width, are the same height as the capital letters, and sit on the baseline.

Link The stroke that connects the bowl and the loop of a lowercase, two-story g.

Lowercase The small letters or minuscule characters as opposed to capital letters. The term comes from the placement of the letterpress case of small letters below the wooden case containing the capital letters.

M

Majuscule Calligraphy term referring to letterforms representing capital letters.

Margin The white space that exists from the edge of the page to the edge of the text or print area of the page on all four sides.

Marginalia Notes in the margin of a book, manuscript, or other document.

Markup In typesetting, the marking of type specifications on the manuscript copy.

Masthead The section of a publication (magazine, newspaper) that contains the editorial credits: names and titles of staff, addresses, contact info, etc.

Meanline The imaginary line that marks the top of the lowercase letters, not including ascenders. Also indicates the top of the x-height.

Measure See *Line length*.

Minuscules Calligraphy term that refers to letter forms evolved from *half uncials*, representing lowercase letters today.

Modern Classification of typefaces, developed in the late 18th century, that have strong contrast between the thick and thin strokes, usually with hair-line serifs and vertical stress.

N

Negative leading Leading, or line spaces, with a value that is less than the point size of the type being used.

Nonbreaking space A word space used to keep a pair of words together so they don't break at the end of a line. If both words won't fit on the line, both are dropped to the next line.

Non-lining numerals See *Old Style figures*.

O

Oblique A type style that is slanted to the right and based on the roman characters of a sans serif typeface. The name of the italic style of a sans serif typeface but does not have cursive design qualities like serif italics do.

OCR (Optical Character Recognition) The process of converting typed, or printed, documents into digital format. The document is scanned, then it is read by OCR software and converted into a word processing file.

Octavo Also called *Eightvo*. A book size that results from folding a sheet of paper of a specific size to form eight leaves; also, a size of cut paper measuring 8 inches by 5 inches.

Offset lithography A printing method that uses photo-mechanical plates that are right-reading. The plates are inked, and the image is offset printed onto an intermediary roller, then printed on the paper.

Old Style A typeface classification that refers to typefaces developed in the late 15th and early 16th centuries. Characteristics include bracketed serifs, diagonal stress, and moderate contrast between thick and thin strokes.

Old Style figures Also referred to as *non-lining numerals*. Numbers that vary in height, imitating ascenders and descenders, so that they blend into a block of text better.

Open type A cross-platform font format that allows a font to be used on both Macintosh and Windows machines, and also allows almost a limitless number of characters in each font.

Optical alignment Aligning elements or letter forms so that they appear to be aligned rather than actually being aligned.

Optical center A point that is approximately 10% above the actual mathematical center of the page. It appears to be more centered than the actual center.

Orientation Position or alignment of elements relative to the direction of the page.

Orphan One or two lines of a paragraph that appear either at the bottom of a column or page, or at the top of a column or page.

P

Page A leaf, or one side of a leaf, in a book or manuscript.

Pagination The numbering of pages in consecutive order.

Pantone® Matching System® Abbreviated PMS. System for specifying colors and printing inks, which are number-coded and a standard element in the printing industry.

Paragraph mark (¶) A typographic symbol used to indicate the beginning of a new paragraph if no indention or other indicator is used.

Parentheses () Used to contain material that may be omitted without destroying or altering the meaning of a sentence. Also used to enclose supplementary information.

P.E. Abbreviation for *Printer's Error*. Used to mark a mistake made by the typesetter, as opposed to the author or designer.

Period (.) Punctuation mark used to indicate the end of a sentence. Also used to mark the end of an abbreviation.

Pica A typographic unit of measurement consisting of 12 points, or ⅙ of an inch. Line lengths and column widths are measured in picas.

Pi characters Glyphs not usually included in fonts, such as mathematical symbols, special ligatures, reference marks, etc.

Pixel Stands for *picture element*, the smallest unit that can be displayed on a computer screen.

Point The basic unit of type measurement—12 points equal one pica. Used to measure the size of type and the amount of leading between lines of text.

Point size See *Type size*.

Postscript A page description language created by Adobe Systems that enables vector-based outlines to be rasterized efficiently. It treats all marks, including type, as graphics.

Pothook The curved "serif" at the top of some lowercase italic letters, like n, m, and u.

Primes (' ") Type glyphs used to indicate feet and inches, and hours and minutes.

Proof A trial print, or sheet of printed material, that is checked against the original manuscript for accuracy, and upon which corrections are made. Any output that can be checked prior to final printing.

Proofreaders' marks Shorthand symbols used by copy editors, proofreaders, and designers to indicate alterations and corrections in the copy.

Q

Quad In metal type, a piece of metal shorter than type-high that is used for spacing. An em quad is the square of the point size of the type being set.

Quarto 1) The page size obtained by folding a sheet of paper into four leaves, or 8 pages, each one-quarter the size of the sheet. 2) A book composed of pages of this size. 3) A name for paper cut to 10 inches by 8 inches.

Question mark (?) Punctuation mark used to indicate the end of a question.

Quotation marks (" ") Punctuation marks used at the beginning and end of a quote to show that it is written exactly as it was originally said or written.

QWERTY The universal keyboard layout, named for the first six letters at the top left of the keyboard.

R

Ragged left A typesetting alignment setting where all text lines are aligned vertically on the right-hand margin but are allowed to be left short on the left margin to fit, creating an uneven margin on the left, hence the "rag."

Ragged right A typesetting alignment setting where all text lines are aligned vertically on the left-hand margin, but are allowed to be left short on the right margin to fit, creating an uneven margin on the right.

Raised initial/Raised cap The first letter of a paragraph that is set in a larger point size than the rest of the paragraph and set on the baseline of the first line of text, causing it to project above the cap height of the first text line.

Raster image processor (RIP) A device or program that converts type and images into an arrangement of dots that can be imaged on a computer screen, digital printer, or other digital output device.

Readability The measure of how easy it is to read a given body of text based on the column width to point size ratio, x-height of the font, amount of leading, and color of the type.

Recto page A page on the right side of a multi-page document. All odd number pages are recto pages.

Resolution The number of dots per inch used to print images on digital printers, or the number of pixels per inch on a computer screen.

Reversed type White or light-colored type dropped out of a dark background.

River In a block of text type, a series of word spaces that accidentally align vertically or diagonally, creating a "river" of white space in the text block. They occur frequently in justified text where the word spacing is opened up to flush align the lines of type on the right margin.

Roman Upright typefaces, constructed on the vertical, which do not slope right or left like italics. Named after the upright serif letter forms of Roman inscriptions.

Roman numerals Letters used by the Romans to represent our Arabic numerals. For example: I for 1, X for 10, L for 50. Today they are used to number the frontmatter pages of a book.

Rough A preliminary sketch or idea, done quickly, to show the general idea of the design or layout.

Rule A typeset line, whose thickness, specified in point sizes, can vary.

Run-in head A subhead that is set into the first line of a paragraph. It is sometimes set larger, bolder, in italics, or in a different font from the text.

Running footline or footer A repetitive line of text, usually the publication or chapter title, or a design element, that appears in the bottom margin area of all pages in a publication.

Running head or header A repetitive line of text, usually the publication or chapter title, or a design element, that appears in the top margin area of all pages in a publication.

S

Saccadic jumps Rapid, intermittent eye movements, such as those that occur while reading across a line of words.

Saddle stitch A binding made by inserting a staple through the center of folded sheets from the back and clinching in the fold.

Scaling The process of calculating the percentage of enlargement or reduction of original artwork to fit a given space.

Script A typeface based on handwritten, joined letter forms, often incorporating a right slant and some flourishes.

Semicolon (;) Punctuation mark used to separate major parts of a compound sentence.

Serif Small stroke added to the end of a main character stroke. Serifs aid in character recognition.

Set solid Refers to type set with no additional leading added between the lines.

Set width In metal type, the width of the body upon which the type character is cast. In digital typesetting, the width of a character plus its side space.

Shoulder 1) In metal type, the top of the type body that surrounds the raised letter form. 2) A curved, lowercase character stroke such as those on the h, m, and n.

Slab serif A square or rectangular serif that may or may not be bracketed. Typefaces with slab serifs also are called *Egyptian*.

Slug 1) In typesetting, a whole line of type cast in hot metal as a single piece on a linecasting machine, such as Linotype. 2) Strips of metal spacing material used to create vertical space on the page in letterpress printing.

Small caps Capital letters that are about the same size as the x-height of the typeface. Unlike capital letters set in a smaller point size, true small caps are drawn proportionally to appear as the same weight as the full-size capital and lowercase letters of the typeface.

Soft return An alternate return command that starts a new line of text without starting a new paragraph. In most page layout programs, it is achieved by holding the Shift key while pressing the Return key.

Solidus (/) Oblique, forward slash or *virgule*, used as a fraction bar to separate the numerator and denominator.

Speccing A term that is short for type specification, meaning to mark up copy with accurate instructions for typesetting.

Spine 1) The central curved stroke of the letter S. 2) The part of a bound book covering the backbone, and usually bearing the title and author's name.

Spur The small nodule at the base of the vertical stroke in some designs of the capital G.

Square serif See *Slab serif.*

Stem The main vertical stroke of a type character.

Stet A proofreader's notation that means the copy marked for correction, or change should not be changed after all. Rather, the text should be left as originally set or typed.

Stress In typefaces that have a contrast of thick and thin strokes, the imaginary axis line that connects the thin strokes that fall at the top and bottom of some letters. This line can be vertical or angled depending on the design of the letters, causing the stress to be either vertical or angled.

Subscript A character set smaller than the point size of the text and placed below the baseline next to another character. Used for scientific or mathematical equations.

Superscript A character set smaller than the point size of the text, placed above, or slightly above, the cap line and to the right of another character. Used to denote footnotes or notes to the text.

Swash characters A decorative alternate letter (usually a capital letter) that has extended ornamental, flowing tails called *flourishes*.

T

Tabular figures Numerals that have the same width and are used to vertically align tabular material, such as tables. The bottom of each number sits on the baseline, which is why they also are called *lining numerals* or *lining figures*.

Tail The descending (usually diagonal) stroke of certain letters, such as Q, R, K, y. See *Leg*.

Teardrop terminal The tear-shaped ending on some serif typeface finials, such as the lowercase f and a in the Times Roman typeface.

Terminal The free end of a character stroke, which may or may not be adorned or have a serif. Types of terminals: ball, half-serif, teardrop, straight, acute, horizontal, convex, concave, flared, hooked.

Text (Body copy) The main body text of a printed piece, as opposed to headings, footnotes, etc.

Text type Fonts designed for maximum legibility when set in normal reading sizes of 9–12 points.

Thin space A fixed space measuring one-fourth or one-fifth of an em.

Thumbnails Small, quick, rough sketches used to portray a number of design concepts for a project.

TIFF (Tag Image File Format) A computer format for saving images as high-resolution bitmapped files.

Tittle The dot on the lowercase i or j.

Tracking The adjustment of the overall letter spacing between all characters in a line or block of text. The space either can be tightened up or opened up. Not to be confused with *kerning*.

Transitional A type style classification of serif typefaces developed in the 18th century. They are the evolving style between Old Style and Modern, and contain characteristics of both of these styles.

Transpose (tr) A proofreading term that means to switch one element (letter, word, group of words, sentence) with another.

Trim marks See *Crop marks*.

Trim size The final size of a printed piece after it has been bound and trimmed.

TrueType Font format that contains outlines that can be rasterized by both the Windows and Macintosh operating systems.

Type 1 The international type standard for digital Postscript fonts.

Typecasting The process of creating type in molten metal, either as individual characters or as complete lines of type.

Typeface See *Type family*. In letterpress, a complete set of characters with consistent design qualities in all point sizes.

Type family All of the various weights and styles of a particular type design (Light, Bold, Italic, Condensed, etc.) that has consistent design qualities in all.

Type gauge A ruler calibrated in points and picas on one edge, and inches on the other. Also includes various line space measurements.

Type-high .918 inches, the exact height of a standard piece of metal type, or a plate that is to be printed on a letterpress printer.

Type size The size of type, measured in points from the top of the ascenders or cap height to the bottom of the descenders, plus some extra space to keep the lines of type from touching one another when set in multiple lines. In letterpress, the term refers to the piece of metal that the character is cut on. Also known as *Point size*.

Type style Individual font in a type family: roman, italic, bold, bold italic, condensed, etc.

Typo (Typographical error) A mistake made in copy while typing or typesetting.

Typographic color Refers to the "blackness" of a block of text created by the thickness of the font strokes, letterspacing, point size, and line spacing.

U

U & lc Abbreviation for uppercase and lowercase. It means to set the copy with a capital at the beginning of a sentence and proper names, and lowercase for the rest.

Umlaut (¨) An accent mark consisting of two dots above a vowel, e.g., ü.

Uncials A round, hand-lettering style from the period of the 4th through the 6th centuries, frequently drawn on guidelines placed 1 inch (uncial) apart.

Underscore A line or rule beneath a character, word, or group of words.

Unit A variable measurement based on the division of the em into equal increments.

Uppercase Another word for capital letters, historically placed in the upper of the two drawers used to hold metal type. Also called *Majuscules*.

V

Venetian Old Style typefaces based on 15th-century minuscule writing. They have little contrast, oblique stress, steeply angled serifs, and a slanted bar in the lowercase e.

Verso In publications, the left-hand, even-numbered pages. Also refers to the reverse side of a printed sheet. See also *Recto*.

Virgule (/) The name for the forward slash mark used to represent "per," as in miles/hour, or alternatives, as in and/or.

W

Weight The lightness or heaviness of a typeface based on the thickness of the strokes. Typeface weights can range from Extra Light through Extra Bold, and even heavier.

White space The space in, and around, typeset characters. Also refers to areas of a page that contain no text or image.

Widow A very short last line of a paragraph consisting of one word or a word fragment.

Word break When a word is split at the end of a line, with a hyphen, to fit the measure.

Word space The standard white space between typeset words, defined in font metrics and varying from font to font, which can be adjusted as needed.

Wrap/Wrap-around Typeset lines that fit around, or "wrap," an image or shape.

WYSIWYG (pronounced wiz-ee-wig) Abbreviation for "What you see is what you get." Refers to the image on the screen being identical to the image that is produced in the final output.

X

X-height The height of the lowercase letters in a font. It does not include the ascenders and descenders. It is measured from the baseline to the meanline. The lowercase x is used as a gauge because its flat top touches the meanline and its flat bottom sits on the baseline.

Index

Note: bold page numbers indicate illustrations.